# A
# CABINE
## OF
# CURIOSITIES

# A
# CABINET
# OF
# CURIOSITIES

# INQUIRIES
# INTO MUSEUMS
# AND THEIR
# PROSPECTS

## STEPHEN E. WEIL

SMITHSONIAN INSTITUTION PRESS

Washington and London

Editor and typesetter: Peter Strupp/Princeton Editorial Associates
Designer: Janice Wheeler
Proofreader: Susan Fitzgerald Fansler

Library of Congress Cataloging-in-Publication Data

Weil, Stephen E.
    A cabinet of curiosities : inquiries into museums and their prospects /
    Stephen E. Weil.
        p.      cm.
    ISBN 1-56098-511-9
    1. Museums—Management.   2. Art museums—Management.   3. Museum
finance—Evaluation.   4. Cultural property, Protection of.   5. Museums—
Educational aspects.   I. Title.
    AM7.W392   1995
    069.5—dc20                                                                94-30993
                                                                                    CIP

British Library Cataloguing-in-Publication Data available

Manufactured in the United States of America

01  00  99  98  97  96  95      5  4  3  2  1

♾ The paper used in this publication meets the minimum requirements of the American
National Standard for Permanence of Paper for Printed Library Materials Z39.48-1984.

Cover: engraving of the natural history cabinet of Ferrante Imperato (1672), Paris,
Bibliothèque Nationale (reproduction courtesy National Gallery of Art, Washington, DC).

To my museum colleagues . . .

. . . in gratitude for more than a quarter-century of
remarkable conversation, occasional contention, and
unfailingly good companionship.

# CONTENTS

# ACKNOWLEDGMENTS

Only a few of the pieces that follow were self-initiated. Most had their genesis in invitations of one kind or another: to lecture at a college or university, to address one or another professional association, to chair a conference, or to contribute to a publication. I am grateful and more to a host of individuals for both the confidence that initially prompted those invitations and for the subsequent help they so generously gave me in shaping these efforts into some final and publishable form.

Among those to whom I am particularly indebted are Milo C. Beach of the Arthur M. Sackler Gallery and Freer Gallery of Art; Stephen Benedict, formerly of the Graduate Program in Arts Administration, Columbia University; Kenneth Aaron Betsalel, University of North Carolina–Asheville; Lee C. Bollinger, formerly of the University of Michigan Law School and now of Dartmouth College; James W. Carignan of Bates College; Harvey P. Dale of the New York University School of Law; Adriana A. Davies of the Alberta (Canada) Museums Association; Diane G. Dufilho of the Asheville Art Museum; Milton Esterow of *ARTnews;* Ellen Schwartz Harris of The Montclair Art Museum; Judy M. Harris, formerly of the Virginia Association of Museums; Linda Linnartz, University of Virginia Division of Continuing Education; David H. Mortimer of The American Assembly; William F. Patry of the United States Copyright Office; Mary Sue Sweeney Price of The Newark (New Jersey) Museum; Barbara Rose, in her once-upon-a-time capacity as Editor

of *The Journal of Art;* Patricia E. Williams of the American Association of Museums; and Rebecca L. Wilson of the Mid-Atlantic Association of Museums.

Special thanks are also due the staff of the American Association of Museums' Publications Program, especially to Program Director John Strand and to Senior Editor Donald Garfield. Since 1976, they and their predecessors at *Museum News* have consistently encouraged me to address a variety of museum-related topics and have provided me with good counsel, generous space, and exceptional editing. Five of the pieces included in this volume first appeared in that magazine.

At the Smithsonian Institution Press, a remarkably able group of individuals oversaw the transformation of these initially scattered articles, reviews, and manuscripts into a book. Amy Pastan was the first to champion the notion that they might be gathered into what, literally, was "a cabinet of curiosities." In time, she was joined by Cheryl Anderson. For the design, my thanks go to Janice Wheeler—and for editing and typesetting to Peter Strupp/Princeton Editorial Associates.

As I have acknowledged in previous volumes, a publication such as this would not be possible except for a long tradition at the Smithsonian Institution whereby its employees are given the space and encouragement to pursue their individual interests through writing and teaching. What should also be acknowledged is the absolute degree of intellectual freedom that the Institution permits its staff in their pursuit of these activities. Not everybody in the Smithsonian by any means agrees with everything that follows, but there has never been the slightest hint of pressure or even so much as a suggestion that any of it ought be diluted, qualified, or left unsaid.

Here at the Hirshhorn Museum and Sculpture Garden, I am grateful above all to the Museum's Director, James T. Demetrion, who has not merely tolerated but on occasion actively encouraged my interest in many of the themes that these pieces explore. Of enormous help has been his willingness to engage with me in a long-term dialogue (now approaching ten years in duration) over the functions of art museums generally and, more particularly, over the linked issues of "formalism," "artistic quality," "point of view," "subject matter," and "content." Also vital has been the support of the two assistants who worked with me over the five-year period during which these pieces emerged. Carole Clore's ingenuity, patience, and critical skills were of

invaluable aid in their production. More recently, Maureen Turman has contributed her uncanny skills as a researcher, her welcome familiarity with publishing procedures, and perhaps most critically, her abundant good humor. None of these have proved superfluous.

Finally, and above all, I thank my wife Joan Wendy Luke. This volume would not have been possible without the sustaining and stimulating environment into which our life together has evolved. Toward the creation of that environment, she has contributed her matchless warmth, decency, acumen, grace, and understanding. My gratitude to her is beyond any words.

# INTRODUCTION

This collection differs markedly from its predecessors—*Beauty and the Beasts* (1983) and *Rethinking the Museum* (1990)—in the greater degree of skepticism and concern that it projects: skepticism toward some of the more extravagant claims made on behalf of museums, and concern, too, about the ability of museums, and art museums especially, to contend with some of the challenges with which they will almost certainly be faced over the next several decades. Readers particularly interested in these perspectives might want to begin their tour of this volume with one of the later-written entries such as the lengthy "On a New Foundation: The American Art Museum Reconceived" (1992) or the brief "Creampuffs and Hardball" (1993).

Concerning the claims made on their behalf, my own view is that museums are not and never can be as autonomous, as permanent, as inherently virtuous, or as broadly capable of serving an educational role as their more zealous advocates claim and sincerely believe them to be. No matter how strenuously members of the museum community may insist on their own objectivity, the fact is that the thrust of every museum is ultimately shaped by the dominant authority under which it operates. When a new government undertakes to reshape the society over which it presides, museums are no more exempt from the totality of such a process than are institutions of any other kind.

Unlike medicine, the law, and certain other professions that offer the opportunity for individual practice and that may provide occasions for courageous resistance, museum work occurs almost exclusively in an institutional setting. Courage is rarely an institutional quality. Consider, for example, the case of history museums. If history (as one historian called it) is "the gossip of winners," should it be a surprise that the versions of history offered by such museums may tend to change almost precisely in tandem with any change in those winners? The very notion of "institutional bravery" would appear to be something of an oxymoron.

Given this country's basic political stability, museums in the United States have rarely been tested in this regard. In Europe, however, where museums are widespread and where the winners may change with some frequency, the record is distinctly different. In a report from former Yugoslavia, for example, Michael Ignatieff recounted what happened to a museum at Jasenovac that was built during the Tito regime to memorialize and pay tribute to the more than 200 thousand Serbs who had perished in concentration camps near that town during World War II. When the Croatian militia overran Jasenovac in 1991, they did not pause to argue with the museum's director or curator about what, in their view, was the one-sidedness of the museum's presentation. They simply defaced or destroyed its entire contents.

Museums of other disciplines are in no better a situation. Although a handful of German art museum officials briefly resisted Hitler's early efforts to purge German culture of its "impure" elements, by the time of the 1937 "Degenerate Art" episode in Munich, thirty-two art museums were complicit in sending works of art to that notorious exhibition. Or consider the situation for museums of every kind in what was only recently the German Democratic Republic. Widely used in the German Democratic Republic was the definition of a proper socialist museum formulated by the late Klaus Schreiner, one of its most eminent museologists. Such a museum, he said, was "a cultural institution in which objects of the moveable cultural property are collected, preserved and decoded in the interest of socialist society and on the ideological basis of Marxism-Leninism." In what manner have the museums of eastern Europe that once adhered so closely to that definition—and I saw many such during 1984 and 1988 visits to the German Democratic Republic—now been transformed? The museum literature deals extensively with the role of the museum as an active agent. It has been relatively silent, however, about the passivity of its sometimes role as a plant.

Similarly, what ought also be recognized is that there is nothing inherently virtuous about museum work. It is simply a technology, a body of knowledge about how to accomplish certain things. Like any technology, judgments about its value must depend on the ends for which (or even the dignity with which) it is used. In this respect, museum work closely resembles teaching (is it per se good to teach anything, even the most up-to-date methods of torture, or the mechanics of terrorism?), publishing, and broadcasting. Discomforting as the notion may be to many of its advocates, the museum is essentially a neutral medium that can be used by anybody for anything.

To take an extreme example, consider the U.S. Holocaust Memorial Museum in Washington (which opened in 1993) and the extent to which the design of its galleries drew on some of the same sources as did the design of The World of Coca Cola in Atlanta (which opened in 1990). What distinguishes the Holocaust Memorial from The World of Coca Cola is not museographical technique (superb in both instances) but subject matter and viewpoint. The worthiness of a museum must ultimately depend on the worthiness of its goals, not on the mere fact that it *is* a museum or even on its technological competence. What, for instance, might one make of a Ku Klux Klan museum, regardless of the skill with which it was designed and managed? Under what circumstance might it be judged to be a "good" museum (or even a "bad" one), and by whom?

Still another issue concerns the museum's role as educator. What museums *can* do, they can do very well. But there is a great deal that they cannot do. Given the central role that objects play in their very definition, the fact is that many subjects are simply beyond the capability of museums to teach. Museums, for example, have rarely (if ever) been able to mount exhibitions that deal successfully with philosophy (who can recall a truly compelling display that addressed questions of metaphysics, epistemology, or ethics?) nor is it likely that they could mount successful object-based exhibitions about Fermat's last theorem, international arbitrage, the generation of airline and railroad schedules, or any aspect of quantum mechanics. Museums are at their best and most distinctly themselves when they deal with "stuff." It may well be the case, as some argue, that the "age of stuff" is slowly evolving into an "age of nonstuff," an age not of things but of interactions and processes. If so, then it may also be the case that the share of reality appropriate to interpretation through the exhibition of authentic objects in museums will be a

diminishing one. As suggested in one of the pieces that follow, some greater modesty about what museums can really accomplish might be in order.

Museums might also be more modest about the extent to which they have the capability to remedy the ills of the communities in which they are embedded. We live, all of us, in a society of startling inequalities, a society that has badly failed to achieve community, and a society that seems determined to lay waste to the planet that is its sole source of support. Museums neither caused these ills nor—except for calling attention to them—have it within their power alone to do very much to cure them. As Amitai Etzioni pointed out in his keynote address at the American Association of Museums' 1994 annual meeting in Seattle, museum workers in this country have sometimes let their energies become too far diverted from what they can actually do by agonizing over what they cannot.

Of the various challenges with which the museum community must contend in the next few decades, several of the thorniest may be demographic. One of those (the issue of how museums ought properly respond to an increasingly diverse and multicultural population in terms of their staffing, governance, programming, collections, and audience development) has already been widely recognized and begun to be addressed. A second demographic challenge, however, has received far less attention. At its heart is (a) the flow of populations from such earlier-settled areas of the country as New England and the middle Atlantic states to the more recently developed communities of the Sunbelt, and (b) even within those earlier-settled areas, the concurrent flow of populations from the older core cities to an outlying constellation of newly built "edge" or "satellite" cities.

Existing museum collections, by contrast, are static. As a consequence, what we are watching is a growing mismatch, one that threatens to become more acute with time, between where these museum collections are and where the people that such collections might serve already are or soon will be. For history and natural history museums, this mismatch ought not pose an insuperable problem. The possibility exists to establish new museums for these new communities and to stock those new museums with collections that primarily emphasize what is both local and still collectible. Nor should it be a problem that such new history and natural history museums will in all likelihood be relatively small in scale. Lack of scale is not an impediment to high achievement in such museums.

The case of the art museum is different. Scale does count, and no matter how interesting a small, exquisitely focused, and highly specialized art collection may be, it can never offer that panoramic sweep across centuries and continents—that density of comparisons, connections, and contrasts—that is the hallmark of our greatest urban art museums. Except for an organization with the resources of the J. Paul Getty Trust (and, even there, the process of amassing a major collection has proved to be a slow and painstaking one), it may no longer be possible to assemble from ground zero what could be counted as an important and wide-ranging collection of art. Most of what survives from past ages has already been collected by other institutions. What has not already been collected is mostly prohibitive in price. The so-called universal art museum may itself be on the way to becoming something of an unreproducible artifact.

If those chiefly responsible for managing these older art museums truly do believe that every person (and most especially young persons) ought be able to have a sustained and first-hand encounter with a wide range of original and important works of art, then something must clearly be done. Short of dismembering and redistributing the collections already accumulated in the nation's great art museums—conceivable, perhaps, under a centralized museum system such as France's but not under our own decentralized one—a formalized program of voluntary collection sharing would appear to be the most practical (and possibly only) solution.

Ideally, such a program would also involve some reverse flow of income to the lending institutions. Just such a pattern was established in the widely publicized 1992 leasing arrangement between the Whitney Museum of American Art and the San Jose Museum of Art, and it appears to offer a double benefit. It would give the people of less art-rich communities the opportunity to replicate the experience of those earlier urban generations that grew up with regular access to important works of art. At the same time, it could provide sorely needed resources to the major urban art museums, which are today longer on collections than they are on the funds necessary to give proper care to those collections. The downside, paradoxically, would lie in the additional risk that might be posed to parts of those same collections by whatever extra travel and handling such a program would entail.

Although several other domestic collection-sharing arrangements also appear to be in place (including, for example, several different arrangements

between the Museum of Fine Arts in Boston and art museums in Dallas and San Antonio), it is questionable whether such arrangements will ever become truly widespread without a degree of national leadership. Who might take the initiative with respect to this? Although the American Association of Museums would be one possibility, art museums are only one of its constituencies and by no means its largest. A more likely candidate might be the Association of Art Museum Directors, whose membership, the directors of the country's largest art museums, most directly controls the works of art that are potentially available to be shared. Conversely, another possibility might be the forum of smaller art museum directors that was formed inside the American Federation of Arts in 1994 and whose institutions are the ones most in need of access to important works of art. More important, who might fund such a program? The National Endowment for the Arts and the major foundations could certainly play a role (in fact, the Pew Charitable Trusts and the Knight Foundation already appear to be doing so), but the major responsibility (as in the case of the Whitney/San Jose arrangement) would most likely fall on the borrowing community, which, albeit poor in art, might be expected to have other resources that could be converted to cultural use.

Without discussing them in detail, three other challenges with which museums will have to contend over the next several decades are noted.

1. To borrow Peter Ames's terminology, there is the unresolved struggle between those who believe that museums must be essentially "mission-driven" and those who believe that they must be "market-driven." Whereas almost everybody understands that the museum that wholly ignores market considerations may lose the *means* to survive, it ought be equally well understood that the museum that turns completely away from considerations of mission may no longer have any *reason* to survive. Market and mission are the two ends of a spectrum. Every museum that hopes to sustain itself as both a meaningful and a viable institution will have to find that point on the spectrum where it can most comfortably accommodate both.

2. There is a real need for many museums to move more quickly toward making evaluation—particularly a process of both program and organizational evaluation—a routine part of their operations. Their failure thus far to do so is certainly not due to any shortage of evaluative techniques or of

potential evaluators. The problem rather (as can be seen most clearly among the art museums) can be traced to a continuing failure to define what it is they are attempting to accomplish with sufficient specificity to permit (a) an objective determination of whether they are actually accomplishing it and, if they are not, to permit some exploration of (b) why they are not and (c) what they might do instead by way of correction. As Yogi Berra once reportedly said, "If you don't know where you're going, you'll almost certainly end up somewhere else." In the current and all-but-certain-to-continue climate of limited resources, museums will find it increasingly difficult to claim their share of such resources when they can offer nothing better to prove the worth of their programs than the faith (or self-confidence) of their staffs and the approbation of their peers.

3. Something must be done about the continuing failure of the museum community to incorporate sanctions of any kind into its own self-prescribed codes of conduct. In 1992, the American Association of Museums came close to including some minimal sanctions in the new Code of Ethics that it was then proposing to its membership. Under pressure from some institutions—it was never made public how many and which—the Association found itself forced to back off. The Code as subsequently adopted eliminated these proposed sanctions, and the committee that would have been established to enforce them was transformed instead into one whose role was to be purely advisory. The question remains as to how seriously the public can regard the museum community's various ethical positions—the stricture, for example, against collecting or exhibiting objects illegally removed from their country of origin or a variety of constraints concerning potential and/or actual conflicts of interest—when the museum community itself is unwilling to take collective action against those who violate its rules.

Given, then, some of the disabilities under which museums labor and given as well the array of challenges that await them, to what compensating strengths can they turn in seeking to meet and overcome these? Several should be noted. To begin with, that same decentralization that prevents museums in the United States from uniting in any single and coordinated approach to what are essentially common problems might also be their greatest asset. With its

thousands on thousands of separately governed institutions (perhaps eight thousand or more in all) the museum community has the ongoing capacity to explore a wide range of potential solutions to each of these problems. There is something almost Darwinian in the notion that the greatest likelihood of finding a maximally innovative and practical way to deal with any particular problem lies in producing the broadest possible array of proposed alternatives from which to make a choice.

In a like manner, museums in the United States are immensely strengthened by the remarkably diverse backgrounds of those who work in them. No less important than maintaining racial, ethnic, and gender diversity within museums is the retention of a body of employees who can draw on widely varied work experiences and academic backgrounds. To date, the American museum community has resisted (and, I think, rightly so) any program of certification for museum work such as that with which museums in the United Kingdom have recently been flirting. Likewise, no common training is prescribed in this country for museum work, nor do we have any examining or review boards that need be satisfied before an employee can embark on a museum career. In fact, the borders of museum work are remarkably porous. Passages between museums and other nonprofit organizations are relatively common. Less common but still frequent are passages between museums and for-profit organizations of various kinds. The Darwinian principle again seems applicable. The likelihood of strong new initiatives emerging from this heterogenous mix of employees would appear to be far greater than would be the case if all the people who worked in museums shared a similar background, education, and work experience.

Also giving strength to the museum community is the palpable enthusiasm, determination, and even zeal that these museum workers typically bring to their employment. The very porosity of the museum community's borders (together, ironically, with the modest salaries that museums most generally offer) gives some assurance that the group of employees to be found working in museums at any given moment is, for the most part, a group that is truly eager to be so employed. (Ripe for study in this connection is the longitudinal pattern of museum careers. It is by no means clear with what frequency such careers last to retirement age or tend to terminate earlier.) Although this missionary spirit may sometimes pose a stumbling block to those who believe that museums ought be more market-driven than they are, the fact that there

is little reason to work in a museum without a passion to do so is one of the things that provides the field with its energy. In great measure, a similar enthusiasm infuses the work of those many volunteers who support museums through their service on governing boards or as unpaid staff. The availability of these energetic and highly motivated volunteers is still another of the museum community's distinctive assets.

Finally to be noted is the synergistic role played by the remarkably numerous and varied associations and committees into which museums and those who work in them have organized themselves. World-wide, these begin with the Paris-based International Council of Museums, composed of ninety-plus national committees and thirty-odd disciplinary and specialist committees. In the United States itself, these organizations include a thicket of geographically based national, regional, state, and municipal associations, together with an overlay of organizations focused on particular museum disciplines (e.g., art, natural history, science, history) and a second overlay of committees based on particular professional specialties (e.g., registration, conservation, curatorship, design). These organizations serve multiple purposes. They communicate the viewpoint of the museum community to various legislative and administrative bodies. They gather statistics. They prescribe standards of performance together with standards of conduct. They provide ongoing training at both entry and mid-career levels. Most important, perhaps, they provide the networks through which information of every kind—programmatic and personal, fiscal and even fictional—can be quickly disseminated throughout the museum community. To the extent that this network of associations and committees enhances the ability of a museum's governance and staff to anticipate problems, to evaluate solutions, and/or to identify opportunities, it serves as still one more of the museum community's important resources.

In summary, then, what ought best equip the museums of this country to cope with the challenges they will face in the next several decades is not, as some would claim, that they are in themselves worthy or of any intrinsic importance. If museums are to do well it must be through the cumulative importance and worthiness of the missions that they choose to pursue, as those missions are backed up by their distinctive strengths: the remarkably disparate ways in which they are organized, staffed, and governed; their independence of any central authority; their retention of a body of energetic

and enthusiastic workers of widely diverse backgrounds (my colleagues, to whom this book is dedicated); their flexibility to experiment in myriad ways; and their capacity, through voluntary associations of their own creation, to keep themselves and each other promptly informed about their common problems and possible solutions, their occasional perils, and their very frequent opportunities.

Like its predecessors this collection consists of pieces that were written for a variety of audiences and intended for presentation in a variety of settings, some more academic than others. Readers who elect to begin at the beginning and to continue doggedly through to the end will encounter some sudden transitions here and there. They will also encounter a few repetitions. Several of these pieces grew organically from one another ("Publicly-Chosen Art: What Standards Apply?" for example, elaborates and expands on several themes that were originally sounded in "Museums, Hitler, and the Business of *Isness*"), and this has led to some consequent overlap of ideas if not of language. Rather than prune that overlap for the sake of the straight-through reader, the editors of the Smithsonian Institution Press have thought it preferable to leave these pieces as originally written for the benefit of those who may read them out of sequence, in less than their entirety, and/or only now and then.

❊ ❊ ❊

# CONCERNING

❊ ❊ ❊

# MUSEUMS

❊ ❊ ❊

# IN GENERAL

❊ ❊ ❊

# SPEAKING ABOUT MUSEUMS:
# A MEDITATION ON LANGUAGE

What follows is a meditation on language. To be considered are several of the ways in which language is commonly used to speak about museums, not only when those of us who work in them speak among ourselves but also when we speak to those various outside constituencies who constitute our public. Central to the discussion are two of the most common ways in which we are apt to use language: when we mold it into such figures of speech as metaphor and, on a grander scale, when we weave it into the fabric of the many stories that we tell. To be able to encompass some other matters as well, my approach is deliberately (possibly even bafflingly) circumlocutious. Please bear with it.

To begin long ago and a good distance away, in the second century B.C., the writer Antipater of Sidon—Sidon was an ancient Phoenician city in what today we know as Lebanon—compiled a list of what he took to be the seven greatest wonders of that ancient world. Astounding in scale, awesome in their impact, these seven wonders were not natural wonders—towering moun-

This text was originally delivered as the keynote address to the Alberta Museums Association annual conference on October 25, 1991, in Red Deer, Alberta, Canada. It was subsequently printed in *Alberta Museums Review* 18 (Spring–Summer 1992): 5–9 and is reprinted with permission of the Alberta Museums Association.

tains, great waterfalls, or the storm-tossed Mediterranean—but human ones. They were monumental creations that had been conceived by human minds and shaped and constructed by human effort.

Antipater was a writer, not a museum worker. The wonders he described could only be gathered in a book, not brought together in a gallery. If we could, nonetheless, imagine him to have been one of our earliest museological ancestors, a kind of Greek-age curator—he was, after all, a person whose talent it was to classify artifacts, to rank them for particular qualities, and to incorporate them into authoritative lists—then, with the hindsight of two millennia, some interesting observations might be in order.

First, Antipater badly mistook what was simply transient to be something permanent. For all their glory, his seven wonders were never able to pass the test of time. Of those seven (the Hanging Gardens of Babylon, the Temple of Artemis at Ephesus, the Pyramids of Egypt, the Lighthouse at Alexandria, the Colossus of Rhodes, the statue of Zeus at Olympia, and the Mausoleum at Halicarnassus), only one and a fraction have survived to this century. The Pyramids still stand along the Nile, and fragments of the Mausoleum can be found in the British Museum in London. Otherwise, the rest are rubble.

Should Antipater be faulted because he failed to foresee this? Or could he perhaps be forgiven, because not even the wisest persons of the second century B.C. yet knew as much as we know today about the rise and fall of things, about that relentless process through which every dynasty, empire, and dominant power sooner or later appears to undo itself and has to watch its accomplishments fall back into ruin?

Antipater might also be forgiven for his second error: He mistook the local for the universal. His seven wonders were not really wonders of the world at all—they were simply the wonders of his immediate neighborhood, the eastern Mediterranean. Two were located in the northernmost part of Africa, two in Greece, and the rest not much farther away. Other humanly generated wonders as astounding and more so (the first monuments at Teotihuacan outside Mexico City, large sections of the Great Wall of China) had long since been built, but those were wholly beyond Antipater's knowledge. He mistook the world he knew for all the world there was, but many among us—curators included—have certainly done the same.

More problematic, though, is what some of us might consider the third of Antipater's errors, that he concentrated so tightly on the brick and mortar

aspects of human creation— the built environment of tombs and temples—to the exclusion of all those less tangible but far more enduring human creations in which these were embedded: systems of religion, systems of law, systems of governance. Those, too, were conceived by human minds and shaped and constructed by human effort. And those, too, were rapidly proliferating, not just in Antipater's neighborhood but throughout the world. In one form or another, they are still with us long after the Colossus was toppled by an earthquake and the Temple of Artemis sacked by the Goths.

Of those ancient and less tangible wonders, perhaps the greatest of them all is language. I would like to set Antipater aside for a while to consider some of the ways in which language may affect the most fundamental ways in which we think about and operate our museums. What I am proposing is, first, that language is understood today to be a far more complex and consequential creation than it might have appeared to a writer in ancient Greece and, second, because language *is* so consequential, that some of the ways in which we use it when we talk *about* our museums and our collections, both to one another and to the public at large, are deserving of more attention than we may generally give them.

Let me begin from a somewhat personal perspective. I was born in 1928. My generation—a generation born more closely to the end of the First World War than to the outbreak of the Second—was perhaps the last to grow up almost wholly oblivious to the possibility that thought and language might be deeply interconnected. For us, language was understood to be simply a relatively transparent medium through which an individual's inner thoughts, feelings, and perceptions—previously and independently arrived at—could be communicated outwardly in some spoken or written form.

It ought not be surprising that we believed this. In the West, at least, the tradition that conceived of language as a neutral form through which to express preexisting thought was an ancient one, a tradition that stretched back not only to Antipater of Sidon, but beyond him, back to Aristotle and even farther. For my generation, it was the tradition in which most of our early teachers had been trained, men and women born—as often as not—before the turn of the century.

Meanwhile, though, a different view of language had begun to assert itself. From the middle of the eighteenth century onward, more and more people had come to suspect that the ways in which we thought about things and the

ways in which we spoke about them might, in fact, be deeply intertwined. In the years since World War II, that second view would appear to have become the prevailing one. It is a view in which language does not merely express what we already think, feel, and perceive but is also seen to enter, and to enter profoundly, into the very shaping and construction of those thoughts, feelings, and experiences. It is the point of view from which one might echo Nietzsche's observation that, for all but the daringly original among us, nothing may be visible but that which already has a name. It is the point of view that was perhaps best expressed by the Viennese satirist Karl Kraus when he observed that language was the mother—not the servant—of thought.

To assign language such a role is not to deny that mathematicians, musicians, visual artists, and dancers—even pastry chefs and chess players—may all share a capacity to conceive and produce their work in nonverbal ways. For most of us, however, it is words—the names that we give to things, actions, qualities, and relationships—that shape the core of our thoughts. And, true as that may be of words, it is truer still of those everyday rhetorical figures of speech in which we deploy those words, rhetorical forms once envisioned as little more than decorative or literary adornments but today widely recognized as powerfully effective in determining how we respond to virtually every aspect of our experience.

Of those rhetorical devices, the most pervasive by far is metaphor, that basic figure of speech in which we describe one thing with words that were originally appropriate to something else. We speak immediately in metaphors as soon as we refer to a painful thought, a light spirit, the approaching hour, an ounce of patience, or the twilight of life.

To use an aquatic metaphor, we are, each day and all of us, immersed in metaphor. Thought without metaphor may scarcely be possible. Consider, for example, the museum organizations in which we work and how dependent we are on spatial metaphors to talk about them at all. Organizationally, we see them as vertical. Somebody is at the top. More people are at the bottom. A smaller group is at midlevel. Information rises, and people hope to do so as well. In terms of their program goals, though, we project museums into a horizontal space. One program could move us forward. The failure of another would be a real setback. A grant is requested for the purpose of advancement. We hope to leap ahead, not get left behind. Progress is positive; to lose ground is bad.

To understand the power of metaphor, not merely to express but to shape our thought, consider two very different ways in which we might think about time. In some cultures, time is understood through linear metaphors. It flows like a stream from here to there. Like a stream it must have a beginning, a source, and, once it reaches its destination, an end as well. Such a view generates its own particular cluster of questions: When did time begin? What was there before it began? What will happen to us when it is finally over? In contrast, there are other cultures that express themselves about time in metaphors that are cyclical instead of linear. Time, as thus envisioned, is a great circle, endless and recurring. In such a culture, other matters become important: the pattern of the seasons, the rhythm of repeated events, the resonance between a time past and its reappearance in a time still to come.

Metaphors and other speech forms are no less instrumental in shaping the way we think about museums. Consider, for example, the metaphor that describes the museum as a form of "temple." Temples have long held an elevated place in our imagination. Antipater's seven wonders of the world included the Temple of Artemis at Ephesus. A second of his wonders, the statue of Zeus at Olympia, was also to be found in a temple. The tradition of the museum as temple dates back to the eighteenth century. On the very first page of the statement of Canadian Museum Policy published in 1990 by Communications Canada, for example, is a quotation from the Abbé Henri Grégoire, an important figure in the French Revolution, who in 1792 referred to museums as "temples of the human spirit."

To call a museum a temple is to summon up a rich mixture of powerful suggestions. It might suggest, for example, that those of us who work within its precincts are performing some kind of a priestly function. It certainly suggests that the attitude most appropriate for visitors to the museum is one of reverence. Above all, it suggests that the museum objects toward which that reverence is due may, in some manner, partake of the sacred.

To invoke notions of the sacred takes us still deeper into the metaphor. Consider how thoroughly the rhetoric that undergirds our daily museum activity is permeated by concepts that relate to the sacred. Don't conservators and curators alike now and then tend to see themselves as guardians of some holy grail? Are they both not specially charged with safeguarding the numinous power of the original object? Don't we all envision museum objects as being

7

in constant danger of pollution—not merely the physical pollution of acid rain and toxic fumes but, as well and worse, the spiritual pollution of sordid commercial interest? Don't we all share a common commitment to ensure and maintain their purity? For that matter, why do some people believe deaccessioning to be so profoundly wrong? Do they think it is a form of desecration to tear what once was holy out of its museum setting and leave it abandoned and forlorn in the profane world that lies beyond?

The metaphors we elect to use in speaking about our museums can directly influence what our visitors expect. Call a museum a treasure house, and their expectation may be of carefully chosen objects of great rarity and value. Call it instead a laboratory for the visual arts and what they may expect instead is the unusual, the novel, the experimental. Compared with the museum as temple, the museum as laboratory is a place where truth and beauty are to be discovered not through revelation but through patient trial and error. In a laboratory, not everything need be right. Research replaces reverence, an inquisitive spirit replaces faith. The institution we imagine is a completely different and far more intellectually driven one than either the museum as temple or the museum as treasure house.

When we speak of the museum in managerial terms, our rhetoric might be cooler still. What if we liken the operation of the museum to the working of some physical system? Now we can speak of inputs, outputs, throughputs, and outcomes. The museum management's task is to transform available resources into desired services. Good management involves making sure that this transformation be made in ways that are demonstrably both efficient and effective. The operative pair of terms in which to discuss the removal of an object from the collection will be neither sacred and profane nor success and failure but cost and benefit. To talk of museums in such systematic terms arouses an entirely different set of responses than to talk of museums in terms of temples, priests, and desecrated objects.

Still other associations emerge when child-raising and schoolroom metaphors come into play. Cézanne called the Louvre "the book in which we learned to read." Here, we have another set of images: pedagogy, instruction, a school without desks, the museum as educator. The Mission Statement of the Minnesota Historical Society, for example, talks of the Society's duty to "nurture a knowledge and appreciation of history" among its constituents. The museum there is personified not merely as a teacher but as a loving parent as well. Implicit in such a

metaphor is the suggestion of a one-way transaction: The museum gives and the visitor receives. We will return to that point shortly.

At an opposite pole, what happens when we envision the museum through a metaphor of antagonism, when we project it as the beleaguered stronghold that guards a fragile and threatened patrimony? This is the treasure house metaphor taken to its extreme. Through such a metaphor, we can give form to all those forces that so blindly endanger our collections: changing tastes, community indifference, social conflict, and—that greatest destroyer of all—the physical decay that must inevitably come with time. Embattled in our museums, we understand deep down that time will ultimately outlast our treasures, but we nonetheless vow to fight gallantly to the end. No longer a priest, scientist, manager, or parent, the museum worker here can play the role of tragic hero.

In a lecture given some twenty years ago at the University of Colorado, Duncan Cameron proposed still another metaphor. The museum that served as "temple," he suggested, needed to be supplemented—not replaced, he stressed, but supplemented—by the museum that could act as a "forum." Museums in this latter mold would, like the forums of ancient Rome, serve as places of confrontation, interchange, and debate. Contrasting process with product, he concluded "the forum is where the battles are fought, the temple is where the victors rest." Omitted from this formulation, though, was any suggestion of where the vanquished might rest. Might not these—the victims of the victors—also deserve their own particular temple? That, too, is a point to which we will eventually return.

Not all the metaphors that surround museums are so positive as these. Those who doubt the value of museums have devised their own figures of speech with which to discuss them. Remember again those seven wonders of the ancient world. One was the Mausoleum at Halicarnassus, and that is how some of their harsher critics talk about museums: as mausoleums, as graveyards, as tombs for discarded and no-longer-living objects. In 1917, Harlan Smith of the National Museum of Canada told of a little girl (possibly a mythical one) who, on first glancing around a museum, described it to her mother as nothing more than "a dead circus." In such a dead circus, what roles might museum workers play? Superannuated jugglers, side-show hucksters, or just sad-faced clowns?

Are these examples just plays on words, nothing more than verbal tricks? Or do they have real and profound consequences for the ways in which we

run our museums? To argue that the latter is the case, let me return to the metaphor of the museum as parent and teacher. Implicit there, as I said before, is the notion of a one-way transaction, that the museum gives and the visitor takes. We talk about the museum providing a learning experience, and we hope the visitor will take something important away. To use a gas station metaphor, our visitors arrive on empty. We try to fill their tanks.

What would happen, though, if we were to reverse this metaphor to suggest that our visitors also had something to contribute and that our museums thereby stood to be enriched? Might we then perhaps approach things differently and, if so, how? A scattering of programs here and there suggests some possibilities. For example, the notion that the visitor has a vital role to play in shaping the museum is certainly inherent in the program of the Committee for a New Museology. It can be found as well in the scatter of history museums that regularly solicit their visitors for background information about the objects or documents they exhibit. Museums, though, can go still farther.

In one noteworthy instance and with funding provided by the National Endowment for the Humanities, the History Department of the Oakland Museum in Oakland, California, established a Response Center intended to solicit the general public's participation in determining how the Museum should represent contemporary life in its galleries. Preparatory to the 1974 opening of a permanent exhibition focused on twentieth-century California, the Museum circulated a brochure inviting the broadest community participation. The text read:

We are appealing directly to individuals, families, businesses and organizations because *your* history and experience in the form of objects both rare and commonplace, and the stories which give them meaning, are vital to an understanding of our recent past and present. Please share your experiences with us to help create a permanent gallery about California as it was and is, not as it might have been.

Writing subsequently about this effort, the Museum's Curator of History, L. Thomas Frye, described his institution as having moved from its traditionalist authoritarian role to the position of "both . . . partner and catalyst."

Among art museums, traditionally the most authoritarian of our museum institutions, such a reversal of role happens less frequently. Still, it can occur. During the mid-1980s, for example, the Columbus (Ohio) Museum of Art

developed a teaching program in which visitors were invited to participate in casually organized discussion groups centered on specific objects under the guidance of a staff member or an art educator from a local university. In lieu of the passive learning that may or may not occur in the customary lecture format (i.e., filling the visitor's gas tank), participants in the Columbus experience were encouraged to learn actively by interchanging responses and reactions with one another in a process loosely molded but not dominated by the Museum's expertise.

The National Gallery of Art in Washington, D.C., recently offered its own version of this teaching program under the title *Learning to Look*. Slightly more formal in its organization, it required participants to register in advance for a series of three group discussions. Although ostensibly focused on issues of visual perception rather than art historical information, the program inescapably involved the affective experience of art as well as its perception. In that respect, it can be understood to have been radical. By encouraging visitors to interchange the full range of their frequently diverse and wholly personal responses to specific works of art, the National Gallery's presentation of those works was immeasurably enriched beyond anything its staff could possibly have offered without such an input from its visitors.

To succeed, though, such a program—one that conceives of museum objects as open to multiple responses, multiple readings, multiple meanings—must overcome one of the most stubbornly entrenched of all museum metaphors. That is the notion that objects can be personified and that, in their personified state, they have voices that speak to us in direct and specific ways—or speak, at least, to those chosen among us who have developed the skill to understand what they have to say.

Our museum practice is laced throughout with this conceit. At one extreme are analytic museologists who—like the Dutch practitioner Peter van Mensch—speak of the "vocality" (sometimes even the "multivocality") of objects and their ability to "emit" information. At the other are the romantics—I quote here from a recent press release from the Brooklyn Museum—who talk of the "myths and memories embodied in . . . objects." Again, is this merely harmless rhetoric? Or might the notion that museum objects speak for themselves be one that carries genuine and potentially negative consequences? I would argue that the latter is the case, and for two reasons. First, not everybody responds to museum objects as if they speak. And second, even

among those who do, not everybody understands those objects to be saying the same thing.

To the extent that we rely on museum objects to communicate for themselves, we risk excluding, even alienating, those members of the public for whom they do not speak. To do so is to go directly against our general sense that the museum ought be a universally accessible institution. Beyond that, however, and perhaps more important, by doing so we also deprive ourselves of the opportunity to engage not only that part of the public but *all* the public in any kind of a focused exchange. In essence, by mislocating the source of their meaning—by treating as literal the metaphor that those objects can speak for themselves—we undercut the possibility of starting with some common understanding about those objects between ourselves and the public, some common understanding from which a further and more fruitful dialogue could then proceed. Such a common understanding is something wholly different and apart from—and need not be incompatible with—the individual visitor responses that were alluded to before.

Edwina Taborsky of Carleton University in Ottawa addressed this question in "The Discursive Object," a vigorously argued essay included in Susan Pearce's 1990 English compilation, *Objects of Knowledge*. Taborsky attacked the notion that meaning can reside in an object and transmit itself whole and intact to the observer who encounters it there. Meaning, she said, can only arise through the interaction of object and observer. Because an observer, in turn, can never be wholly detached or "free" but must always function from within a specific social context, the meaning that arises in any such interaction must, of necessity, be a meaning profoundly influenced by the nature of that social context. Museums that fail to understand that meaning is contextual, not inherent, run the danger of misinforming their public. Museums that do understand this interaction and are able to account for it in their exhibition practices may not only enrich their visitors' understanding of other cultures but, conceivably, of their own culture as well.

In the final report which it submitted in Denver in May 1991, the Task Force on Museum Education of the American Association of Museums came to a similar conclusion. Discussing the changing nature of museum interpretation, it observed that

concepts of the "meaning" of objects and the way museums communicate about them [are] changing. Objects are no longer viewed as things in themselves, but as

things with complex contexts and associated value-laden significance. Each visitor supplies yet another context and another layer of meaning as he or she brings individual experiences and values to the encounter with objects in a museum setting.

If we think that this is so, then it might perhaps be timely to put out to pasture—there is a good agrarian metaphor—those personifying figures of speech that envision our museum objects as engaged in a lively banter with our appropriately responsive visitors. Like anything else, metaphors can be more or less useful, and these seem to have outlasted whatever use they might once have had.

Finally, let's consider an even more complex way in which we regularly use language in the day-to-day operation of our museums: Language is the raw material out of which we construct stories, all the different kinds of stories that we tell in museums, stories about our collections, stories about our buildings, stories about our community and institutional histories. Here, too, there is cause for suspicion. In much the same way we came to suspect that language might be a source of thought—not simply its servant—we are beginning to suspect as well that to tell a story may not be quite so simple a matter as once it seemed.

Here we might usefully return to Duncan Cameron's double metaphor of the museum as forum and the museum as temple. "The forum," as you will recall he said, "is where the battles are fought, the temple is where the victors rest." In a parallel vein, we might say that once the battles *have* been fought, the stories that we tell in museums tend mostly to be the stories of the victors, not the stories of the vanquished. As the historian Frank Moorehouse once observed, "History is the gossip of winners." The defeated have neither a temple in which to rest nor a story in which they can play the role of protagonist.

What kind of stories do we tell to our visitors? Typically, they are stories of destiny, of inevitability—of how a currently prevailing type of art could not have helped but evolve as it did to emerge triumphant over competing styles, of how a currently dominant culture was foreordained from the very start to occupy its presently superior position. It is almost a commonplace among historians today that these stories—historical narratives, most particularly—do not so much recreate or represent the past as they legitimatize the present. They are not about what really happened in other times so much

as they are about why our own times, our own society, our own pecking orders could only be the way we find them and not some other way.

Just as one culture is necessarily distorted when seen through the lens of another—there is a good optical metaphor—so is the past distorted when seen through the lens of the present. Those, though, are only two of our difficulties. A third is that every story must be somebody's story. Once upon a time—in the time of our grandparents or certainly of our great-grandparents—people still believed in what one writer has called "the certainty of an ultimately observable, empirically verifiable truth." We no longer do. As people who live in this world, we cannot discuss it with the detachment of somebody who lives outside it. No matter how earnestly any storyteller purports to tell us a story truthfully, we understand how deeply the story that is told must be biased from the start by his or her point of view. Moreover, because such a narrator—no more so than the observer who interacts with a museum object—can never be wholly detached or "free" but must always function from within a specific social context, then even the most purportedly truthful story must, in turn, be profoundly influenced by the nature of that social context. Like the meanings that adhere to our objects, the stories that we tell in museums turn out to be, at bottom, social constructs.

What if we could, nonetheless, somehow surmount these difficulties, somehow eliminate every vestige of personal prejudice from these stories, pare them down to only what is empirically verifiable and free of bias? Curiously, we might still be far from any very inclusive truth. As we have learned from the literary explorations of Northrup Frye, story-telling itself may be an inherently defective way to capture reality. To achieve its final effect, the aesthetic demands of constructing a satisfying story may require the suppression—if not the outright elimination—of some elements as superfluous and the elevation of others to the status of essential causes. Unlike the annal or chronicle—fundamentally uncritical, bare-boned, and no-brain recitals of what events actually occurred and in what order—the story form must necessarily sacrifice factual verisimilitude in the interests of a more shapely form, a deliberately controlled pace, and a meaningful relationship of means to ends.

It may even be the case that not only the stories we tell but the museum itself reflects, in a curious way, one of Frye's master narrative forms—what he refers to as the "apocalyptic" myth. This is a myth that summons us to a

world of ultimate harmony and eternal reconciliation, a perfect time of some final measure and fit. Are those not, in fact, the very ways in which we most often try to project the world through our museums? Do we not, in fact, tend to suggest throughout our institutions that some overarching rationale links together the seeming diversity of the things we display? In our basic stress of clarification over confusion, of connection over disjunction, are we not engaged in telling a more profoundly fundamental story than what our curators may set down in their catalogues or our docents repeat in the galleries? Is it too great a reach to suggest that the very existence of the museum affirms a belief in some underlyingly ordered world? If that is so, then we must also remember that stories always leave things out, and we must try to understand exactly what those things are that we may have left out.

In Shakespeare's *Twelfth Night,* the wondrously carousing Sir Toby Belch poses a question to his cousin's prissy steward Malvolio. "Dost thou think," he asks, "because thou art virtuous, there shall be no more cakes and ale?" We might ask ourselves a similar question. Must it mean—because the language we use in and about museums may so mislead us, is so capable of deconstruction, because the stories we tell in museums are so likely to distort any reality, and in so many ways—that we shall no longer be able to display the marvelous, no longer be a place for wonder, no longer be a source of delight? It need not, I think, mean that at all.

What these things should suggest for museums and museum workers, though, is that a certain humility might be in order. Consider again our old friend Antipater of Sidon. What if—in presenting the pyramids, the Colossus, the Hanging Gardens of Babylon, and the rest of his collection—he had called them not the "Seven Wonders of the World" but "Seven Neighborhood Structures That I Like a Lot"? His list would have been no less interesting, and the reputation he left might today be somewhat higher.

In the same manner, our museums ought be no less interesting if some of our claims were moderated to a more local dimension. What we choose to collect and show may have neither universal nor permanent significance. Such things might be local wonders only, and transient as well. Perhaps all wonders are. They still, though, may honestly seem to us the very best choices we could make among all the things we might possibly know or could possibly display. We need not be ashamed to acknowledge such a limitation.

What we need to acknowledge as well is the humanity of our choices. The Field Museum of Natural History in Chicago recently began to display, right alongside some of its new exhibits, photographs of the staff members who were responsible for those exhibits. The message was clear. This exhibit did not just tumble down from out of the sky in some complete and final form. To the contrary, it was and is a human product—with all the limitations that involves—and these are the particular people we entrusted to produce it.

To go with this humility, we also need to be more sensitive about the language we use, both in talking among ourselves and in talking to our public. The use of metaphors is inescapable. That, of course, is still another metaphor. Nonetheless, as Susan Sontag pointed out in her two extraordinary books about the language we use—*Illness as Metaphor* and, more recently, *AIDS and Its Metaphors*—we can choose to abstain from or try to retire those metaphors that do not meet our purposes. The museum as gas station might be one of these. As noted earlier, the talking object might be another. Beyond that, simply to understand the degree to which metaphors form—not merely express but form—our thought should in itself be a spur to considering more carefully the way we talk about what we do.

Finally, we must understand more about the stories we tell, about what they leave out, and about what they modify. Stories, like metaphors, are inescapable. Reality is far too rich, too dense ever to be presented whole. To chronicle accurately what all the people of even one small village did, thought, said, and felt on even a single day would be a daunting task. How then can we ever talk about countries or continents as they have evolved over centuries or millennia except by telling stories that omit infinitely more than they can ever encompass.

Beyond that, for many of us—perhaps most of us, perhaps all—stories may sometimes be essential to help us to cope with the randomness of life. Stories enable us, in Roger Rosenblatt's phrase, to make "disorderly occurrences orderly." Just as the grand stories of history may serve to legitimatize the present for nations and for empires, so too can the smaller stories of everyday life serve to make the things that happen to us more than simply a series of happenstances. When somebody is struck by lightning, we may find a certain comfort to think that such a person was foolish enough to have taken refuge under a tree. To blame the victim may be a more general tendency than we usually imagine, not just a quirk of the mean-spirited. It comes with story-telling.

The solution, again, is not to stop telling stories but to recognize them for what they are: a version, our version, but by no means the only version nor necessarily a wholly true version. The notion that there could even be a wholly true version of anything may itself be a metaphor. Simple statements may be true or false, but something as complex as a story can never be, in that traditional legal formulation, the truth, the whole truth, and nothing but the truth.

In sum, what we might gain from thinking about Antipater of Sidon are some useful cautions. We need to be moderate in our claims of what we know. We need to be sure that, in our concentration on the concrete and tangible, we do not overlook some intangibles that may be vastly grander and more wonderful. We need to be cautious in our use of language, lest it mislead us. We need to understand that our stories can never mirror reality in any perfect way.

Curiously, though, rather than restrict us, these cautions might be a source of liberation. What they suggest is the degree to which it is human choice— and, with choice, a concomitant responsibility—that lies at the heart of the museum enterprise. As museum workers, we are not merely passive reflectors of the world—simple recorders of its seven wonders—but active participants in how the world is perceived and understood, participants in the creation of its meaning, shapers of reality.

To me, that seems both an exhilarating and humbling way to think about museum work: exhilarating in the freedom it provides us to shape reality to our several visions of it, and humbling in the need to understand that this freedom is not ours alone. For here we must consider still another wonder, that the claims made for other realities—a host of other realities—may be no less valid than the claims that we make for our own. Need all these realities— here is a last metaphor—necessarily be in conflict? Need one prevail and the rest be vanquished? Again, I think not. The final wonder—surely apocalyptic in its essence but not beyond our reach—would be that, through our ever-deepening insights, through the insistent practice of good will, through the continuing development of mutual understanding and respect, we will in the end be able to accommodate all these realities together.

# PROGRESS REPORT FROM THE FIELD: THE WINTERGREEN CONFERENCE ON PERFORMANCE INDICATORS FOR MUSEUMS

Performance indicators are statistics, ratios, costs and other forms of information which illuminate or measure progress in achieving the aims and objectives of an organization as set out in its corporate plan. The use of performance indicators is an aid to good judgement and not a substitute for it. Performance indicators are provocative and suggestive. They alert managers to the need to examine the issue further. Thus, for example, the unit costs of museums as measured by the cost per employee; the cost per person admitted or whatever is not a performance measure—it does not suggest that one museum is more efficient than another because its unit costs are lower. It is instead a performance indicator since it signals to management the need to examine why the difference exists.—Peter M. Jackson[1]

The question of whether and to what extent quantitative indicators of effectiveness and efficiency might provide useful information to those who

1. "Performance Indicators: Promises and Pitfalls," in Susan Pearce, ed., *Museum Economics and the Community* (London: The Athlone Press, 1991), 51.

Reprinted with slight modifications from *The Journal of Arts Management, Law and Society* 23 (Winter 1994): 341–351, with permission of The Helen Dwight Reid Educational Foundation. Published by Heldref Publications, 1319 18th Street, N.W., Washington, D.C. 20036–1802. Copyright 1994.

manage or make grants to museums was first raised in the early 1970s.[2] In the two decades since, it has attracted growing interest, particularly in the United States, the United Kingdom, and Australia. Only since 1990 or so, however, has there been an internationally coordinated effort to examine the potential use of such indicators in any greater depth.

That effort took a major step forward in June 1993 when performance indicators, together with several related diagnostic tools that might potentially be generated from the measurable or quantifiable aspects of a museum's operations, were the subject of a three-day Management Institute for Senior Museum Professionals held at the Wintergreen Resort in Wintergreen, Virginia. The Institute, *Measures of Success: Accountability Systems for Museums,* was a collaboration of the Virginia Association of Museums (VAM) and the University of Virginia's Division of Continuing Education (UVA). It was supported in part by the Institute for Museum Services, a federal granting agency.

Giving particular timeliness to the proceedings at Wintergreen was the recognition that the public has become increasingly concerned about the manner in which nonprofit organizations are being operated. Repeated newspaper accounts of disproportionately high administrative expenses including excessive executive compensation and "perks," deceptive fund-raising practices, and questionable conflict-of-interest transactions have all combined to undercut the esteem in which such organizations have long been held. Some have called the current situation a "crisis of credibility."[3] Museums, like many

2. For a book-length description of an early experiment involving the Akron Art Institute (now the Akron Art Museum), see William S. Hendon, *Analyzing an Art Museum* (New York: Praeger Publishers, 1979). For a more recent overview, see Peter Ames, "Measures of Merit?" *Museum News* 70 (September–October 1991): 56. For a contemporary view from Great Britain, see Robert Bud, Martin Cave, and Stephen Hanney, "Measuring a Museum's Output," *Museums Journal* 91 (January 1991): 29. As these sources indicate, the recent exploration of performance indicators has not been restricted to museums of any one particular discipline or scale. Indeed, a 1990 study of such indicators undertaken by Coopers & Lybrand Deloitte for Great Britain's Office of Arts and Libraries was based on fieldwork carried out at three very different London institutions: the National Gallery, the Natural History Museum, and the National Science Museum. The participants at Wintergreen came from an equally diverse group of institutions that ranged in their collecting interests and size from the National Gallery of Canada and the Henry Ford Museum down to a number of modestly scaled historical houses and local art and science centers.

3. See, for example, "A Crisis of Credibility for America's Non-Profits," *The Chronicle of Philanthropy* 5 (June 15, 1993): 1. See also the seven-part series carried in the *Philadelphia Inquirer* beginning April 18, 1993, under the title "Warehouses of Wealth: The Tax-Free Economy."

other nonprofits, are today under pressure to provide a greater quantity of hard data about the ways in which their resources are being used and in what measure their stated program goals are actually being met.

Externally, funding sources are continuing to redefine the notion of accountability to require a higher level of *quantitative* information to supplement the typically *qualitative* evaluation traditionally provided by peer review. Internally, the situation has been compounded by the stress of dwindling resources. Faced with stagnant or even declining support from their customary funding sources, museum trustees and senior managers are seeking to make the most efficient use possible of their remaining resources while at the same time assuring themselves that such resources are being directed, in fact, toward the effective accomplishment of what they have identified as their highest priority programs.

Those who traveled to make formal presentations at Wintergreen included Robert Bud, Head of Life and Environmental Sciences at the British National Science Museum in London; Richard F. Larkin, Technical Director for the Not-for-Profit Industry Services Group in the national office of Price Waterhouse and a member of the Financial Accounting Standards Board Not-for-Profit Advisory Task Force; Rebecca W. Rimel, Executive Director of The Pew Charitable Trusts in Philadelphia; Philip M. Nowlen, Dean of the University of Virginia's Division of Continuing Education and Director of the Museum Management Institute; and L. Carole Wharton, the Director of Planning and Budget for the Smithsonian Institution. Also appearing through a video tape were Elizabeth Blatt, Deputy Director for Science Education at the Science Museum of Virginia, and Philippa Glanville, Curator of Metalwork at the Victoria and Albert Museum.[4]

Also, brief informal presentations were offered by three of the Institute's participants: Susan Graziano, Director of the American Association of Museums' Museum Assessment Program; Stuart MacDonald of the Museums and Galleries Division, Department of National Heritage, London; and Jennifer Sanders, Assistant Director for Collections at the Power House Museum in Sydney, Australia. Judy Harris, Executive Director of the VAM, and Linda Linnartz, Director of UVA's Roanoke Center, provided a light-hearted prelude to the Institute through a slide presentation demonstrating how a variety

4. Blatt and Glanville had been taped during a panel chaired by Nowlen and addressing this same topic at the VAM's annual meeting several weeks previously in Charlottesville.

of indicatorlike devices were currently being used to rank-order such widely divergent subject matters as airline performance and the conformity of coonhounds to an ideal type. I served as moderator and also presented an introductory synopsis and overview of the program.

Alternating with these presentations was a series of intensive breakout sessions during which the thirty-six participants, working in smaller groups, attempted to sort through, evaluate for their utility, and improve further on some 150 performance indicators that had either been suggested in the recent literature or otherwise devised to stimulate discussion at the Institute. Among the specific topic areas that these indicators addressed were museum visitors and visitation; collections management; exhibition costs and schedules; facilities management; staff recruitment, retention, and training; membership and development; and the operation of boards of trustees. Also examined were several indicators intended to go beyond this "nuts-and-bolts" level and address such major components of institutional performance as scholarship and the educational impact of public programming.

Avoiding the extreme positions that have frequently bracketed earlier discussions of this topic—the argument from one side that the values with which museums deal are essentially intangible and that to try to use performance indicators in such a setting is a futile effort to "measure the immeasurable";[5] the equally sharp retort from the opposing side that the use of performance indicators is essential to the management of any enterprise because "you can't manage it if you can't measure it"—the participants generally chose a middle path. In reporting on their breakout sessions, they continually emphasized the point that the indicators under examination were not intended to serve—indeed, that these could not serve—as qualitative assessments, evaluations, or measurements. Their utility, rather, was as a means through which important questions relevant to a museum's operations might be more readily identified and addressed. In a similar way, during his formal presentation, Bud likened the typical performance indicator to a "can opener"—an instrument of little interest in itself, but which enables the user to get more readily at what might really matter.

5. As might, for example, be the case if one attempted to measure the beneficial effects of church attendance by counting—the phrase was humorously suggested by Larkin—"souls saved per pew hour preached."

Among the most potentially useful developments at Wintergreen was the emergence from the breakout sessions of two distinctly different (but nonetheless related) classificatory schemes through which the somewhat unwieldy mass of performance indicators put before the participants could be broken down into smaller and more manageable groups. One of these schemes differentiated between proposed performance indicators that sought to measure

*inputs* (i.e., the resources required to produce a particular output)

*outputs* (i.e., the program, product, or other result thereby produced)

*outcomes* (i.e., the ultimate impact of that output on the museum's targeted audience)[6]

Rather than mutually exclusive, these indicators appeared to be potentially complementary. Thus, for example, in examining its educationally driven exhibitions, a museum might concurrently use *input* indicators derived from the cost of these exhibitions in such measurable quantities as dollars and staff time, *output* indicators expressed in terms of the quantifiable merit of the resulting exhibitions as determined by peer or other expert review, and *outcome* indicators that sought to measure the extent to which the intended learning in fact took place. In the case of scholarly initiatives, *input* indicators might be built around a measurable investment of dollars and staff time, *output* indicators might be based on the number of refereed publications resulting from such an effort, and *outcome* indicators might be derived by calculating the number of subsequent citations in scholarly publications. Likewise, the ability of a museum to liquidate its backlog of deferred maintenance might be addressed through *input* indicators that took into account the measurable dollars and staff time needed to perform such maintenance, by *output* indicators that measured the number of tasks completed on time and within budget expressed as a percentage of all work done, and finally, by *outcome* indicators that sought to capture the museum's overall progress toward providing its staff and visitors with a safe, clean, and comfortable facility.

Under the second classificatory scheme that emerged from the breakout sessions, proposed performance indicators were sorted into four groups.

6. Both Nowlen and Wharton, in discussing the introduction of performance indicators into the evaluation of postsecondary education, mentioned the particular emphasis recently given to *outcome* indicators. These may typically address the question of whether an institution of higher learning is, in fact, educating its students in the manner that it claims to be doing.

One, which stood somewhat apart, consisted of indicators referenced as *red flags.*[7] The other three groups included indicators that addressed *effectiveness, integrity,* and *efficiency.*

Red flag indicators, which may serve as early warnings of impending problems, were of particular interest to the participants and received extended discussion. Such warning signs might range from demographic changes in the surrounding community to steadily dropping attendance to a continuing decline in the ratio of current assets to current liabilities. In the area of human resource management, excessive turnover and a rising rate of absenteeism were both identified as red flag indicators. An indicator that seemed of particular interest to the participants was one recently suggested by Kent John Chabotar, Vice President for Finance and Administration of Bowdoin College.[8] A potential indicator of the need for institutional retrenchment, according to Chabotar, was either (a) a 30 percent increase in the size of administrative staff over a period of five years, or (b) a situation in which the size of an organization's administrative staff was increasing at a rate 20 percent greater than the size of its nonadministrative staff.

As viewed through the most recent statistical survey published by the Association of Art Museum Directors—one of several statistical compilations that was provided for reference during the Institute—the larger art museums across the United States would appear to be in precisely the situation described by Chabotar. Whereas the total resources provided for their operations over the period 1987–1991 rose some 32 percent, a breakdown of this figure shows that the resources directed toward their administration increased by a rate half again higher than their curatorial and exhibition expenses. It was for just this kind of

7. A phrase introduced into the performance-indicator literature by Mary M. Wehle. Wehle's work in this area covers more than a dozen years. She was one of the principal authors of the report *Museum Management Tools* submitted to the National Endowment for the Arts in December 1978 by CCG, Inc. (a subsidiary of the Management Analysis Center), the first broad-based study of the potential utility of performance indicators for museums. More recently, she authored the working paper *Museums and Measurements* submitted by Idmon Associates of Chicago to a symposium on performance indicators organized by the International Council of Museums' International Committee on Management (ICOM–INTERCOM) and held in Paris on June 12–13, 1991.

8. This was one of a group of indicators signaling a possible need for institutional retrenchment described in an article prepared by Chabotar for *MMI* '92, published by the Museum Management Institute, a program of the J. Paul Getty Trust administered by the American Federation of Arts.

longitudinal analysis rather than comparisons between museums that the Institute participants felt performance indicators might ultimately prove most useful.

Effectiveness indicators were envisioned as similar to the outcome indicators described above. They could be used to calibrate the degree to which a museum might be successful in achieving its individual mission-related goals.[9] There was unanimous agreement among the participants that such an indicator must always be specific to a particular institution and should never be based on some hypothetical benchmark or standard applicable to all museums or even to the museums of a specific discipline, scale, or type of governance.

In contrast with the result-oriented focus of these effectiveness indicators, integrity indicators were envisioned primarily as providing information as to how closely the pattern in which a museum allocates its resources matches its stated priorities. Integrity indicators were seen as a means, literally, of testing whether an institution was "putting its money where its mouth was." Could a museum that had elevated education from simply one of several goals to its principal objective demonstrate that, as a trend over time, it had made a corresponding reallocation of the resources committed to the support of that activity? Echoing a phrase recently current in higher education, the internal reallocation of institutional funds from lower to higher priority programs was referred to throughout the Institute as "growth by substitution."

Efficiency indicators were understood as a means through which a museum might examine the relationship of inputs (measured mostly by dollars or staff time) to outputs. How much does the museum currently spend per square foot for routine cleaning and maintenance? How long does it take on average to fill a staff vacancy? What is the yield on a membership solicitation from each one thousand pieces mailed? What is being spent to ship an object from point A to point B? Given, however, that such a numerical indicator can only be meaningful when there is a similar indicator to which it can be compared, the participants devoted considerable time to the question of appropriate comparability. Having once been generated, with what might such an efficiency indicator most usefully be compared?

Of several possible comparisons, those between individual museums (or between one museum and the average of all other museums) appeared to be

---

9. As thus used, *effectiveness* should not be confused with *cost-effectiveness,* which is actually a measure of efficiency.

the most problematical. Although a museum might occasionally be able to identify one or two other institutions with operations so substantially similar to its own that meaningful comparisons might be possible,[10] the participants thought that more broad-based comparisons—except, perhaps, for something so generic as staff turnover rates or the total return on endowment—could only be misleading.[11] Not only do different museums count most things in vastly different ways (in a discussion of staffing, for example, there was not even agreement on how many part-time employee or volunteer hours constituted a full-time equivalent) but, even when similar means of counting are used, such comparisons can only be meaningful when all the surrounding factors are equal (which they seemed almost never to be).

Consider, for example, the comparison of energy costs per square foot. To what extent might such a comparison provide useful information when the museums to be compared may be located in different climates, be constructed with different building materials, and have different types of collections, different levels of visitation, and different local fuel costs? Similarly, even if a group of museums were able to agree, for example, on how to calculate the cost of gallery security, the variety of gallery configurations and methods of display as well as significant differences among the objects (from moths to masterpieces) to be guarded and disparate patterns of visitation would all combine to make any comparisons between such museums largely meaningless.

By contrast, there were two comparables with which the participants felt generally comfortable. One was a museum's *own* performance in prior time periods. As in the case of the red flag indicators discussed earlier, such a use of comparisons across time—referred to throughout the Institute as "trend analysis"—was generally regarded as among the most promising ways in which performance indicators could be used. The other well-accepted comparison was with a target previously established as a planning goal. In both these instances, the problem of consistent "counting" and of inconsistencies in the surrounding factors could be largely, if not wholly, eliminated.

10. Wehle has referred to this as a "buddy system."

11. There was also some discussion as to when comparisons with entities other than muscums might be useful. Cleaning costs, for example, might more usefully be compared with a local nonmuseum than with a similar museum located in a different community with a different labor market.

More controversial was the question of benchmarks or other externally derived standards. Granting that it might not be possible to prescribe benchmarks that were applicable across the whole range of museums, some participants thought that such standards might still be usefully established—perhaps in some informal format, like "rules of thumb"—for smaller segments of the field. Concerning the minimum desirable size of a museum's endowment, for example—treated as an indicator of whether the museum's board of trustees could ensure that sufficient resources would be available for its continuing operations—it might be argued that, at least for institutions of a middle scale, an endowment equal in value to twice the museum's annual operating costs might serve as an appropriate standard. Other participants thought that the variability among museums was simply too great to establish any such benchmarks. Larkin, for example, made the point that even in the area of fiscal management, where the for-profit community has long accepted certain fixed ratios as desirable standards, the individual museum manager would be far better advised to find a personal "comfort zone" than to adhere to some predetermined and externally generated fiscal ratio.

Tempering the generally positive attitude toward performance indicators were, however, several cautions. Given the availability of so many potentially useful indicators, the participants thought that some degree of restraint was necessary lest an organization find itself overwhelmed with more information than it could usefully assimilate. A frequent suggestion envisioned such indicators as grouped into a pyramid with senior management making use of a relatively small number of red flag, outcome, integrity, and effectiveness indicators whereas progressively lower levels of the organization used a progressively greater number of more fully detailed input, output, and efficiency indicators.

As to whether performance indicators might have any useful predictive value, the participants were generally dubious. Particular care had to be taken that numbers that were nothing more than statistical outcomes were not confused with rationally derived benchmarks. One example cited was the cost of raising funds. A study done for fifty-one colleges and universities by the Council for Advancement and Support of Education for the years 1985–1988[12] had shown that six dollars were raised for every one dollar spent on fund

12. See *The Chronicle of Philanthropy* 2 (September 4, 1990): 5.

raising. The question was posed as to whether this might serve as a reliable guide to an institution planning its own fund-raising efforts. Could it be assured that it would get six dollars back for each dollar spent? Nobody thought so.

By contrast there was general (but not unanimous) agreement that the introduction of performance indicators might have a substantial impact by way of feedback. To the extent that a museum department understood that its work was to be "scored" and that the resulting scorecard would be read by senior management, experience suggested that it might be driven by pride (or even by the satisfaction of being noticed—the "Hawthorne effect") into a more productive or focused effort. Several participants asked whether the same might not be equally true for a senior management that knew that its board of trustees or other governing body was regularly checking its "score."

On the other side of this discussion were some who thought that with too formal a system of performance indicators in place, staff members might be tempted to work toward good indicator results to the exclusion of pursuing those less tangible museum goals that were not so easily susceptible to measurement or quantification. Reverting to the opening slide presentation, the analogy was made to a coonhound that might score very well on all the required points (i.e., the conformity of its muzzle, legs, tail, and so on, to an ideal type) while still failing (as a companion, guardian, hunter, or pet) to be a very rewarding dog. The analogy to museums seemed clear enough. Underlining this view was the point mentioned earlier, but reiterated throughout the Institute as critical, that the real utility of performance indicators was as diagnostic or investigative tools, not as measures of evaluation or assessment. Moreover, even in those instances when some degree of assessment might inevitably be implied, under no circumstances could such assessments properly be considered as measures of *individual* (as contrasted with *departmental* or *institutional*) performance.

There was also general agreement that great care needed to be taken to distinguish between the internal and external circulation of performance indicators. To the extent that public funding authorities require evidence that a museum is operating according to plan and providing "value for money"—a British phrase that cropped up frequently during the Institute—output and outcome indicators appeared to be a useful way to give such assurance. Other indicators, though, most particularly efficiency indicators, were probably best

confined to internal use. Given the propensity of the press to make comparisons of the incomparable—phrases derived from "apples and oranges" were used repeatedly in this connection—the external availability of such indicators was all too likely to result in one or another public misunderstanding.[13]

Another frequently mentioned concern was that performance indicators should be built around numbers that were already being generated as a matter of course in a museum's normal operations and that they should not—unless the benefit would clearly outweigh the cost—require the calculation of any new (or "exotic," as one participant described them) figures that would not otherwise be useful. Some even took the view that, rather than formal management devices, performance indicators might better be understood as simply one of the several ways in which a "numerate" management could intuitively make use of the quantitative data that it routinely had available.[14]

In general, the Wintergreen participants resisted the temptation to devise indicators that attempted to reflect the total performance of museums and confined their discussion of performance indicators to particular aspects of management and to the outcome of specific substantive programs. In this context, management was discussed in purely instrumental terms and on the premise that good management constituted a *necessary,* but by no means a *sufficient,* condition for the operation of a good museum. Beyond the scope of

13. The participants in the ICOM–INTERCOM symposium referred to in note 7 reached a similar conclusion concerning the internal and external use of such indicators. In their final report, they noted that

> it was the sense of the meeting that such Indicators, when carefully tailored to a museum's mission and prospectively incorporated into its planning process, could be extremely useful supplements to peer review in evaluating departmental or institutional (but not individual) performance. . . . At the same time, the participants expressed serious reservations as to the propriety of using such Indicators as norms or predictors. Their greatest concern was that governments or other resource providers might ultimately be tempted to employ such Indicators as a means to compare institutional performance and/or to allocate resources.

14. That data underlie but do not determine management decisions was another theme repeated throughout the Institute. Blatt, in fact, used it as a recurring motif in her video presentation, which began and ended with a printed placard that read "Data do not a decision make."

management were such critical factors as the quality of a museum's leadership and the importance of its mission.

Despite all the talk of numbers at Wintergreen, such larger issues of institutional purpose seemed ever-present. Ever-present as well was the sense that those issues must now be dealt with against a prevailing background of what Rimel described as "corrosive cynicism." Underlying the Institute—indeed underlying much of the self-scrutiny in which the nonprofit sector finds itself so deeply engaged—were two questions that Larkin finally articulated directly during the Institute's final morning session. Unlike a for-profit organization, where the bottom line may be a clear measure of how well it has achieved its purpose and where effectiveness and efficiency may be overlapping concepts, how does a nonprofit organization define success, and how can it (and its funding sources) determine whether and when that success has been achieved?

Although the 1993 Institute at Wintergreen was not yet able to answer those questions, it did perhaps enrich the vocabulary and understanding with which they may hereafter be discussed. For that alone, profound gratitude ought be due to those who made the Institute possible. If performance indicators should ultimately prove to be useful in examining these larger institutional issues, then the time and effort invested in their exploration will have been richly rewarded.

In the end, though, as everybody seemed to acknowledge, no museum can long survive merely through the competence of its management. Something more profound is required. It must be able to make manifest that the service it provides to society is not simply as a depository of its past but that, as prescribed in ICOM's 1974 definition of a museum, it is capable of playing a dynamic role in its future development as well.[15] Toward that end, it must also be able to demonstrate that—in Nowlen's cautionary phrase—it is something more than a "federation of self-interest" in which curators are content simply

15. Section II, Article 3 of the ICOM Statutes adopted by the 11th General Assembly of ICOM (Copenhagen, June 14, 1974) and incorporating the amendments adopted by the 14th General Assembly (London, August 1–2, 1983) and by the 15th General Assembly (Buenos Aires, November 4, 1986) defines a museum as "a nonprofitmaking, permanent institution in the service of society and of its development, and open to the public, which acquires, conserves, researches, communicates, and exhibits, for purposes of study, education and enjoyment, material evidence of man and his environment."

to curate, conservators to conserve, and registrars to document and manage collections. To survive, it must, rather, be able to define the positive difference that it can make to the community from which it solicits its necessary support, and it must also be able to show that community that it is, in actual fact, making such a difference. To do so is more than just a managerial imperative; it is also an ethical necessity.

# 3

# CREAMPUFFS AND HARDBALL:
# ARE YOU REALLY WORTH WHAT YOU
# COST OR JUST MERELY WORTHWHILE?

The questions about their field that museum workers serve up to one another at their periodic gatherings (national, regional, and local) are generally creampuffs. Although shaped and flavored in a variety of ways, these questions can almost invariably be reduced to the single one of whether the museum, in essence, is truly a worthwhile institution. With almost equal invariability, those attending these gatherings conclude that it is. To those who work in them, it appears all but self-evident that, notwithstanding their temporary shortcomings, museums do make an important contribution to society. They preserve and transmit our natural and cultural heritage, they add to the world's store of knowledge, and they provide their publics with expanded opportunities for learning, personal growth, and enjoyment.

As crunch time approaches, however, and as the demands that are made on the public and private resources available to the nonprofit sector continue to grow at a faster rate than those resources themselves, virtually every museum may find itself faced with several much tougher questions—not

Reprinted with permission from *Museum News* 73 (September–October 1994). Copyright 1994, American Association of Museums. All rights reserved. A portion of this text was also included in a talk given at the New Jersey Association of Museums annual conference on June 20, 1994, in Trenton.

creampuffs this time but hardball. Without disputing the museum's claim to worthiness, what these questions will address instead is its *relative* worthiness. Is what the museum contributes to society really commensurate with the annual cost of its operation? Could some other organization (not necessarily a museum) make a similar or even greater contribution at a lesser cost? What would be the consequence—how much lost? how much gained?—if the same expenditure were to be devoted to some other activity entirely? We currently spend billions of dollars each year on the operation of our museums. We have yet to determine, however, in what measure that expenditure represents a wise and informed public policy choice and in what measure it may simply be the hangover of some old and still-to-be-fully-examined habit.

Underpinning these hardball questions is a profound and ongoing shift in the way that nonprofit organizations are being evaluated by those who provide them with resources. This shift, which appears to have started with social service and health care agencies and worked its way through higher education, can now be sensed as spreading across the entire nonprofit sector. It involves a newly heightened concentration on "outcomes" rather than either "inputs" or "outputs" as the principal basis on which to judge a charitable organization's public programs.

Little more than a generation ago, a museum was still measured largely by the resources (i.e., the inputs) that it had available: How good was its collection? How well trained and respected was its staff? How adequate and in what condition were its facilities? How solid was its attendance? How large was its endowment? Good numbers equated with a good museum.

In the years that followed—in the 1970s and well into the 1980s—the principal focus shifted from inputs to outputs. No longer judged so much by the measurable resources that they had available, museums tended to be judged instead by the programmatic use to which they put those resources. "Better utilization of collections" was a key phrase, and peer review became a principal means of evaluation. Who better could judge the skill with which a museum staff deployed the limited resources at its disposal than its colleagues in other museums who daily faced the same challenge? Output analysis goes still a step farther. It examines the impact of those programs rather than simply their quality.

In the United Kingdom, a remarkably direct phrase has emerged to describe the expectation of those responsible for providing public funds. What

they expect is "value for money." Typical of its use are recent remarks by the Right Honorable Peter Brooke, who, as the United Kingdom's Secretary of State for National Heritage, oversees the funding of the United Kingdom's major museums. Noting that publicly supported cultural organizations will be expected to carry out their day-to-day operations "within an overall framework of priorities and public policies determined by Government," Brooke emphasized that they must also "assure value for money for the taxpayer in pursuit of those aims."

What this all involves in essence is a new accountability in which organizations will be required to demonstrate not only (a) that they can account for the resources entrusted to them and (b) that they used those resources efficiently but, above all, (c) that they also used those resources *effectively*— that they used them to produce a positive outcome in the community intended to be served. The museum that seeks to meet the standards of this new accountability must be prepared to show in what positive ways its target community has benefited from its programs. This need not be a narrow constraint. That the museum continues to preserve a community's otherwise endangered heritage might certainly be one such beneficial outcome. Other beneficial outcomes might relate to the transmission of knowledge and/or skills, to the modification of behavior, or simply to the provision of enjoyment or recreation. The only required constant is that the benefits described be in response to what some have called the ultimate "so what?" questions. So what difference did it make that your museum was there? So what would have been the difference had it not been?

Implicit also in this new accountability is the question of limits. How are those allocating funds to determine the boundaries of an applicant's need? Is the outcome that an organization seeks infinite in scope (with the inference that the organization's need for additional resources will consequently be insatiable) or is there a point at which the organization may be considered as accomplishing its goals? Is there such a thing as an adequately funded museum, or is nothing ever enough? Richard F. Larkin, the Technical Director for the Not-for-Profit Industry Services Group at Price Waterhouse, has observed that this is a problem endemic to almost all charitable organizations. Their goals are generally formulated in open-ended terms ("to encourage an understanding and appreciation of contemporary art" or "to improve the health services available to the indigent members of our community") with little to

indicate what would constitute actual success or assist an observer seeking to determine whether it was being achieved. This is in sharp contrast to the for-profit organization in which success or failure can be determined by comparing some bottom line "outcome" figure with one or another of the organization's inputs.

Without a definition of success, of course, museums also lack a definition of failure. Might this be the reason that so few museums ever seem to fail? Dance companies dissolve, symphony orchestras collapse, and literary magazines disappear with regularity. Most museums, though—held in place perhaps by their collections—seem to survive indefinitely. They may shrink, they may lose or fail to earn accreditation, but rarely do they expire. Short of outright insolvency, the museum field seems to have few ways to identify those institutions whose chronic inability to achieve any demonstrably beneficial outcome cannot possibly justify the ongoing expense of their maintenance.

The museum seeking to articulate the ways in which it intends to have an effect on its target community would be wise to observe one caution: that it concentrate on those object-related outcomes that are most distinct to museums and not inadvertently undermine its unique importance by describing outcomes that might as easily be achieved by some other organization. Put another way, a museum may only be considered essential so long as its impact is perceived to be both valuable *and* incomparable. Consider, to use a wicked example, the museum improvident enough to base its case for public support on an economic impact study that quantifies its value to the community in terms of tourism, jobs, and purchasing power. What will justify the continuing public investment in such an institution when some other entity (a sports team, a theme park, a rock concert amphitheater) can demonstrate that—for a similar public investment—an even greater economic impact might be achieved? If museums cannot assert their importance *as* museums, then museums may not be perceived to be important at all.

More troubling in this respect is the extent to which some museums have begun to stress general educational objectives as the principal outcome for which they ought be valued. By doing so, they may ultimately leave themselves vulnerable to the claims of more traditional educational institutions that these latter could, with a only little inexpensive tinkering, deliver a comparable value at a fraction of the cost. The recent emergence of so-called single-subject museums—story-centered rather than object-centered and relying on what

the designer Ralph Applebaum (a leading practitioner of the form) describes as "theatrical constructs" instead of what he calls a "giant cabinet-of-curiosities approach"—may pose a similar problem. The experiential outcome at which these museums aim may eventually (as soon, perhaps, as the widespread advent of virtual reality) be accomplishable by other and, again, less costly means. When incomparability is no longer an issue, then such cost comparisons may validly become the single criterion by which an institution is judged. The museum that casts its aspirations in such nontraditional terms cannot complain of "apples and oranges" when it finds itself unexpectedly measured against organizations of other kinds that can provide a comparable value at a far lower cost.

Beyond making the case for continued support, the ability of a preponderance of museums to define their intended outcomes and to specify what they would consider a successful level of achievement might have an important side effect. It could help lay to rest the perception that museums sometimes operate as what Philip M. Nowlen, Director of the Museum Management Institute, has called "federations of self-interest." In a field so largely self-initiated, the images that Nowlen conjures are all too familiar: the museum whose governing board believes—notwithstanding the clear language of its charter or its current mission statement—that organizational survival is the institution's driving and highest purpose, the museum in which the staff channels a disproportionate effort into its own professional development, the museum summoned into being for no better reason than to house a privately gathered collection that might otherwise have had to be dispersed, the museum that survives primarily to serve as a social focus for those who support and take turns governing it. Future funding prospects may be dimmest for those museums that appear to be little more than sites for self-indulgence, brightest for those that can most adequately answer the question "To what ongoing public need is this institution a response?"

It will be argued by those who resist these impending hardball questions—those who find them crude, insensitive to cultural values, too money-minded, or too result-oriented—that they constitute nothing more than an inappropriate effort to apply a clumsy cost-benefit analysis to an activity that belongs in some different sphere altogether. Although there may certainly be institutions (e.g., the family, public schools, religious orders) as to which such a cost-benefit analysis seems inappropriate, nowhere is it written (nor may it

be any more than wishful thinking) that museums necessarily will or ought be exempt from such scrutiny. That museums were once described as "temples of the human spirit" is no guarantee that they will be forever considered sacred. Nor is the fact that they have been well supported in the past a guarantee that they will always be thought to have such an entitlement.

If this analysis still seems far-fetched, consider health care. The time is fast approaching when, in allocating health care resources, public policy–based decisions will have to be made about the value of providing care to one patient in comparison to another, about the value of, literally, saving one life rather than another. That the lives involved may all be worthwhile will be beside the point. Not every human being can be saved, and hateful as we may find the thought, medical care must ultimately be rationed by public decision, just as it has hitherto been rationed by the less visible forces of the marketplace. Might one reasonably expect something more clement for museums?

In summary, when (not if, but only when) the anticipated crunch in public and private funding materializes, worthiness alone may not justify the continued support of every museum or similar institution. The questions that each museum may have to answer are just these hardball ones: Are you really worth what you cost or just merely worthwhile? Could somebody else do as much or more than you do for less? Are you truly able to accomplish anything that makes a difference, or are you simply an old habit, or possibly even a kind of indulgence? Beyond doubt, the great majority of museums will be able to develop positive and solidly convincing responses to these indisputably difficult questions. It is by no means too soon, however, for a museum's governing authority and senior staff to begin to consider just how that might best be done. Hardball is nigh.

# 4

# A BRIEF MEDITATION ON MUSEUMS AND THE METAPHOR OF INSTITUTIONAL GROWTH

The Viennese social critic and satirist Karl Kraus once observed that language was the *mother* rather than the *servant* of thought. In this, he reversed the conventional understanding that language follows after thought and is merely the means through which we communicate such preexisting thought to one another.

An instance of how we generally use language in museums provides an interesting demonstration of Kraus's insight. It is a commonplace of museum discourse to refer to these past two decades as a time of unprecedented "growth," both for individual institutions and for the field as a whole. It can be argued, however, that—as used in a museum context—*growth* is a singularly inapt and misleading metaphor. By its suggestion of a dynamically independent process, the notion of growth clouds the issue of management's involvement in and responsibility for a museum's expansion in much the same way as does the young child's classic description of how a broken toy came to be broken—"it fell down."

Plants, animals, and other organic things may grow (even crystals, too) but not an organization. When an organization expands in any of its dimensions,

it does so as the result of the managerial decisions made or, not infrequently, of the managerial decisions avoided, not from any natural process of growth. To describe it otherwise is to suggest, and falsely, that the process of management is dominated by a certain organic inevitability (e.g., in the oft-repeated complaint that "the way our collection's been growing lately, we'll certainly need new space within another ten years") and not by choice. As suggested by Kraus, what starts with muddled language can often end with muddled thinking.

Growth in and of itself is neither good nor bad. Bigger is not necessarily better, but neither is it necessarily worse. Growth may sometimes be positive, such as seeing our children grow or successfully growing a rose bush. It may also be negative, as when our garden is overrun by weeds, or downright frightful, as in the case of a malignant tumor. Similarly, the expansion of a museum may sometimes be seen, and rightly, as a reasoned response to changing circumstances. Alternately, such an expansion may represent its leadership's inability—or, worse, its abdication from the effort—to deal with the myriad and dissonant pressures under which managerial decisions must constantly be made.

In some respects, the museum may be hostage to external forces, and a degree of growth will be inescapable. That is particularly so in the case of the operating budget. The maintenance of existing programs may require that there be budget increases (as well as concomitant increases in endowment, earned income, and other sources of funds) at least equal to the ongoing rate of inflation. Budgets may also require expansion to meet the increasingly stringent regulatory requirements that apply to such areas as employee safety, environmental hazards, and visitor access. Similarly, a museum with an expanding constituency might reasonably determine that its program activities ought be expanded in some commensurate manner.

For other aspects of the museum, though, and most particularly for the collection, the application of something akin to a "steady-state" approach to growth might be a genuine alternative. A thought experiment may be illustrative. Imagine, for example, a museum that determined to maintain the size of its collection at a constant five thousand objects. The criterion for accepting a new object into the collection would then be (a) that this new object was more important (suitable, appropriate, relevant, of "greater quality," or however else defined) than at least one of the other five thousand objects

already in the collection, and (b) that this second and less important object could then be promptly deaccessioned and disposed of.

Contrariwise, if the proposed new object was *not* more important (e.g., suitable) than any of the five thousand objects that were already in the collection, then (and no matter how fascinating a footnote one or another expert might think it would make to something else already on hand) it would have to be rejected. Arguably, the five-thousand-and-first most important (e.g., suitable) example of almost anything in the world might be more appropriately kept in an archive rather than in the collection of an active and program-oriented museum.

It will be objected that this approach will not be practical for museums that collect in "open" areas (e.g., museums of contemporary history or contemporary art). Because the universe of things out of which those museums collect is constantly expanding, their collections must constantly expand as well. Still incumbent on the management of such museums, though, would be some obligation to determine at what rate and to what limits this expansion could continue. The *reductio ad absurdum* of any contrary approach is that, infinitely expanded, the growing collections of these museums would someday choke off all other known forms of life.

Could such a steady-state approach be usefully applied to facilities as well? If some proposed new use of space is not more important than every other old use, is such a new use really necessary? If it *is* more important, perhaps one or another old use could then be phased out. And what about staff? Is it thinkable that no new position ought ever be created without proposing the elimination of an old one? Consider the museum from which nobody ever leaves, in which new employees simply accumulate like sediment in a pond. Does such a museum necessarily appear to be a well-managed institution in terms of its program goals? Or does such a museum raise at least a suspicion that its management might be as much focused on the well-being and morale of its staff as on the accomplishment of its mission? Such a steady-state analysis may not always produce a practical solution, but at the very least it should provide a useful device for internal review.

A museum's management (like any management) constantly faces a flow of decision points at which it must opt either for "growth" or for "no growth." The latter may also include a certain possible shrinkage. Vital to understand is that these contrasting impulses by no means present themselves to manage-

ment in any balanced way. The playing field on which they contend is scarcely level. Of the two, the consequences promised by "growth" are by far the more alluring.

The well-polished chestnut that museum leadership frequently suffers from an "edifice complex" still conveys an important truth. Brick-and-mortar achievements will be evident to all. Expansion, moreover, can be an exhilarating challenge, an opportunity for heroic achievement at both the board and staff levels. As a catalyst, it can bring all levels of the museum into some pleasing and desired synchrony. For those who relish authority, it can offer the expanded authority that comes with an expanded institution. For those who enjoy the limelight, its opportunities are boundless. Not least, management's choice of a growth option can eliminate the painful need to set priorities. Experience has shown, however, that exercise of the growth option, nevertheless, requires the setting of priorities, if not by choice, then later by default.

In contrast to the sometimes siren song of growth, the option of no growth has as little glamour as a cautionary foghorn. Its charms are gray, its aspect dull. The maintenance of a museum in a steady or close to steady state will attract little newspaper notice and win small praise. When was a museum director last honored for a twenty-year record of consistent resistance to every expansionary impulse? And yet, in the heroism of everyday life, the latter course may actually be by far the bolder one. Not everything is as important as everything else. To take a stand publicly as to which is which is a courageous act. Indeed, morality itself may—as Léon Blum, France's Premier on the eve of World War II, once said—"consist solely in the courage of making a choice."

Although there are many who would agree that museums, together with other nonprofit organizations, ought to be more "businesslike" in their operating methods, that is not to say that they must also be more like businesses in the goals that they pursue. For the publicly held corporation, an escalating market share and/or a steady pattern of earnings growth may be necessary to maintain its independence and to fend off corporate predators. A museum need not put itself into an analogously embattled position. If programs of relevance, steady excellence, and consistent achievement are not sufficient to retain its support, the question must then be asked of just what it is that its supporters have enlisted to support. Do they really believe that a fine watch can only be truly successful through the risky business of turning itself into a clock?

There is a children's game in which the players take turns adding to a pile of blocks until the pile finally topples over. The last player to increase the pile before it topples is declared the winner. Trial and error, though, is not an acceptable way to manage a museum. As the stewards of a public resource, we have more at stake than winning a children's game. We cannot wait for the pile to topple over to find out what the outer limits of our expansion might have been.

In sum, the scale of a museum (i.e., the dimensions of its staff, budget, programs, collections, and facilities) must be seen as a matter of careful management choice. This choice of scale is among the most basic of managerial decisions. It is a process of choice that can only be confused by language (and, inescapably, by the confused thoughts that such language engenders) suggesting growth to be an independent and dynamic element with which management must contend. It is no such thing. It is a phenomenon wholly within management's control. Museums do not "grow." They just appear to do so when their managers fail to deal wisely with those frequently seductive impulses that constantly push and pull them toward the alluring prospect of expansion.

❈ ❈ ❈

# CONCERNING

❈ ❈ ❈

# ART AND

❈ ❈ ❈

# ART MUSEUMS

❈ ❈ ❈

# MUSEUMS, HITLER, AND
# THE BUSINESS OF *ISNESS*

Nobody can long listen to the current public disputes about the visual arts (What should properly hang in our museums? What ought the National Endowment for the Arts [NEA] fund? What role for decency?) without recognizing that something's not right with the language in which these disputes are couched. To even a casual listener, the works of art denounced by some and defended by others (works by Mapplethorpe, for example, or Serrano or Wojnarowicz) must sound like different things entirely. What is generally at issue, though, are different aspects of the same thing. Public discussion of the arts sorely needs a richer and more discriminating vocabulary that would better reflect these distinct and different aspects.

An initial difficulty is that we are accustomed to think of works of art as indissoluble, as a fusion of elements that—once combined—cannot readily be separated. Appropriate as that might sometimes be (e.g., in choosing what we would hang at home), works of art nevertheless come to us in an irreducibly double aspect. As Susan Sontag pointed out in her 1965 essay *On Style,* "Art is not only about something; it is something." The point at which our public discourse most often seems to founder is in failing to make the necessary distinction between those two aspects, between the *aboutness* of a work of art and its *isness.*

The following imaginary (but by no means improbable) instance may be illustrative. A well-regarded young artist has painted a series of thirty mono-chromatic portraits depicting significant (and mostly deceased) figures in twentieth-century history. First shown together at a New York gallery, they have been extensively praised by both the local and national art press as original in approach, imaginatively conceived, and skillfully executed. Singled out for particular mention has been the artist's subtle use of color.

On the recommendation of its chief curator, a publicly funded art museum purchases what in the curator's opinion are the two indisputably finest of these paintings—the portraits of Woodrow Wilson ("A Study in Ultramarine") and Adolf Hitler ("A Study in Ochre"). The museum first shows these in an exhibit of recent acquisitions. The accompanying labels give no more or less informa-tion than do the labels for other works in the exhibition: artist, title, date, medium, and dimensions.

Ought we be surprised if the public reaction is swift and negative? A veterans group pickets the museum, claiming that the display of Hitler's portrait ("A Study in Ochre") is a personal affront to those who lost or risked their lives in World War II. The legislative body responsible for funding the museum appoints a committee to investigate its governance, management, and acquisition policies. Letters to the local newspaper denounce the mu-seum's director as a proto-fascist. Several corporate and individual contribu-tors threaten to withdraw their support.

This is the gulf of misunderstanding that our customary art language seems inadequate to bridge. For the curators at the museum (or, at least, for those who have resisted the lure of revisionism), the *isness* of art is the principal focus of their daily work. That the portrait of Hitler is an originally conceived and beautifully painted work of art ought be reason enough to acquire and display it. From their perspective, it may be all but inconceivable that other people would put so great an emphasis on the painting's *aboutness*.

For most people, though, images rarely function through their *isness*. In the world outside the art museum, images most frequently serve as a means of reference. Like Hitler's portrait ("A Study in Ochre"), they are generally regarded as illustrative, not to be thought ends in themselves. If Hitler is really Hitler (Führer of the Third Reich and the cause of great suffering) when his portrait is hung in a history museum, then by what legerdemain does that same portrait become primarily an excellently wrought arrangement of

forms and color—a study in ochre—when it is hung instead in an art museum? That the traditional art museum is so largely premised on the self sufficiency or autonomy of images is by no means well understood.

*Aboutness* and *isness* are complementary points of view, not competitive ones. Neither can be wholly excluded from any ongoing discussion of art and its place in society. Nonetheless (and, perhaps, curiously), they are not of equal weight. In one important respect at least—government support for the arts, whether through the direct operation of public museums or through such grant-making bodies as the NEA—there are compelling reasons why *isness* must be treated as the more important.

Consider, for example, some of the great fifteenth- and sixteenth-century paintings that hang today in Washington's National Gallery of Art, paintings such as Jan van Eyck's *Annunciation* (which one of the Gallery's former directors called "a masterpiece of Christian symbolism") or Raphael's *Alba Madonna*. Given that the First Amendment specifically prohibits our government from the establishment of any official religion, how can the display of such works by a publicly funded institution be justified on any grounds other than the excellence of their *isness*? In terms of their *aboutness*—the propagation of a particular faith or set of beliefs—their display could well be judicially condemned as an impermissible attempt at religious persuasion.

What saves these works from such condemnation is the special nature of the art museum, that it is a place that quintessentially emphasizes what these paintings are (i.e., works of art) and not what they depict (i.e., stories about Christ). The art museum's core business, quite literally, is *isness*. In this, it differs markedly from other educational institutions. A requirement, for example, that reproductions of these same religious paintings by van Eyck and Raphael be displayed in every public school classroom across America—a context emphasizing *aboutness* above *isness*—would undoubtedly be struck down as unconstitutional.

The First Amendment is also relevant to the grant funds awarded by the NEA and the various state councils on the arts. Again, it pushes toward *isness* rather than *aboutness*. Because government is constitutionally precluded from interfering with an artist's right of free speech, such grant-making bodies are similarly precluded from basing their funding decision on the "content" of the artist's work (i.e., its *aboutness*). They cannot consistently fund the production of art favoring one point of view while, with equal consistency, denying funds

for the creation of art that espouses an opposite point of view. Toward content, their stance must be neutral. Typically, the NEA's establishing legislation thus directs that, instead of any considerations of *aboutness,* what it must consider in its grant-making decisions are such non-content-based criteria as "standards of professional excellence."

Could it be otherwise? Consider the converse. Imagine that we had established instead a program of government support for the arts based solely on their content (i.e., on the correctness of what they are about rather than the artistry and excellence with which they have been created). By mandating *aboutness* over *isness,* would we not have precisely replicated the programs of public art that evolved in Nazi Germany and the Soviet Union? In the end, these became programs of propaganda, not art.

Regardless of whether we are dealing with publicly or privately supported art, we need to enrich the vocabulary we use in talking about it with one another. We need to find language that not only distinguishes between the *aboutness* and *isness* of art but that recognizes as well that these aspects must invariably be coupled together. When Archibald MacLeish argued that "a poem should not mean/But be," he was not, despite his words, indifferent that the reader grasp his meaning. The art museum which, on the criterion of the painting's excellence alone, chooses to display "A Study in Ochre" should be prepared to discuss its reasons with those outside the museum for whom its *aboutness* about Hitler may be a larger consideration than its excellence as a painting. In turn, though, those outside the museum must also understand that, in the world of the visual arts, there must be a fully generous space for *isness.* Without it, art would no longer be art, and we would all be the poorer.

# 6

# PUBLICLY-CHOSEN ART:
# WHAT STANDARDS APPLY?

To understand the situation of a governmental or other public body required to make judgments with respect to works of visual art, a useful way to begin might be to imagine yourself as having undertaken to jury an open and competitive exhibition in which you are not only to determine which works will or will not be included but must also select one of those to be included as the best in the exhibition.

Surprisingly (or perhaps not), it seems to me that the two principal factors that must necessarily guide your judgment as such a juror and the two factors that, in the end, must inevitably govern a program of public support for the arts are fundamentally the same. One of these involves a network of considerations that we customarily lump together in such short-hand (and sometimes bitterly contested) phrases as "aesthetic excellence" or "artistic merit" or refer to simply as "quality." The second involves a related cluster of

The original version of this text was twice delivered as a lecture, first at Bates College on November 4, 1993, and the following week at the Asheville Art Museum on November 11. This revised text appeared in *The Journal of Arts Management, Law and Society* 24 (Fall 1994). Reprinted with permission of The Helen Dwight Reid Educational Foundation. Published by Heldref Publications, 1319 18th Street, N.W., Washington, D.C. 20036-1802. Copyright 1994.

considerations that we generally sum up with the word *artistry*. What follows is an exploration—one that may, admittedly, appear at the outset to be somewhat roundabout—of just what might be meant by these concepts of quality and artistry, of what roles they might play in public decision-making concerning the arts, and of why they might have an importance that far transcends the more immediate questions of what will or will not be chosen for a juried award or what will or will not be designated to receive governmental support.

We are accustomed to think of a work of art as an indissoluble entity, to think that every painting, sculpture, or graphic work consists of a fusing or blending together of its particular subject matter and its artistic form—of *what* it depicts and of the *way* in which it depicts it—into a unique, unified, and inseparable whole.[1] We are further accustomed to think that the way in which each of us responds to such a work of art is through an encounter between our own totality as a psychologically, physically, and historically discrete individual and the work of art's totality as a complex, indivisible, and discrete object.

Notwithstanding that this may, in fact, be precisely the way in which we generally experience works of art, there may nevertheless be special occasions on which a different approach is required—occasions when it may be necessary, so that they can be examined and evaluated on their own, to precipitate out of this totality some of the separate and distinctive ways in which a work of art may function. To take an analogy from chemistry, such a process might be likened both to the qualitative analysis by which an investigator seeks to identify the individual elements that constitute a complex substance and to the quantitative analysis by which the investigator seeks to measure just how much of each of these elements might be present. To jury an exhibition is just such a special occasion. It is a time when the works of art to be evaluated cannot be approached as totalities, a time when the most relevant of their functional aspects must be disentangled from each other so that these can be judged one by one and in isolation as to their respective merit.

Lest this sound like a dubious procedure or something of a fiction—to separate the inseparable, to divide the indivisible—consider the enormous

---

1. My late Smithsonian colleague Joshua C. Taylor, for example, sometimes described "the combined effect of subject matter and visual form" as constituting an indissoluble whole which he called "expressive content." See Joshua C. Taylor, *Learning to Look* (Chicago: University of Chicago Press, 1957), 43–44.

repertory of devices that we have developed in almost every sphere of life to do exactly this. In his poem *Among School Children,* William Butler Yeats asks how we are to know the dancer from the dance.[2] The fact is that we make such distinctions all the time. In watching a prima ballerina perform as the Sleeping Beauty or Swan Queen, no balletomane worthy of that name would shrink from dissecting the performance's total effect to determine which part was attributable to the choreography and which part was due to the dancer's own effort. Nor would any regular football fan hesitate for a moment to analyze how much of a particular play's success or failure was attributable to its design and how much was due to its execution.

Sports can provide any number of useful analogies. The Olympics are particularly rich in examples of how one aspect of a performance may be singled out as critical in one instance whereas some other aspect may serve as the basis for judgment in another. In some Olympic events, all that may count is the single, measurable factor of time, weight, or distance. How fast was the race run? How far was the discus thrown? How much weight was the lifter able to lift? We care nothing about the grace or lack of grace with which these achievements were accomplished. All that counts is the measurement. By contrast, there are other events—figure skating, gymnastics, and platform diving would all be examples—in which we consider any objective measure-ment to be inadequate and in which we substitute the subjective judgment of a panel—a jury, so to speak—of experts. The winner is determined by evaluating the relative grace, concentration, agility, and originality displayed by the competitors. In still other events, such as tennis or wrestling, the prize goes to the competitor who has defeated the greatest number of opponents, regardless of whether this was done with any measurable excellence, discern-ible grace, or even a modicum of originality.

Daily life is not different. Notwithstanding your indissolubility as an individual, you may still be judged by a different standard in each of the myriad roles that you regularly play: as a spouse, a child, or a parent, as a midlevel

---

2. O chestnut tree, great rooted blossomer,
   Are you the leaf, the blossom or the bole?
   O body swayed to music, O brightening glance,
   How can we know the dancer from the dance?"

*The Collected Poems of W. B. Yeats* (New York: Macmillan, 1949), 251.

corporate executive, as a sometimes athlete, as a weekend hobbyist, or as an active citizen. What is so striking is not merely how inconsistently your performance in one role may be judged from your performance in another—it is perfectly thinkable, for example, that there may be good fathers who are rated as bad golfers, or good golfers who are thought to be mediocre cooks—but the great variety of means by which these different performances may be considered and judged.

As a midlevel corporate executive, you may be subject to an annual performance appraisal based on a detailed performance plan agreed on at some earlier time by you and a supervising official. Rarely, however, will your performance as a spouse, child, or parent be judged in any comparably formal or periodic way. As a golfer, what may count most is your handicap. As a board member at the local hospital, your merit may be judged by the hours of volunteer time that you give, by the wisdom and leadership that you provide, or by your annual cash contributions. As a cook, your success or failure may, literally, be a matter of taste.

The point to be made is this: It is not as far-fetched as it may at first appear to say (a) that a work of visual art—notwithstanding its apparent indis-solubility—can, for certain purposes, be regarded as combining a variety of functions, (b) that those functions can be disentangled from one another, and (c) that each such function can be evaluated separately by the particular means that is most appropriate to it. Three such functions are examined here.[3] Although these may actually be characteristic of the whole range of the visual arts, for simplicity's sake this examination is confined to just the case of paintings. The three ways in which we consider a painting as able to function are first, as a kind of commodity; second, as a form of communica-tion; and third, as a composition made up—in the painter Paul Cézanne's words—of "colors, contours, and planes" combined on a two-dimensional

---

3. This is not to imply that, beyond these three functions, works of art may not sometimes be intended to have, or may not sometimes assume, such additional functions as the symbolic, the therapeutic, or the inspirational. They may also function sometimes as forms of diversion or entertainment. As the French sociologist Pierre Bourdieu has long pointed out, they may also serve as a means through which to replicate class distinctions in successive generations. See, for example, Pierre Bourdieu, *Distinction: A Social Critique of the Judgment of Taste* (Cambridge: Harvard University Press, 1984).

surface.[4] Few things upset fledgling artists so much as the notion that the works of art they so painstakingly create may be dealt with as commodities. Although it is certainly the case that paintings lack the fungible, interchangeable qualities of such commonly traded staples as cotton, rice, oil, or copper, they do nevertheless resemble commodities in that their price is determined by the interplay of supply and demand and not—as is in the case of manufactured goods—by the cost of their production and distribution. To the frequently asked question of what a work of art is "really" worth, the only answer possible is that it is generally worth neither any more nor any less than what it can fetch in the marketplace.

The more experienced artist learns not to despair over this. As the painter Jasper Johns once observed, there is little continuity between the painting as it exists in the artist's studio and its subsequent career in the world. First, he said, "The work is done. After that the work is used. . . . Publicly a work becomes . . . the way it is used."[5] Once it is in the hands of the public, a painting's artistic merit may no longer be relevant to its value. If and when the market's demand for such a work is based on its artistic merit, then the price it may fetch should be relatively commensurate with that merit. However, to the extent that such demand may be based instead on such other factors as the celebrity or popularity of the artist, the notoriety of its subject matter, or the current enthusiasm for a certain style, there may be little to no relationship between the work's market value and its artistic merit. Think, for instance, of literature. In how many recent years was the year's *best-selling* novel also its *best* novel? Think, too, about television. On how many evenings do you think that the *best-watched* network program was also the *best* available program?

The commodity function of a painting is relatively simple to think about, however, in comparison with its communicative function. That every painting is generally perceived to have some kind of meaningful content seems beyond question. We all but take it for granted that a painting is a kind of index, that it points or refers to something outside of itself, and that it is intended to and that it does convey some mixture of visual fact and personal feeling—some-

---

4. As quoted from the artist in "Cézanne's Maxims," *The New Criterion* 6 (December 1987): 45. In another of these maxims, Cézanne remarks, "To make a painting is to compose."

5. G. R. Swenson, "What Is Pop Art?" *Artnews* 62 (February 1964): 66. Reprinted in Barbara Rose, ed., *Readings in American Art 1900–1975* (New York: Praeger, 1975), 148.

times more of the one, sometimes more of the other, but almost invariably some of each. Beyond that, however, there is little agreement as to how the "colors, contours, and planes" that comprise a painting might actually communicate such a particular meaning.

Is such a meaning fixed and stable, or does it change over time? Does the painting itself generate this meaning, or is it something that is projected on to the painting by the viewer? If the painting itself *does* generate a meaning, is the meaning that it generates entirely one that the artist intended, or was the artist, in whole or part, simply a medium through which the spirit of a particular time, place, or system found its expression? Alternatively, if meaning originates with the viewer, does every viewer project the same meaning? To what extent might viewers of a different cultural background project a different meaning? What about viewers of a different experience? Of a different sophistication? Is it possible that none of the foregoing is the case and that meaning of a painting arises, instead, principally from the context in which the painting is seen? Does a *Virgin and Child* seen in a church have the same meaning as a *Virgin and Child* displayed in an art museum?

Rather than pursue such questions here, the inquiry into the communicative function of a painting is narrowed to just two dimensions. For convenience, these can be referred to as subject matter and viewpoint. Subject matter refers to what a painting actually depicts, its manifest content. The range of possible subjects is boundless. In the case of so-called representational painting, it might include people, objects, scenes, events, or activities, and these might be either real or imagined, or sometimes a combination of both. The distinction scarcely seems important. In the great museum collections, portraits of real renaissance princes hang comfortably next to depictions of imagined devils, angels, and woodland nymphs. In so-called nonrepresentational painting, by contrast, an artist may seek to give visual form to some less tangible subject matter: a psychological state of mind or an emotion, mood, or feeling; a formal relationship of one kind or another; a personal vision of the workings of history or the implacable forces of nature; a philosophical concept; the passage of time; life; or death.

Every painting, in other words, depicts *something,* is a picture of something. In some instances, such as portraiture, this depictive aspect may be central to the artist's focus. In other instances, it may simply be a device through which

the artist intends to direct the viewer's attention to some other and larger interest. It is how—with what attitude—the artist addresses this other and larger interest that gives rise to the second dimension of a painting's communicative function: viewpoint. Confronted with a painting, the question invariably arises: Has the artist chosen to depict its subject matter for its own sake alone, or is the painting actually intended either as a means through which to express the artist's personal feelings or as a means to convey the artist's particular point of view? More often than not, one of these latter will be the case. As the art historian Leo Steinberg has observed, "Every picture is to some degree a value judgment, since you cannot represent a thing without proclaiming it to be worthwhile."[6]

Recalling such extraordinary depictions of horrific subjects as *Saturn Devouring His Children* by Goya or Munch's *The Scream,* one might well want to amend Steinberg's observation to read that "you cannot represent a thing without proclaiming it worthy of attention." The point, however, remains the same. Paintings almost invariably reflect value judgments. And, again, as was the case with subject matter, the range of things *about* which an artist may have feelings or *toward* which he or she may have a viewpoint is boundless. Boundless as well is the variety of such feelings and viewpoints. Over the past several centuries, and by visual means alone, artists have used their skill to memorialize those whom they love and sometimes those whom they despise, to celebrate or condemn earthly pleasures of every description, to pay tribute to the beauties of nature and to react with revulsion to the horrors of war, to celebrate or criticize one or another political or religious orthodoxy, and to express every shade of feeling from loathing and shame to exultation and joy.

Sometimes the expression of such feelings or such a viewpoint is central to the artist's intention. At other times, it may be incidental. In either event, however, the point to be emphasized is this: Important as the communicative function of a painting may be—and, indeed, there will be times for most of us when it may be a painting's most important function—it is still only *one* of the painting's functions. Moreover, there may be other circumstances—the situation of a juror charged with choosing a work of art as the best submitted to an open competition

---

6. Leo Steinberg, "The Eye Is a Part of the Mind," in *Other Criteria: Confrontations with Twentieth-Century Art* (New York: Oxford University Press, 1972), 297.

is just such a one—when neither its subject matter nor its viewpoint may serve as a legitimate criterion for singling out one work as being more worthy than another. On such an occasion, some other function must take precedence.

Which brings us, then, to the third of these ways in which a painting can function: as a composition made up—to repeat the description given by Cézanne—of "colors, contours, and planes" combined on a two-dimensional surface. It is in this aspect that we think of a painting not as pointing to or being about something outside of itself but, rather, as being an object, a thing *in* itself.[7] We think of it in terms similar to those that Archibald MacLeish proposed for poetry when he wrote in his *Ars Poetica* of 1926 that "a poem should not mean / But be." Whereas, in its communicative function, a painting might be understood as a comment or explanation about something other than itself, here—in its compositional function—it serves not to explain but to demonstrate, and what it demonstrates is nothing other than itself.

Two observations about painting, both made near the turn of the century, might help to clarify this distinction. In his 1909 "Essay on Aesthetics," Roger Fry quoted an artist of his acquaintance who defined the act of painting as "the art of imitating solid objects on a flat surface by means of pigments."[8] In marked contrast is an observation made in 1890 by the French painter Maurice Denis: "Remember that a painting—before it is a battlehorse, a nude woman, or some anecdote—is essentially a flat surface covered with colors assembled in a certain order."[9]

---

7. "A work of art encountered as a work of art is an experience, not a statement or an answer to a question. Art is not only about something; it is something. A work of art is a thing *in* the world, not just a text or commentary *on* the world." Susan Sontag, "On Style," in *Against Interpretation* (New York: Dell Publishing Co., 1969), 30. In this same regard, it seems worthy of note that in *Miller v. California,* 413 U.S. 15 (1973)—the case in which the U.S. Supreme Court established its still-current test for obscenity—the Court envisioned that a distinction could be drawn between what a work of art "depicts or describes" and whether, taken as a whole, it possesses "serious . . . artistic . . . value." Query whether this does not in some sense parallel Sontag's distinction between "aboutness" and "isness." For an interesting discussion of how the aesthetic and / or historical aspects of art objects (including the two hundred or so religious paintings in Washington's National Gallery of Art, which, as Chief Justice Burger noted, was "maintained with Government support") might be split off and considered separately from their manifest subject matter, see *Lynch v. Donnelly,* 465 U.S. 668 (1984).

8. Reprinted in Roger Fry, *Vision and Design* (New York: Peter Smith, 1947), 11.

9. Reprinted in Linda Nochlin, *Impressionism and Post-Impressionism 1874–1904: Sources and Documents* (Englewood Cliffs, N.J.: Prentice Hall, 1966), 187.

This latter view, that the essence of a painting is not in it being the imitation of a solid object but in it being "a flat surface covered with colors" has been central to the development of modernism as one of the principal modes of twentieth-century visual art. It has also been the target of recurring attacks from those who denounce such art as "sterile formalism" and who argue that art must be created for some larger social purpose than for its own sake alone.

Whether one adopts the extreme formalist position that the compositional function of a painting is the *only* function through which its excellence ought be determined, to acknowledge that this compositional function has *any* importance at all is to introduce an entirely new and distinct set of terms into the way that such a painting can be evaluated. In its commodity function, we may speak of a painting as being successful or unsuccessful in terms of its reception in the marketplace. In its communicative function, we may speak of a painting as being successful or unsuccessful in terms of the response it elicits. We may find its subject matter appealing or not. We may have a positive emotional response to it or not. We may agree with its viewpoint or not. None of these terms, however, constitutes a measure of a painting's success or failure as a composition, its quality as a work of art. Quality is not a measure of its market value, its subject matter, or its viewpoint. It is solely a measure of its compositional merit. It has also, in recent years, become the subject of a considerable controversy within the art world.

Few issues, in fact, have so deeply or bitterly divided the art world—that constellation of artists, art critics, gallery owners, museum workers, and collectors whose daily lives revolve around the visual arts—as has this question of quality.[10] Is there really any such thing, its detractors ask, or is it simply an exclusionary device, an instrument of "cultural repression" by which those in authority keep marginalized artists away from the center of power and preserve the status quo? If there *is* such a thing, by what objective standards can it be measured? Are those standards universal, or do they differ from one culture to another? However, if there are no such standards—if judgments as to quality are wholly subjective—what privileges one person to

---

10. For a good summary of the opposing positions, see, for example, Michael Brenson, "Is 'Quality' an Idea Whose Time Has Gone?" *The New York Times,* July 22, 1990, and (in response) Hilton Kramer, "A *Times* Critic's Piece about Art Amounts to Political Propaganda," *The New York Observer,* August 13–20, 1990.

make such judgments rather than another? Might not all such judgments be equally valid or, even, equally invalid?

Not surprisingly, a good deal of this argument parallels the debate over "meaning" alluded to earlier. It also tracks a related argument about the definition of beauty—whether, for example, beauty exists only in the eye of the beholder and whether beauty can ever be universal or must always be culture-specific—that can be traced back to antiquity and that remains unresolved (and perhaps unresolvable) to this day. Rather than rehearse those arguments here, let me simply suggest that this issue of artistic quality need not be addressed in the kind of abstracted terms so frequently used by aestheticians and other theorists. By approaching it in a more common-sensical way, we ought be able to adopt a working hypothesis that, while modest in its claims, would still permit us to talk about the quality of a painting with a reasonable assurance that we are talking about a defensible concept.

The working hypothesis is this: What we refer to as quality in a work of art may not be all that terribly different or any more mysterious than what we refer to as quality in an automobile, a pair of shoes, or any other common object. The underlying components, which, when taken together, might constitute our notion of quality, appear, when considered one at a time, to be perfectly straightforward and wholly familiar: that there be a high degree of excellence in the workmanship by which such an object has been made, that it evidence a similar degree of excellence in its design, that it meet a reasonable expectation of durability, and that it meet the requirement of a proper fit.

Concerning workmanship, it would be very strange if, as Hilton Kramer has suggested, the making of works of visual art did not resemble virtually every other human activity insofar as some people were sometimes able to do some things more skillfully than other people were able to do other things.[11] Like every other human production, works of art may be graded by the skill with which they were made. The work of art stands both as a thing in itself and as a record of the artistry by which it was created. Nor need the components of that artistry be any more mysterious than the components that constitute our notion of quality. Such artistry is a combination of the imaginative power that was initially required for the artist to conceive the work and

11. Hilton Kramer, "The Assault on the Museums," *New Criterion* 9 (March 1991): 5.

the physical skill that was required for the artist to translate that initial conception into its final and tangible form.

Excellence of design is perhaps a more elusive notion. Nonetheless, there does appear to be substantial agreement among commentators as to what some of the components of such excellence might be: a purposeful interplay of variety and order, a sense of wholeness and harmony, unity, balance, proportionality, vitality, clarity, density, a right mix of regularity with irregularity, and—perhaps more important in the case of a painting than of an automobile or a pair of shoes—a degree of genuine originality.

With respect to durability, the issue is not merely one of physical durability—perhaps best ensured in an automobile or pair of shoes by the materials from which these were fabricated and the workmanship used in the process—but of what Professor Albert Elsen of Stanford has referred to as "esthetic durability."[12] A work of art is aesthetically durable when it does not wear out "its intellectual and emotional welcome" over time. This notion that the quality of an art work must ultimately be judged over time appears repeatedly in the critical literature. Meyer Schapiro put it in terms of "a sustained experience of serious looking and judging."[13] Clement Greenberg referred to quality judgments as rooted in a "consensus *over time.*"[14]

Concerning the requirement of a proper fit, what might be meant in the case of a work of art is that the compositional means that the artist has chosen to use bear some appropriate relationship to the communicative end for which the artist was striving. A painter intending to convey the irrational power of a storm at sea might be expected to use a different mix of compositional elements than one intending to convey the serenity of a summer twilight. A painting intended to convey a sense of hope might be organized differently than one intended to convey a sense of despair. Quality, in this sense, may be considered a judgment as to the consonance between these artistic means and the artist's communicative ends. The greater our perception of this consonance, the greater our perception that the work is one of high quality.

12. See his essay in the catalogue *Bruce Beasley, An Exhibition of Bronze Sculpture* (Rohnert Park, Calif.: Sonoma State University, 1990), 7, 9.

13. Meyer Schapiro, *Modern Art: 19th and 20th Centuries* (New York: George Braziller, 1978), 232.

14. Quoted in Donald B. Kuspit, *Clement Greenberg: Art Critic* (Madison: The University of Wisconsin Press, 1979), 144.

With all that said, we should finally be, or almost be, at our long-deferred starting point: the task you would face having undertaken to jury an open competition and to select one of the works of art as the "best" of those submitted. I say "almost," however, because there is one last question that still needs to be addressed. In such a context, what do we mean by "best"?

That the context is critical should be clear. Taking the word *best* in its ordinary meaning of what is most suitable for a purpose, any judgment as to which work is best must fundamentally depend on the purpose for which we intend to use it. What might be the best painting to hang in the reception area of a children's hospital—perhaps a lively circus scene, or something with bright balloons—might not be the best painting to acquire for an art investment trust looking for a long-term profit. The painting that might serve best to cover a large and badly splotched wall might be different than the painting that would best serve as the souvenir of a vacation in Paris or the painting that would best complete an interior decorator's tan and orange color scheme for a law office conference room.

Let us suppose that the exhibition you are to jury is to be presented in an art museum, an institution the very *raison d'être* of which is to focus attention on the aesthetic aspect of works of art. What I take to be your task in such a context is to choose the work of art that, in your view, best succeeds *as* a work of art, the work of art that, in the terms we have already considered and in comparison with the other works on hand, evidences the greatest compositional excellence in itself and the greatest artistry in its creation.

Consider the alternatives. Under what circumstances might you choose instead the work that appeared to you to have the greatest commodity value? That might be appropriate if, rather than jurying an exhibition, you were visiting the museum as the owner of a commercial gallery looking for paintings that you might readily sell. Your task then would be not to choose what you personally thought to be of the greatest artistic merit but to try to anticipate what your clients—perhaps sophisticated, perhaps not—would most likely want to acquire for their homes or offices. Or, again, if you were visiting on behalf of that previously mentioned art investment trust, you might be looking for something that might be retained for some period of years in the hope of ultimately yielding a long-term profit.

What if, instead, one or another of the communicative aspects of the works under consideration were to be the basis for your judgment? Here we come

to an issue of basic fairness. Let us suppose that you made subject matter—what the painting depicts—the basis on which to choose the winning entry. Let us further suppose that you are somebody who enjoys spending time in the city of Paris. Whatever reminds you of Paris gives you great pleasure. In your own home, you would rather hang the meanest, scruffiest, most poorly conceived and clumsily painted image of the Eiffel Tower or a café on the Champs Élysées than art of any other kind. May you carry that preference, a wholly legitimate and perhaps even understandable personal preference, over into your judgment as a juror? Could anybody imagine that to be fair to the competitors who submitted their work?

Would this issue of fairness disappear if the museum's competition had been announced in advance as "PICTURES OF PARIS ONLY"? I think not. In that case, your task would still have been to choose which was the best of those scenes of Paris as a painting, not which one depicted the scene that was your favorite scene among all the various scenes depicted. With artistic excellence as the standard, there is no fair way in which your preference for one subject matter over another can serve as the basis for selecting the winning submission.

When we turn to the second of these communicative dimensions—viewpoint—we find that it is an equally inappropriate basis for judgment. Let us further suppose that, in addition to your affection for Paris, you are deeply opposed to the use of nuclear energy and that you consider the possibility of a nuclear accident to be an unacceptably high risk. Let us also suppose that among the paintings you are to judge is one entitled *Shame at Chernobyl,* which depicts a ruined landscape littered with human remains. Are you free to award this painting the prize solely because you agree so strongly with its viewpoint, because you think it makes a passionate and correct-thinking statement about a matter that seems to you of urgent public concern? Again, I think not.

The case might be different if an antinuclear group had staged a juried competition in which artists were asked to address this theme and in which the winning work was to be the one that most successfully aroused public opinion against the continued use of nuclear energy. Notwithstanding that it involved works of art, such a contest would not, however, be an art contest—it would be an advocacy contest. The question for the jury would not be which painting was the best painting but which painting had the greatest propaganda value. Propaganda is not in itself ignoble, but it must be clearly understood as a category of art in which the success of a painting is directly proportional

to the response it can arouse in its viewers and not to whatever intrinsic aesthetic merit the painting itself may possess.

Come back to our hypothetical competition, and reverse the situation. Imagine that you are not an opponent but, instead, a passionate advocate of nuclear energy. What are you then to do when you, as a juror, encounter the painting *Shame at Chernobyl*? Can you reject it out of hand because you think its viewpoint is incorrect? Or is your assigned task to suspend your viewpoint preference and to judge this painting as a work of art, regardless of whether its viewpoint is one with which you agree or disagree? Is that not the very basis on which artists were induced to submit their work in the first place? Would they not have deserved some fair warning if their work was to be judged by its perceived correctness or incorrectness with respect to some public issue instead of for its artistic merit?

Not everybody agrees with this position that art should be judged as art. On the one hand are those who look to art as a means to underline and affirm the existing social order. Art's purpose, as the late Congressman George Dondero of Michigan once argued, should be to "glorify our beautiful country, our cheerful and smiling people, and our material progress."[15] On the other hand are those who look to art as a means to raise questions about that very same social order. Dan Mayer, an attorney who has worked on art censorship issues, argued for this position at a 1991 symposium in Washington. "Art," he said, "is at its best when it challenges us to think."[16] Although art may certainly be at its most patriotic when it glorifies our country or at its most provocative when it challenges us to think, it nevertheless seems to me that the question of when art is at its best *as art* is one that can only be answered in aesthetic terms, not in terms of what other values it may affirm or seek to question. To be recalled in this regard is the caution once offered by the painter Ad Reinhardt. There is, he said, a "ceaseless attempt to subserve [art] as a means

15. Quoted in William Hauptman, "The Suppression of Art in the McCarthy Decade," *Artforum* 12 (October 1973): 48. The extract is taken from an interview with Emily Genauer of the *New York World-Telegram*. For a full-length examination of the use of art as a patriotic instrument, see Hellmut Lehman-Haupt, *Art under a Dictatorship* (New York: Octagon Books, 1973).

16. His paper, "The Religious Right and Arts Funding," appears in "The First Amendment and Public Support for the Arts: A Symposium," *The Journal of Arts Management, Law, and Society* 21 (Winter 1992): 328–354. Mayer goes on to say, "If art is not challenging, it belongs above a color-coordinated couch, not for public viewing."

to some other end or value."[17] As Reinhardt, in rejoinder, insisted repeatedly, "ART IS ART. EVERYTHING ELSE IS EVERYTHING ELSE."[18]

So that, it seems to me, is the way that you must proceed as a juror: to choose what seems to you the best of the works of art under review not for its potential market value as a commodity and not for a content that you find congenial or a viewpoint that you think correct, but on the basis that it is a well-made and well-conceived work of art that, since a juror does not have the luxury of the test of time, you can only trust will also prove to have a durable aesthetic value. In a sense, it is not a very different task than that undertaken by those earlier-mentioned Olympic judges when they evaluate the artistry of figure skaters, gymnasts, or platform divers.

When we turn to examine the relationship of the federal government to the arts—and particularly the question of what art the government may or may not choose to support—many of these same considerations seem relevant. There is, however, one significant difference. What may simply be a question of basic fairness in the case of a juried competition—that you, as a juror, will not let your nonart preferences intrude on your artistic judgment—may blossom into a full-fledged question of both statutory and constitutional law when it comes to determining on what basis the federal government may choose to favor one particular work of art over another.

In the case of the National Endowment for the Arts, there has never been any doubt as to what standard it must apply in determining the art that it will support. That standard is "excellence," and references to it echo throughout the Endowment's history. Among the most interesting of these references is an extract from a 1965 report of the Senate Labor and Public Welfare Committee issued when the bill that established the National Endowment for the Arts and Humanities was taking its final shape. Speaking of the arts, the Committee said,

The intent of this act should be the encouragement of free . . . expression. The committee wishes to make clear that conformity for its own sake is not to be en-

---

17. Ad Reinhardt, *Art-as-Art: The Selected Writings of Ad Reinhardt* (New York: The Viking Press, 1975), 55.

18. Ibid., 51. The painter Robert Tynes, who teaches studio art at the University of North Carolina–Asheville, has pointed out that the teacher required to grade the work of art students is in a situation analogous to the juror's. Notwithstanding the frequently political nature of student work, it must nevertheless be graded for its artistic merit and not on the basis of its content or viewpoint (conversation with the author, November 1993).

couraged, and that no undue preference should be given to any particular style or school of . . . expression. Nor is innovation for its own sake to be favored. The standard should be artistic . . . excellence. While evaluation in terms of such an abstract and subjective standard will necessarily vary, the committee believes such a standard to be sufficiently identifiable to serve the broad purpose of the act.[19]

The legislation that was subsequently enacted in September 1965 carried this idea forward in its enumeration of the kinds of projects that the Endowment might support. Among these were "projects that will encourage and assist artists and enable them to achieve standards of professional excellence."[20] More than two decades later, in an extensive 1988 report to the President and the Congress, the Endowment returned to this theme. As a part of its legislative mandate, it said, one of its missions was "to foster the excellence, diversity and vitality of the arts in the United States."[21]

How, then, does such a legislative mandate play out against these three ways in which we have seen that art may function: as a commodity, as a communication, and as a composition? To start, it should be evident that commodity value (i.e., a work of art's potential for commercial success) was never intended to be the basis on which the federal government was to provide assistance. To the contrary, the Endowment was intended from the start to serve as something of a complement or counterweight to the existing marketplace. Oddly, however, the Endowment has come under frequent attack for this. A vocal minority— motivated perhaps by some Darwinian sense that in art, as among species, only the fittest ought survive—has argued that it is against the public interest to give support to works of art not otherwise popular enough to make it on their own in the marketplace. What this argument fails to note is that much of the older art that we today cherish as our patrimony did not initially flourish through its popularity in the marketplace but was nurtured through the patronage of a governing class. Against this minority, a larger share of the public appears to accept the notion that the marketplace may not be the sole measure of artistic merit and that the

19. Quoted in The Independent Commission, *A Report to Congress on the National Endowment for the Arts* (Washington, D.C., 1990), 15.

20. Ibid., 14.

21. National Endowment for the Arts, *The Arts in America: A Report to the President and the Congress* (Washington, D.C., 1988), 485.

community may benefit by encouraging the creation and dissemination of art that may have other than an immediate popular appeal.

It is with respect to the second of these functions that a work of art may perform, its communicative function, that we encounter a constitutional question, a question that concerns freedom of speech and the First Amendment's guarantee against governmental interference with that freedom. In our earlier discussion, we focused on two dimensions of this communicative function: subject matter and viewpoint. To what extent may the Endowment permissibly take subject matter and viewpoint considerations into account in making decisions about how it will distribute the congressionally appropriated funds at its disposal?

Concerning subject matter, let us summon up a hypothetical artist whose work (for whatever reason) consists entirely of depictions of Adolf Hitler. Can the Endowment refuse to support this artist's work, regardless of whether the work may or may not have a high degree of aesthetic merit, simply on the grounds that many people would find its subject matter disturbing? Many things, after all, are disturbing—if not to one person, then to another. What if the artist, instead, intending to call attention to a perceived social injustice, depicted nothing but badly battered infants? What about depictions of lynchings? Might the Endowment categorically refuse to fund the Hitler paintings but support these latter ones instead?

It seems to me doubtful that the Endowment could make its funding decisions in such a way. In the administration of a grant-making agency, funding decisions must generally rest on some more principled basis than the likelihood that they may or may not prove popular. For public policy purposes, could one really discriminate so neatly between one kind of disturbing image and another to deny support categorically in the one case and to permit it in the other? Under the Endowment's establishing legislation, "excellence," rather than what the public may or may not find disturbing, is set forth as the basis on which its funding decisions are to rest.

The constitutional difficulty comes into fuller focus when we turn to the second dimension of art's communicative function: viewpoint. Consider again the imagined painting at which we looked earlier, *Shame at Chernobyl*. This, you will remember, was intended by the artist as a condemnation of nuclear energy. Assume that the U.S. government has a policy that favors the greater use of nuclear energy. Can the Endowment, as a part of that government and

in furtherance of that policy, categorically refuse to give funding to support the creation or display of art that could be interpreted as opposing that policy? Such a question takes us squarely into the midst of an ongoing argument about what lawyers refer to as "unconstitutional conditions."[22]

To understand how this applies to the arts, we need to take several steps back. First, it is by now well established that visual expression, even when not accompanied by words, falls within the category of "speech" that is protected by the First Amendment. Second, in view of that, it is also clear that the federal government would be constitutionally prohibited from interfering with an artist's right to create and publicly display a painting such as *Shame at Chernobyl*. The question, then, is whether the government may do indirectly what it cannot accomplish directly. Might there be some point at which the government's targeted refusal to give funding based on the artist's viewpoint alone might be considered tantamount to a prohibited effort to suppress that viewpoint? In short, even if the government is forbidden to silence artists who disagree with it, can it nevertheless decide to fund only those artists who do agree with it?

The issue here is not whether artists have a right to public money. As virtually every commentator in this field has acknowledged, the federal government is under no obligation to support the arts. The issue is whether, having once decided to support the arts, it may discriminate among them on the basis of viewpoint.[23] Consider some of the other media to which the

---

22. On the subject of unconstitutional conditions generally, see Kathleen M. Sullivan, "Artistic Freedom, Public Funding and the Constitution," in Stephen Benedict, ed., *Public Money and the Muse: Essays on Government Funding for the Arts* (New York: W. W. Norton & Co., 1991), 82–86; Beverly M. Wolff, "Government Funding of the Arts: Content-Based Regulations and Unconstitutional Conditions," *Columbia-VLA Journal of Law and the Arts* 15 (1990): 47. See also David Cole's contribution "Defending the Unpopular" to the symposium referred to in note 16; Stephen F. Rohde, "Art of the State: Congressional Censorship of the National Endowment for the Arts," *Hastings Communications and Entertainment Law Journal* 12 (Spring 1990): 353; Jane S. Catler, "Note: Standards for Federal Funding of the Arts: Free Expression and Political Control," *Harvard Law Review* 103 (June 1990): 1969.

23. See paragraph 2 of the Legal Task Force Consensus Report included in *A Report to Congress on the National Endowment for the Arts*, 85–87: "If federal funds are used to subsidize the arts . . . constitutional limitations on how the arts are funded may come into play. The most important of these is that while Congress has broad powers as to how to spend public funds, it may not do so in a way that the Supreme Court has said is aimed at the suppression of dangerous ideas."

government gives support. How, for example, would we respond if the only public radio stations that could benefit from government funding were those that accurately reflected the government's point of view? Would it be tolerable to us if special postal privileges were extended to magazines and newspapers that faithfully supported government policy but not to those that opposed it? Do not these seem like the very areas in which the First Amendment was intended to confine government to a neutral role? Is it not arguable that the case of the arts—another powerful means of expression—should be the same?

Suffice it to say that when and to what extent governmental conditions on funding that interfere with speech may or may not be permissible is an issue still in the course of resolution by the federal courts.[24] For the moment, however, we can safely conjecture that if the Endowment's next set of published guidelines were to announce, blatantly, that funding was henceforth to be restricted to art expressing a viewpoint congenial to the federal government, such guidelines would quickly be challenged and in all likelihood struck down. Moreover, if the Endowment is prohibited from making viewpoint an *official* basis on which to make or withhold its grants, then neither can it make it an *unofficial* one. Some other basis for decision-making is necessary.

Which brings us full circle back to the criterion of artistic excellence. The situation of the Endowment in choosing what art it will support is all but exactly parallel to the situation in which you as a juror must make a judgment as to which of the submissions to a competitive exhibition is best. Tempted as

24. Discussions in this field have been dominated in recent years by the Supreme Court's decision in *Rust v. Sullivan*, 111 S. Ct. 1759 (1991), in which the Court declined to recognize a First Amendment right pursuant to which doctors in federally funded family planning programs might be free (if they so believed) to advise their clients that abortion was an available option. The principal art-related case is that of the so-called NEA Four, which, at this writing, was still awaiting a decision in the U.S. Court of Appeals for the Ninth Circuit. In the District Court trial of that case—the opinion is *Finley v. National Endowment for the Arts*, 795 F. Supp. 1457 (C.D. Cal. 1992)—Judge Tashima refused to apply the *Rust* rule in an arts context. He likened the situation of the arts to that of the university—a site for free inquiry—and referred to them both as settings in which government's neutrality was of a greater than usual importance. An undated press release (summer 1993) from the Washington, D.C., office of People for the American Way noted that the Department of Justice had, as of late June 1993, determined not to press further with the argument it originally made in the District Court that the *Rust* doctrine should be applicable in this instance.

a decision-maker might be by such other considerations as an agreeable subject matter or a sympathetic viewpoint, these cannot serve as the basis for choice. Only artistic excellence—difficult as that may sometimes be to disentangle from these other considerations—can serve as such a basis.

Lest this seem like too confining a straightjacket, consider that, in the exercise of a public authority, the prescription of such a narrow standard is by no means unusual. Think, for example, of a criminal trial. As a juror there—a different kind of a juror, but not entirely—you will be asked to set aside those gut instincts, basic intuitions, and similarly elusive elements that enter into your normal, everyday decision-making. You will be asked, instead, to base a decision solely on the evidence presented in court and solely with respect to the particular acts with which the defendant is charged.

That it may be crystal clear to you that the defendant (accused, let's say, of embezzlement) probably embezzled from three earlier employers, that he will, if acquitted, probably embezzle from the next three as well, and that the community would be more than well served if he was sent away to prison is irrelevant. Unless there is proof beyond a reasonable doubt that the defendant committed the crime for which he is now on trial, then you must acquit, regardless of your own personal view of what he might deserve or what might best protect the public. It cannot be otherwise when you are called on to act in a public capacity. The arbitrary exercise of unbounded authority is abhorrent to our whole notion of limited government. An art juror, like a criminal court juror, must have some basis for decision beyond personal preference. Artistic excellence—as manifested both by the completed work of art and by the artistry through which it was created—provides such a basis.

Still, a nagging question remains. Is artistic excellence really all that important? When we once more consider a work of art in its totality—consider it with its commodity, communicative, and compositional functions once again reintegrated into an expressive whole—how important is this quality of aesthetic excellence in comparison with the work's communicative power, its capacity to convey strongly held feelings, its potential to project the artist's viewpoint in a visually compelling manner and/or to arouse in its viewers a spectrum of responses that may range from pleasant reverie to outright terror? Is artistic excellence merely a flimsy and even artificial pretext through which to justify juried awards and public funding decisions, or does it have an

independent importance and a validity uniquely its own? I would argue that the latter is the case, that aesthetic excellence and the artistry by which it is produced are not merely independently important and valid aspects of a work of art but that they may, in some respects, be its most critical aspects.

Here we need move to a larger framework. In both the ordering of society and in the ordering of our own individual lives, we find ourselves caught constantly between the conflicting pulls of order and disorder. The vocabulary we use to describe this conflict may vary from one context to another, but the conflict remains fundamentally the same. At the social and political level, it may be posed as the classic confrontation between authority and freedom. At the individual level, it may surface in our conflicting desires for security and adventure, for a comfortable mix of the anticipated and the surprising, for a life characterized on the one hand by discipline and marked on the other by spontaneity.

What we sooner or later learn is that there is no single and certainly no final way in which this conflict between order and disorder can be resolved, that even the most seemingly plausible resolutions will, invariably, turn out to have been at best only provisional. Such is the human condition. To mediate the conflicting claims of order and disorder is the ongoing work of every social group and each of its members. To paraphrase the first-century sage Rabbi Tarfon, the fact that this task can never be completed does not free us to desist from trying.[25]

It is precisely because works of art may be so relevant to this task—not only through their communicative function but as much or more so through their compositional one—that aesthetic excellence is to be so strenuously sought and valued. Beyond the manifest content of any painting—its depiction of the Eiffel Tower or the ruins of Chernobyl—each such painting has a latent aesthetic content as well. Through the particular coherence of its forms, the particular relationship of its parts to one another and to the whole, the degree of unity and harmony that the artist has achieved or deliberately avoided, the adjustment of its lines, colors, and planes to one another—through all these, and more, each such painting presents us with a discrete, distinctive, and alternative model of how order and disorder might be workably related to

---

25. "It is not your duty to complete the work, but neither are you free to desist from it." *Ethics of the Fathers,* chap. 2, verse 15.

one another. Not only works of visual art can serve us as such models, but works of music, architecture, dance, and literature may do so as well. In contrast to the sometimes sordid and often messy reality of our everyday life, works of art, thus used, may provide us what the Swiss writer Martin Dean once called a "utopian corrective."[26]

In this same regard, Harvard Law School professor Paul Freund has written movingly of the connection between art and the law:

All law resembles art, for the mission of each is to impose a measure of order on the disorder of experience without stifling the underlying diversity, spontaneity, and disarray. . . . In neither discipline will the craftsman succeed unless he sees that proportion and balance are essential, that order and disorder are both good virtues when held in proper tension.[27]

Think for a moment of the terms in which we generally speak of the good society or of the well-lived life. Consider how deeply those terms are rooted in notions of compositional excellence. We refer to what we seek in such a life as a pattern, and what we hope that pattern may contain is a good balance, a sense of proportion, but also of completeness, amplitude, plenitude. What we say we are searching for is harmony, a graceful blend of life's frequently disparate elements, a good rhythm to our days, variety within unity, and one may even hope, a degree of originality and a measure of elegance. Consider, too, how very different our notion of such an ideal life might be if the only terms available with which to describe it were drawn from the vocabularies of economics or industrial engineering or quantum mechanics. Which of us would aspire to live like a flow chart, a diagram, or a blueprint? Notwithstanding that our basic definition of art is that it is nonutilitarian—something created primarily for our contemplation rather than for any hands-on use— the fact is that we *do* use art. We use it to provide ourselves with models of alternative ways in which the world might be organized and in which our lives might be lived.

26. Martin R. Dean, "Market or Muse—The Uneasy Partnership between Art and Private Enterprise," *Passages/Passagen: A Swiss Cultural Magazine* 6 (Autumn 1988): 13.

27. Paul Freund, "New Vistas in Constitutional Law," *University of Pennsylvania Law Review* 112 (1964): 631.

Not even that insight, however, fully exhausts our understanding of what a work of art can offer us. Not to be forgotten is that every work of art is more than "an object to be experienced in its own right."[28] It is also a human accomplishment, the product of a deliberate effort. It is, after all, just that—their human and purposive origin—that distinguishes the objects that we keep in our museums of art from the sometimes equally attractive objects that we keep instead in our museums of natural history. By recognizing this aspect of a work of art, we can bring still another mode of evaluation to the way in which we judge it. Rather than focusing solely on the work in its finished form, we can broaden our inquiry to consider as well the artistry that brought the work into being. With what degree of originality was it conceived? With what degree of skill was it executed? With what raw materials (physical and imaginative) did the artist begin, and by what means and in the face of what obstacles, what challenges were those materials transformed and shaped into the completed work?

Understood not solely as an object but also as the outcome of a process, the work of art takes on an additional and still more profound relevance to our lives. Artistry is not alien to any of us. The projects to which we bring our own artistry may be very different than that of creating a work of art, but the elements that go to make up that artistry—the combination of imagination and skill that underlies it, the determination to overcome obstacles and to carry things through to their completion—are all elements with which each of us can readily empathize. It is what we do every day in our jobs, in our homes, and in our hobbies. Even the most fundamental problem with which the seriously ambitious artist must contend—the question of how to achieve an authentic originality without departing so far from tradition as to sever all connection to it—is not dissimilar from the problem that each of us faces in seeking to shape a personal life that is at once authentically our own but yet permits us to retain the strong and sustaining links we need to our family, our traditions, and our community. Art, in its own form, contains and reflects the drama of all our lives.

To return, then, finally to the beginning, public choices of art must demonstrably rest on the twin criteria of excellence and artistry. Those

28. Bates Lowry, *The Visual Experience: An Introduction to Art* (Englewood Cliffs, N.J.: Prentice Hall, 1961), 260.

making such choices must seek as best they can to identify those works of art that are both most exemplary in what they are and most admirable in how they were created. These criteria would seem to be the only appropriate grounds on which, in such a public context, one work of art may be chosen as superior to another. Such a basis for choice, however, is neither incidental nor trivial. It goes directly to the heart of what, for many of us, makes works of visual art so rich, so complex, and so endlessly rewarding.

# REVIEW: EXCLUSION PRINCIPLE

*The Love of Art: European Art Museums and Their Public.* Pierre Bourdieu, Alain Darbel, and Dominique Schnapper. Translated by Caroline Beattie and Nick Merriman. Stanford, Calif.: Stanford University Press, 1990. 182 pp., hardbound, $32.50.

Pierre Bourdieu is a sociologist whose prolific writings, long success as an academic, and energetic professionalism have made him one of Europe's best-known social scientists. Elected Chair of Sociology at the Collège de France in 1981, Bourdieu was cofounder with Raymond Aron of the Center for European Sociology in the mid-1960s and sole founder in 1975 of the journal *Actes de la recherche en sciences sociales.*

Although Bourdieu's principal interest has been in education and the arts as embraced in high culture—his published work constitutes an ongoing examination of how these function to reproduce the existing class structure in each successive generation—*The Love of Art* is his only book focused solely on art museums and their audiences. First published in Paris in 1969, it was based on data collected in a series of surveys conducted among museum

Reprinted with permission from *Museum News* 72 (March–April 1993). Copyright 1993, American Association of Museums. All rights reserved.

visitors in France, Greece, Holland, Poland, and Spain during 1964 and 1965. (Alain Darbel, Bourdieu's co-author, is credited for formulating the sampling strategy and for developing some of the elaborate mathematical models reprinted in the text.) Given the frequency with which its original French edition has been discussed in recent museological literature (to say nothing of its own compelling interest), it is to be regretted that this welcome English translation has been so long in coming. The museum community would benefit greatly if the means could be found to make such relevant texts accessible on a more timely basis.

The outcome of Bourdieu's visitor surveys will not be a surprise to workers in this field. One of his principal conclusions is that education is the single variable that most closely relates to the frequency, duration, and even the satisfaction to be derived from visits to art museums. What makes his work of such interest is, rather, the framework of theory that these surveys were originally undertaken to verify. As an introduction to that theory, one can usefully speculate on how differently most American museum workers, on the one hand, and Bourdieu, on the other, might react to some of the ways in which museums are regarded by those who are *not* among their regular visitors.

Consider, for example, the following comment drawn from the Getty Center for Education in the Arts' recent focus group experiment intended to explore the attitudes held toward art museums by both visitors and nonvisitors. Referring to the Art Institute of Chicago, one nonvisitor said: "It is for the cultured or your rich people who appreciate the arts because they've had a chance to see paintings or because they own paintings. The moderate people don't get to experience the art or get the background to appreciate the art that's there."

For most American museum workers, such a comment runs directly counter to their aspiration for museums to be perceived as inclusive institutions and not as elitist. The museum community in the United States is officially on record in urging that museums should be more welcoming places for all people regardless of their age, ability, education, class, race, or ethnic origin. In diametrical contrast, Bourdieu would interpret this comment as evidence of the museum triumphant. In his view, the museum's very *raison d'être* is to induce just such a sense of exclusion.

Bourdieu's argument begins with the hypothesis (based on previous research) that the art museum's principal function (together with that of the

university and a broad range of other cultural organizations) is to contribute toward the "consecration of the social order." It does this by helping to replicate anew in each generation a sense of distinction between those few who are perceived to be cultivated and those many who are perceived to lack cultivation. Not surprisingly, this distinction in *status* can be seen as roughly parallel to the distinction in *power* between those who dominate the society and those others over whom they exercise economic and political dominion. It is not the case that Bourdieu advocates such a role for museums. In fact, he appears to deplore it. As a social scientist, however, his primary interest is neither in supporting nor condemning museums so much as in assessing their role as agents of cultural diffusion.

If that were the whole extent of Bourdieu's enterprise, museum workers who questioned his conclusions might readily respond in several ways. They might argue that his survey data were more than a quarter-century old and no longer valid. Alternately, they might argue (and Bourdieu himself to a degree acknowledges this) that what was true for museums in Continental Europe might not necessarily be true elsewhere. They might even argue (and Bourdieu seems to acknowledge this as well) that museums of other disciplines have not been as exclusive as his survey data have shown art museums to be. Still better, rather than argue with Bourdieu (because it may be that arguments with sociologists are best left to other sociologists), those responsible for art museums might simply try to demonstrate that such museums need not necessarily be as Bourdieu has described them. To the extent that they could sustain a perception of their museums as more user-friendly, then the thrust of Bourdieu's analysis might be blunted.

Bourdieu's theory, however, cuts far deeper. He does not simply contend that the fine arts (or the theater, concerts, or a classical education), although genuinely of value in themselves, have been appropriated by the "cultivated classes" as a means to establish their own social position. To the contrary, what he appears to argue is that these cultural manifestations may not, in fact, have *any* fundamental value in themselves. (The literary critic Fredric Jameson has referred to this aspect of Bourdieu's thought as an "implacable assault on the very rationalizations and self-justifications of culture itself.") Such value as those objects classified as works of art appear to have may be wholly arbitrary—a value constructed and imputed, not one inherent and discovered. That there should be so much continuing interest in such objects may not be

due to any intrinsic worth so much as to their continued utility as tools to perpetuate class distinctions. Rather than to collect, preserve, study, exhibit, and interpret these objects, the "true function" of the art museum, argues Bourdieu, "is to reinforce for some the feeling of belonging and for others the feeling of exclusion."

Nor is that the end of Bourdieu's analysis. Key to the process he is describing is that the attainment of cultivation by members of the dominant classes must appear (both to them as well as to the "vulgar") to be the inevitable outcome of some inherent personal superiority. To be at ease in the museum, at a concert, or in a literary discussion must seem to occur without effort and as an instinctive personal trait. To be *"forgotten or denied"* is the extent to which such a disposition toward high culture may actually be the outcome of both early family experiences and an extended education in which the practice and appreciation of the arts has played a profoundly significant part. As summarized by Bourdieu,

So that cultured people can believe in barbarism and persuade the barbarians of their own barbarity, it is necessary and sufficient for them to succeed in hiding both from themselves and from others the social conditions which make possible not only culture as a second nature, in which society locates human excellence, and which is experienced as a privilege of birth, but also the legitimated hegemony (or the legitimacy) of a particular definition of culture.

What practical implications might Bourdieu's work have for art museums? Most important, perhaps, is his view that they cannot succeed in making themselves substantially more "welcoming places" simply by lengthening their outreach or by widening their doors. If the predisposition to visit museums in any regular way is, as he claims, principally a by-product of educational attainment, then it is only through a general increase in the educational level of the surrounding community that museums will be able to attract and retain their desired new visitors. Bourdieu likens museums that conclude otherwise—that think they can encourage such added visitation through aggressive publicity—to "those people who imagine that they only have to shout louder to be better understood by a foreigner." He is equally dubious that nonvisitors can be transformed into regular visitors by some special event or exhibition intended for that purpose. Like any technique, museum visiting will only be

practiced with regularity when it is "integrated into the total system of attitudes and customs which alone can give it a foundation and a meaning."

More troubling are the implications of *The Love of Art* at the level of public policy. If art museums hope to receive substantial support from federal, state, and other governmental sources, then they must be prepared to give a far more positive account of their purposes and accomplishments than that which Bourdieu provides. Basic to any such account must be a justification of the visual arts as something more than the arbitrary emblems of "cultivation" to which they are reduced by Bourdieu's sociology. Arguments supportive of the art museum must necessarily begin with arguments supportive of the arts. Here it might be useful to emphasize, as Dennie Palmer Wolf and Mary Burger of the Harvard Graduate School of Education have recently done, the extent to which the arts have become indispensable "ways of knowing, contributing to, and participating in a culture."

So brief a review can neither indicate the complexity of Bourdieu's analysis nor adequately suggest the vigor and spiky astringency of his prose. His work needs to be experienced first-hand. *The Love of Art* is essential for inclusion in museum reference libraries and ought be required reading in museum training courses; those wanting to become better acquainted with Bourdieu's ideas more generally might find it wiser to begin with one of his later (and less densely mathematical) books in which he further explores how those who are initially possessed of a knowledge of and predisposition toward the arts are ultimately able to transform such "cultural capital" into "economic capital." One such work (which also deals with culture broadly, although touching only briefly on museums) is *Distinction: A Social Critique of the Judgment of Taste,* which first appeared in France in 1979 and which, with the assistance of grants from the National Endowment for the Humanities, was published in English in 1984 by the Harvard University Press. However one first encounters him, Bourdieu is a formidable figure and one with whose challenging ideas museum people must prepare themselves to deal.

# 8

# ON A NEW FOUNDATION:
# THE AMERICAN ART MUSEUM
# RECONCEIVED

For some segment of the American public—a segment that would appear to be largely well educated, generally affluent, and disproportionately white[1]—the growth of interest in the visual arts that began after World War II has, with only occasional fits and starts, continued to this day.

The evidence surrounds us. Newspapers routinely report the prices fetched at art auctions with the same speed and extensive coverage that they once reserved for baseball games and presidential elections. In Washington, members of the Congress wrangle over whether particular works of art might or

1. To the extent that art museum attendance may be considered a reliable indicator of an individual's interest in the visual arts, see J. Mark Davidson Schuster, *The Audience for American Art Museums: National Endowment for the Arts Research Division Report* 23 (Washington, D.C.: Seven Locks Press, 1991). This study was based on the 1985 Survey of Public Participation in the Arts sponsored by the National Endowment for the Arts and conducted by the U.S. Bureau

This text was delivered on April 14, 1993, at the University of Michigan as the first in the thirty-fifth series of William W. Cook Lectures on American Institutions. The overall title of the series was "The American Art Museum: Three Perspectives." The remaining two lectures were given on April 15 and 16 by Annamaria Petrioli Tofani, Director of the Galleria degli Uffizi in Florence, and Marcia Tucker, Founder and Director of The New Museum of Contemporary Art in New York City.

might not be appropriate for public funding. In California, the San Jose Redevelopment Agency announced that it would lay out $3 million to lease a rotating collection of works of art from the Whitney Museum of American Art in New York City to fill a recently completed but largely empty wing of the San Jose Museum. The lease price may also include a right of first refusal for certain touring exhibitions.[2] Meanwhile, back in New York during the winter of 1992–1993, eleven thousand people a day visited the René Magritte exhibition at the Metropolitan Museum of Art while another seven thousand visitors a day—the maximum capacity—concurrently crowded their way into the Henri Matisse exhibition at the Museum of Modern Art. On West 53rd Street outside the Modern, ticket scalpers were reportedly reselling the $12.50 reserved admissions for up to $100 a pair.[3]

At the calm center of all this commerce and commotion—serving frequently as its site and almost invariably as its anchor—sits one of the most traditionally august and even aloof of American institutions, the art museum itself. Few social institutions play such a variety of roles—some deliberately chosen, others thrust upon it—as does the art museum. As viewed from within, its principal focus is on education and preservation. It does its work by assembling a collection of art works that it seeks to make both physically and intellectually accessible for the benefit of a present generation while at

---

of the Census in collaboration with the University of Maryland. The basis for the Survey was 13,675 interviews conducted with a probability sample of the American adult population. Of this group, 22 percent—or two of every nine participants—reported making an art museum visit during the previous twelve months. The attendance rate ranged from 4 percent for those with a grade school education to 55 percent for those with at least some graduate school and from 11 percent for those with incomes between $5,000 and $10,000 to 45 percent for those with incomes of more than $50,000. Although African-Americans were only half as likely as European-Americans to have visited an art museum during the relevant period, it is unclear whether this was an independent variable or a function of their educational and income levels. Studies from other Western countries cited by Schuster suggest that education and income (which may themselves be to a degree related) play similar roles in determining who attends their art museums as well. See also Pierre Bourdieu, Alain Darbel, and Dominique Schnapper, *The Love of Art: European Art Museums and Their Public* (Stanford, Calif.: Stanford University Press, 1990).

 2. *The New York Times,* October 30, 1992; *Art in America* 80 (December 1992): 136.
 3. The Washington Times, December 1, 1992; *The New York Times,* December 26, 1992.

the same time preserving that collection to serve as the patrimony of a succession of future generations.[4]

By contrast, as perceived by the larger part of its public, the art museum functions principally as an arbiter of excellence. It has the authority to confer substantial and enduring value on the works of art that it chooses to collect and/or exhibit. To describe a painting as being of "museum quality" is to attest to its excellence. Contemporary artists may calibrate their reputations by the number of museums that have collected or displayed their work. To have been included in even a temporary museum exhibition can enhance an art work's value in the marketplace.

By any measure, the American art museum is today a considerable institution. From its modest beginnings in the years just following the Civil War, the community of art museums has grown to include more than twelve hundred organizations nationwide.[5] Some statistics will suggest its scope:

*Operating expenses.* In fiscal year 1991, there were approximately 150 American art museums that had annual operating expenses that exceeded $1 million.[6] Of those, twenty had operating expenses of more than $10 million. Three had operating expenses that exceeded $50 million.

*Visitation.* Total art museum visitation for fiscal year 1991 is estimated at 40–50 million individual visits. One hundred art museums recorded 100 thousand individual visits or more. Five had visitor counts that exceeded one million.

4. Concerning the educational aspirations of art museums, see Barbara Y. Newsom and Adele Z. Silver, eds., *The Art Museum as Educator: A Collection of Studies as Guides to Policy and Practice* (Berkeley and Los Angeles: University of California Press, 1978). For a recent discussion of education in museums of all disciplines, see *Excellence and Equity: Education and the Public Dimension of Museums* (Washington, D.C.: American Association of Museums, 1992). For a general overview of collecting and other museum activities, see *Museums for a New Century* (Washington, D.C.: American Association of Museums, 1984).

5. Data Report, 1989 National Museum Survey, American Association of Museums, Washington, D.C. Although there was a scattering of museums founded earlier, the date of 1870 is generally taken to mark the beginning of the art museum movement in the United States.

6. The figures in this and the following paragraph are drawn from the 1992 Statistical Survey published for its membership by the Association of Art Museum Directors, New York, N.Y.

*Collections.* A 1989 survey found that American art museums then held some 13 million works of art in their collections.[7] Although there is no reliable estimate of the total value of these, the collections of the several largest museums might easily exceed several billion dollars in value each. To estimate a national total, if one were to assume even a modest average value of $5,000 for each work in these collections, a figure of $65 billion would be produced.

*Endowment.* Data drawn from the same 1989 survey indicated that approximately $14 billion was then held in endowment funds permanently set aside for the support of these art museums. Depending on how such funds were invested, that total should be considerably greater today.

Given an institution of such apparent solidity, reach, and vitality, one might readily assume that the American art museum must rest on some equally solid intellectual foundation—that, underpinning this enormous activity, popularity, and accumulation of wealth, there must be some widely accepted and bedrock cluster of concepts that justifies the existence of such a considerable institution, determines its functions, shapes its values, and provides guidance for its future direction and growth.

In fact, there once was just such a solid foundation. From the late eighteenth century when the first European art museums were established to the second half of the nineteenth century when similar museums first began to appear along America's eastern seaboard, there was a reasonably workable consensus (at least among those who were interested in such things) about an entire network of notions that concerned art and artists. These included the idea that visual artists were people of a special, privileged, and elevated kind; the idea that the works of art that these artists created were objects of a singular or even, at their best, inherently spiritual significance; the idea that those who, whether by natural taste or practiced discernment, were best able to understand and appreciate these works of art—connoisseurs, collectors, and ultimately, curators—were also people of a special, privileged, and elevated kind; and the idea that the accumulation and display of these works

---

7. The figures in this and the following paragraph are drawn from the 1989 National Museum Survey.

of art in an art museum must of necessity constitute a public good of an all but religious dimension.[8]

That foundation, however, is no longer solid. Since the start of this century, virtually every one of those notions has come under assault, and scarcely any of the premises on which the art museum was initially created and for so long maintained now remains undamaged.[9] If the American art museum is to survive through anything more than habit—a poor prospect, certainly, given that even the most ingrained of habits must ultimately weaken and fade—then those who care for its survival may well find it necessary to work toward its reconception and restructuration on a largely new and different foundation from that on which it was originally established. We will, in time, consider what some of the elements of that reconception might be.

I

The American art museum was, at its founding, a nineteenth-century copy of an eighteenth-century original—the European art museum. In some important respects, however, this copy differed from the original. It is, for example, a commonplace of the museographical literature that whereas the creation of the European art museum involved already-existing collections and was deeply intertwined with political change—as can be seen most dramatically in those instances in which royal or ecclesiastical collections were expropri-

8. In this same vein, Linda Nochlin has suggested that implicit in the establishment of the public art museum "is, of course, the notion that there is such a thing as art, that this art consists of certain classes of objects rather than others, and that confrontation of these objects, knowledge of their history, and enjoyment or appreciation of their quality are unquestionably good for the general public—a view . . . taken for granted by most art workers." Linda Nochlin, "Museums and Radicals: A History of Emergencies," in Brian O'Doherty, ed., *Museums in Crisis* (New York: George Braziller, 1972), 37.

9. Notwithstanding that these founding premises no longer play a dominant role in the museum field's own internal discourse, they still survive significantly in the ways in which the public at large views and discusses art museums. Thus, in one of the surveys reported by Bourdieu, Darbel, and Schnapper, *Love of Art,* 66 percent of "working class" participants (as contrasted with 45 percent of those identified as "middle class" and 30.5 percent of those identified as "upper class") said that the public institution of which the art museum most reminded them was a church. See also Tom Wolfe, "The Worship of Art," *Harper's* 269 (October 1984): 61.

ated and served as the basis for museums created in what had only shortly before been palaces—the American art museum began from an idea of communal improvement and was intended from its very start to be fundamentally pedagogic in nature.

S. Dillon Ripley's brief description of these early American art museums captures what was most typical of them:

Many of these collections represented a conscious effort by what was called the enlightened class to donate materials for public show in order to elevate and educate our citizens. Art collections . . . were to be exhibited for public edification. The [donors] were concerned, as a moral issue, with the educational and cultural development of their fellow citizens. . . . There was a strong, a zealous missionary desire to uplift, to create cultural equality as one of the fundamental outgrowths of our new democracy.[10]

In one respect, however, the European original and its American copy were to coincide almost exactly. That was in the religiously tinged and reverential rhetoric in which art, artists, and even the museum itself were almost invariably bathed. Several brief quotations may suggest the drift and intense spirituality of this rhetoric.

Here, for example, is the young Johann Wolfgang von Goethe's reaction on visiting the still-private but by then open-on-request royal Saxon gallery in Dresden in 1768:

That *salon* turning in on itself, magnificent and so well-kept, the freshly gilded frames, the well-waxed parquetry, the profound silence that reigned, created a solemn and unique impression, akin to the emotion experienced upon entering a House of God, and it deepened as one looked at the ornaments on exhibition which, as much as the temple that housed them, were objects of adoration in that place consecrated to the holy ends of art.[11]

Nearly thirty years later, the early German romantic writers Ludwig Tieck and Wilhelm Wackenroder could be found using a similar religious metaphor. In their 1797 collection of essays *Effusions of an Art-Loving Monk,* they wrote:

10. S. Dillon Ripley, *The Sacred Grove: Essays on Museums* (New York: Simon & Schuster, 1969), 43.

11. Quoted in Germain Bazin, *The Museum Age* (New York: Universal Book, 1967), 160.

A picture gallery appears to be thought of as a fair, whereas what it should be is a temple, a temple where, in silent and unspeaking humility and inspiring solitude, one may admire artists as the highest among mortals.[12]

As the next century unfolded and the romantic movement spun toward even dizzier heights, so too did this fusion of art and the artist with the sacred. By 1825, we find the French social reformer Henri de Saint Simon addressing the public on the role of the artist in these terms:

It is we artists who will serve you as an avant garde . . . when we wish to spread new ideas among men, we inscribe them on marble or on canvas; what a beautiful destiny for the arts, that of exercising over society a positive power, a true priestly function, and of marching forcefully in the van of all intellectual faculties.[13]

Against such a background, who could doubt the moral and social utility of the art museum as this new kind of institution began its westward spread across America? Likened to a House of God, declared to be a temple, crowded with marbles and canvases on which a priestly class had inscribed the secret signposts of progress, the art museum—itself a neutral and disinterested institution, established only to serve and staffed by public servants able by birth or training to distinguish the excellent from the meretricious—offered itself freely (or virtually so) as a place where all (rich and poor, native and immigrant, sophisticated or not) might come to improve themselves, their lives, and their communities by communing for an hour or two with the exalted spirits of artists as those spirits were embodied in exalted works of art.

Notwithstanding that the predominant purpose of the American art museum was to "uplift" and "edify" rather than to celebrate and make manifest—as had been the case of such older European museums as the Louvre—that

12. Quoted in Arthur C. Danto, *Beyond the Brillo Box* (New York: Farrar, Strauss & Giroux, 1992), 207.

13. Quoted by Robert Hughes in his "Afterword: Art and Politics," in Robert Hobbs and Frederick Woodward, eds., *Human Rights/Human Wrongs: Art and Social Change* (Iowa City: Museum of Art, the University of Iowa, 1986), 217. In this same vein, albeit more secular than sacral, was Percy Bysshe Shelley's declaration in his 1821 *A Defense of Poetry* that poets were the "unacknowledged legislators of the world." See also Stewart Buettner, *American Art Theory: 1945–1970* (Ann Arbor, Mich.: UMI Research Press, 1981), 12, discussing the prevalence in the nineteenth century of the view that artists alone were capable of "revealing truth."

what had once belonged to the King now belonged to the people, it was still bottomed on that same faith, that same spirituality, that same reverence for works of fine art and for those who created them. It was, as Germain Bazin called it, "a temple to human genius."[14] And to even the most benighted, it was prepared to offer—in a memorable phrase that William Cullen Bryant used in 1869 to describe the soon-to-be-established Metropolitan Museum of Art—"entertainment of an innocent and improving character."[15]

It is such a vision of the art museum that is today no longer supportable. Its premises have been battered, weakened, and in some instances all but totally undermined by close to a century of critical assault. Whether and to what extent this criticism might be valid is almost beside the point. Its impact has been cumulative and damaging. In making the case for the ongoing public and private patronage that is essential to its survival and—no less essential— in competing for the leisure time of its potential visitors, the American art museum no longer enjoys its once-unblemished prestige. It can no longer take for granted that it will be regarded as a place of simple, unqualified, and self-evident good. The day when such an institution might be perceived as innocent and inherently virtuous has passed.

## II

What, then, are the criticisms, questions, and doubts that have been raised to challenge the art museum? They fall generally into two broad categories. Some focus on the twin subjects that have been traditionally central to the museum's whole program—visual artists and the works of fine art that they create. The remainder focus on the museum itself, on the nature and propriety of its performance as an institution. Does the art museum, in fact, do what it claims to do, or does it really do something else entirely?

The questions about artists and their art begin with the most fundamental. Limiting the inquiry, for simplicity's sake, to the case of painters, it starts by asking why it is that those who make painted marks on a two-dimensional surface should have been so singled out from other artisans—from potters,

14. Bazin, *Museum Age.*

15. Quoted by Nathaniel Burt, *Palaces for the People: A Social History of the American Art Museum* (Boston: Little, Brown & Co., 1977), 91.

goldsmiths, tailors, carpenters, sandal-makers, or jewelers—to be deserving of a particular adulation and special status.

Immediately striking is the fact that neither is it everywhere the case nor, in those places where it *has,* in fact, become the case, has it *always* been the case that the painter was accorded such an elevated status. Was this a matter of revelation? Have we succeeded in recognizing—as other cultures and ages had failed to do—something inherently important in the work that the painter does that sets his or her production apart from other hand-made goods? Or is there some historical happenstance that might account for the public elevation of this particular mark-maker from a more-often-than-not anonymous member of the painters' guild to the exalted rank of an identified artist?

The evidence points toward happenstance. The notion that a painter might be something more than a mere decorator, that he or she might actually be the practitioner of an "art," appears to have been fabricated in Florence toward the end of the fifteenth century. Previously, under a classificatory scheme that can be traced back to Greek and Roman times, the "arts"—or more properly the "liberal arts," as contrasted with the "servile" or "mechanical" ones—were limited to those creative activities that required the exercise of mental skills, not merely the application of manual dexterity. Of what we still recognize today to be the arts, only literature and music met this original standard.

The Florentine painters aspired to a higher social status than that of mere mechanics. In pursuit of that aspiration, they successfully argued that the practice of their craft was as much a matter of mind as it was of physical effort. With the recent development of perspective, for example, painters now required a thorough knowledge of geometrical theory. Likewise, a knowledge of optics had become necessary. Likewise, the artist needed to understand anatomy. Above all, they pointed out, painting was no more a mechanical skill than was writing. As sentences were formed in the mind and then written down, so paintings too were formed in the mind and only then transcribed through painted marks. Painting, they argued, should be classified as one of the liberal arts, and those who practiced it were accordingly worthy to be known as artists. Their argument apparently carried the day.[16]

16. See Jean Gimpel, *The Cult of Art: Against Art and Artists* (New York: Stein and Day, 1969), 24–35. See also Rudolf and Margot Wittkower, *Born under Saturn: The Character and Conduct of Artists* (New York: W. W. Norton & Co., 1969), 14–16.

The analogous case of architecture is instructive. Almost concurrently with the elevation of painting to an art, the practice of constructing buildings was undergoing a similar metamorphosis. Whereas it had previously been seen as largely a materially based matter of carpentry, masonry, and knowing how much of a foundation was needed to support what measure of weight, it now began to emerge as still another form of art with, almost needless to say, its own newly invented kind of artist, the architect. Leon Battista Alberti's description of this newly hatched architect, written in the mid-fifteenth century, could—with its emphasis on mental activity and the need to acquire advanced knowledge—have equally well been written of the painter:

Him I consider an architect, who by sure and wonderful reason and method, knows both how to devise through his own mind and energy, and to realize by construction, whatever can be most beautifully fitted out for the noble needs of man. . . . To do this he must have an understanding and knowledge of all the highest and most noble disciplines.[17]

Fast forward three hundred years. By 1797, we find that this erstwhile mark-maker, the painter, whom the Renaissance elevated to the rank of artist, has now been elevated still farther—the phrase, you will recall came from Tieck and Wackenroder—to the rank of "highest among mortals." Fast forward another two hundred years. In 1993, how many of us are still able to think about the painter in such terms?

Many no longer do. With the end of the romantic movement, the image of the artist as a solitary and autonomous genius has diminished considerably. That the greatest of artists have the capacity to transcend the temporal—to infuse their work with something of the eternal—is no longer a widely accepted notion. Michelangelo could no more have painted the Sistine Chapel to look like Matisse's chapel at Vence than Rembrandt could have painted a landscape to look like one of Renoir's. This was not, though, for lack of talent. No matter how stubbornly individual or visionary they may be, artists remain embedded in and captive to their times. As Robert C. Hobbs described their situation,

17. Quoted by Witold Rybczynski from Leon Battista Alberti, *On the Art of Building in Ten Books*, review of Mark C. Taylor's *Disfiguring: Art, Architecture, Religion* in *The New York Review*, November 19, 1992.

When artists innovate, they do not originate a totally new language. Rather, they find a means to alter the existing one, and their works become critiques of this language. . . . [The] work of art is a response to a pre existent attitude as well as an initiator of new responses.[18]

Thus considered, the artist is like a link in a chain—free to move but only so far.

Neither do we unquestioningly accept the notion today that a work of art must or can only emanate from the sensibility of the single artist working alone. Since the time of World War I, artists have increasingly participated in the creation of collaborative or collective works of arts. Critics, in turn, have not treated these works of art as being of less interest, albeit sometimes of a different interest, than individually created works of art.[19] At the end of a century in which collaboratively produced film, video, and radio have become commonplace, the possibility that a masterpiece of visual art might be crafted by committee is no longer quite so startling as it might once have seemed. It is not, however, a possibility that comports easily with our once-vibrant vision of the artist as a solitary genius.

Might it nonetheless be argued that the artist is a kind of endangered species, that the artist ought still be accorded some special status to ensure that such skills as mark-making and its analogous methods of artistic production (rock chipping, plate scratching, and so on) are not irretrievably lost? That danger seems remote. Whether or not artists were once rare creatures in need of protection, they are not so today. On the contrary, we are today up to our ears in artists, hundreds of thousands of them in this country

18. Robert C. Hobbs, "Rewriting History: Artistic Collaboration since 1960," in Cynthia Jaffee McCabe, ed., *Artistic Collaboration in the Twentieth Century* (Washington, D.C.: Smithsonian Institution Press, 1984), 65.

19. "Collaboration in our epoch is a polyphony of real, historical, and conditioned voices speaking of their common predicament in subjugating systems. As John Cage has spoken of a demobilization of language, these collaborations aim at a demobilization and disarmament of man. The human is reinstated as an allegory of collaboration. He who does not collaborate is a god or a beast." David Shapiro, "Art as Collaboration: Toward a Theory of Plural Aesthetics 1950–1980," in McCabe, *Artistic Collaboration in the Twentieth Century,* 61. Beyond the question of whether works of art must invariably be the creation of the individual artist lie questions about the nature of individuality itself. See, for example, Stanley Aronowitz, "Reflections on Identity," in *October 61* (Summer 1992): 91–103.

alone.[20] Tomorrow there will be more. As of the fall of 1991, the National Association of Schools of Art reported that its 176 member institutions, which offer most but not all this nation's degree-granting art programs, had more than sixty-one thousand students enrolled in Bachelor of Fine Arts programs and majoring either in art or design.[21]

Is it the continuing desire to be "highest among mortals" that drives most students or practitioners toward careers as artist? Or has being an artist simply become another profession, like dentistry or the law, that one might choose to follow? Do young people set out to become artists today out of a compelling vision of the art they hope to make? Or does being an artist seem to offer a permissibly offbeat life-style—something like that of computer programming but not so technically demanding—that appeals to students looking for some unbuttoned alternative to what they regard as the prevailing tight-buttoned corporate culture? The late critic Harold Rosenberg, with perhaps only a touch of cynicism, suspected a variant of the latter. "The urge to transform oneself into an artist," he wrote, "is provided by the artist myth, with its lure of fame, glamorous sex and wealth."[22]

The degree to which the "artist myth" *is* a myth, most particularly as it bears on wealth, is borne out by a recent survey that indicated that in the calendar year 1990 fewer than 10 percent of American painters made more than $20,000 through their art. Nearly 75 percent earned less than $7,000.[23] Strongly suggested is (a) that, rather than there being any scarcity, artists are far more numerous today than the market for their work can possibly support, and (b) that, insofar as the public may be said to vote with its pocketbook, it

20. *Employment and Earnings,* January 1992, a publication of the Bureau of Labor Statistics, U. S. Department of Labor, reported that 208 thousand individuals self-designated "artist" as their primary occupation in the 1991 Current Population Survey. This total must both be reduced to eliminate craftspersons (who were included in the definition "artist") and increased to include those painters, sculptors, and printmakers (the remaining occupations in the definition) for whom being an artist was not their primary occupation and who supported themselves primarily through teaching or other means.

21. Telephone conversation, December 1992, with the National Association of Schools of Art, Reston, Virginia. This figure does not include the additional thousands enrolled in MFA programs or those who simply take art courses without pursuing a degree.

22. Harold Rosenberg, *Discovering the Present: Three Decades in Art, Culture, and Politics* (Chicago: The University of Chicago Press, 1973), 218.

23. *The Artists Training and Career Project: Painters,* a 1991 report prepared for the Research Center for Arts and Culture, Columbia University, New York, N.Y.

has elevated only a very small number of these artists to even the rank of the solvent, much less to that of "highest among mortals." In most of them, it shows no great interest.

Marcel Duchamp—perhaps the most astute observer of this century's art scene—thought that the rhetoric surrounding the artist had become overblown. To think of the artist as primarily creative, he suggested, was to misunderstand the degree to which the artist resembles other productive members of society:

He's a man like any other. It's his job to do certain things, but the businessman does certain things also. . . . Now, everyone makes something, and those who make things on a canvas, with a frame, they're called artists. Formerly they were called craftsmen, a term I prefer. We're all craftsmen, in civilian or military or artistic life.[24]

If the romantic vision of the artist as autonomous genius is no longer viable as one of the art museum's supporting premises, what then of the work of art itself? Putting aside the threshold question as to whether any object truly exists as a work of art in itself or simply becomes regarded as a work of art by its deliberate insertion into an "art world" context—the question that Duchamp raised when he first began to exhibit his "readymades" in 1916— there still remain the questions of how such a work is to be evaluated and to what public purpose it might be put.[25] Can the art museum—as a concept— still be supported by the interlocking premises that some works of art may be distinguished from others for their superior artistic quality, that the museum has the expertise to identify, as well as the duty to collect and/or display, these higher-quality works of art, and that such a display simply, in and by itself, may constitute a public good? Once again, each of these premises is today under fire.

One of the places where the battle has been most fiercely joined is over the issue of artistic quality. Is "quality" an inherent characteristic of a work of

24. Pierre Cabanne, *Dialogues with Marcel Duchamp* (New York: The Viking Press, 1971), 16.

25. For an extensive discussion of Duchamp's most notorious "readymade"—the urinal that he exhibited in New York City in 1917—see William A. Camfield, *Marcel Duchamp: Fountain* (Houston: Houston Fine Arts Press, 1989).

art or, like beauty, does it lie not merely in the eye but ultimately in the mind—and, possibly, even in the entire social experience—of the beholder?

Perhaps nobody in recent years has made the traditional case that artistic quality is a property intrinsic to works of art in more unequivocal terms than Lorenz Eitner, for many years the Chair of the Art Department at Stanford University. "Quality resides in the object," he said, "and it endures as long as its physical substance."[26] To the suggestion that artistic quality may be relative either to the time and place in which a work of art was created or to the circumstances in which the work is being perceived, Eitner responded by arguing that such quality is universal and absolute:

The quality in a work of art is unaffected by the shifting cultural and social conditions that surround it. It may remain unrecognized over long spans of time, but where it lives in a work of art it is forever ready to communicate itself to a beholder who comes to it with unobstructed senses. . . . Quality differences intersect the varieties of content, style, and technique developed by the different cultures and periods. They have nothing to do with conformity to rules of art or standards of taste. They are unaffected by social relevance. Their durability . . . rests on the fundamental permanence of the human sensory constitution. For the experience of quality is not, I believe, a divine gift or the stirring of some mysterious special organ, but a very human response to arrangements in the work of art that are calculated by the artists, guided by agelong wisdom, to accommodate and stimulate the senses.[27]

Eitner leaves us with this difficulty, though: Neither he nor anybody else has yet been able to propose a formulation that would successfully capture what he or she means by quality.[28] Acknowledging this, Eitner's long-time Stanford colleague Albert Elsen has suggested that, in its verbally elusive but nonetheless (to him) palpable reality, "quality" might well be likened to obscenity in that—as Supreme Court Justice Potter Stewart observed about the latter—without being able to define it he would still know it when he saw

26. Lorenz Eitner, "Art History and the Sense of Quality," *Art International* 19 (May 1975): 78.

27. Ibid.

28. For a thorough book-length critique tracing the efforts of philosophers to do so from the eighteenth century down to our own time, see George Dickie, *Evaluating Art* (Philadelphia: Temple University Press, 1989).

it.[29] Lest this might tempt one to think, however, that quality might be instantly perceptible, Elsen also suggested—the point is one on which a good number of other commentators agree—that quality must be determined over time. A work of art of quality is one, he said, with "aesthetic durability," one that does not wear out "its intellectual and emotional welcome."[30] In a similar vein, Meyer Schapiro noted that "the best in art can hardly be discerned through rules; it must be discovered in a sustained experience of serious looking and judging."[31]

For those who hold this view, the primary role of the art museum is clear. As noted earlier, it is to distinguish works of art of greater quality from those of lesser and to make these greater-quality works accessible to the public. The late Alfred H. Barr, Jr., who all but single-handedly created the Museum of Modern Art in New York, once described the day-to-day work of the art museum in just such terms. It consisted, he said, of "the conscientious, continuous, resolute distinction of quality from mediocrity."[32] Expanding on this, the critic Hilton Kramer identified the art museum's principal purposes as twofold: first, in its role as collector, "distinguishing and preserving what informed judgment found to be the best in art, the highest accomplishments of their kind," and second, in its role as educator, "to aid us in understanding this distinction and in making the highest of these accomplishments a permanent part of our existence."[33]

29. Essay by Abert Elsen in the catalogue *Bruce Beasley: An Exhibition of Bronze Sculptures* (Sonoma, Calif.: Sonoma State University, 1990), 7. Justice Stewart's observation is to be found in *Jacobellis v. Ohio*, 378 U.S. 184, 197 (1964).

30. Elsen, *Bruce Beasley*, 9.

31. Meyer Schapiro, *Modern Art: 19th and 20th Centuries* (New York: George Braziller, 1978), 232.

32. Quoted by Richard E. Oldenburg in his foreword to Alfred H. Barr, Jr., *Painting and Sculpture in the Museum of Modern Art* (New York: Museum of Modern Art, 1977), ix.

33. Hilton Kramer, "The Assault on the Museums," *New Criterion* 9 (March 1991): 5. For a yet more rarified vision of the art museum's purpose, see Marc Fumaroli, "What Does the Future Hold for Museums?" appendix to *Masterworks from the Musée des Beaux-Arts, Lille* (New York: Metropolitan Museum of Art/Abrams, 1992), 288. Fumaroli saw the original purpose of the museum as "the awakening of artistic genius through contact with works of genius, and the development of artistic taste through the careful comparison of masterpieces." Although such great urban institutions as London's National Gallery, the Louvre, or the Metropolitan Museum of Art may continue to be perceived as operating in accord with such an original purpose, is it really still germane to so dispersed an institution as the American art museum with its more than twelve hundred organizations, 13 million objects, and 40–50 million annual visitors?

Once more, not everybody still believes this. Some of those who doubt it argue that such an emphasis on quality is simply an extension of the nineteenth-century rationalization that an art that served no other purpose might still be of value for its own sake alone. At its most intense, they charge, this concentration on art-for-art's-sake can only lead toward a sterile formalism through which art becomes wholly divorced from life. The contemporary artist Hans Haacke put it this way:

The gospel of art for art's sake isolates art and postulates its self-sufficiency, as if art had or followed rules which are impervious to the social environment. Adherents of the doctrine believe that art does not and should not reflect the squabbles of the day. Obviously they are mistaken in their assumption that products of consciousness can be created in isolation."[34]

By way of a necessary correction, proponents of this view urge that museums and their publics ought concentrate not on whether a work of art is well or poorly made but on what it is about—its content or subject matter—as well as on the social conditions attendant to its production and to its public display. By no means clear, however, is the basis on which the museum would select which of many competing works of content-heavy art it ought exhibit to the public. Would, for example, a poorly executed work that could be understood to advocate the favored side of a political or ideological dispute be deemed preferable for public display to a better-executed work that advocated the contrary position? If so, who gets to decide which position is favored, and what happens to the continuity of value when one decision-maker replaces another?

At an even further remove from any focus on quality is the argument that art ought not be judged merely by the acceptability of the idealogy it advocates but by the degree to which it proves itself effective in translating that ideology

34. Hans Haacke, "Museums, Managers of Consciousness," in Brian Wallis, ed., *Hans Haacke: Unfinished Business* (New York: The New Museum of Contemporary Art, 1986), 66. As Michael Lind points out in "Reinventing the Museum," *The Public Interest* 109 (Fall 1992): 22–39, the notion of quality has been attacked from the right as well as the left. Lind's prime example is Ananda K. Coomaraswamy, the first curator of the Boston Museum of Fine Art's Indian collection. According to Lind, Coomaraswamy considered it a sign of decadence for a society to pay more attention to the form of a symbol than to its meaning. In such a view, to treat an object made for use as primarily a work of art is to *devalue* the object, not to ennoble it. More recent attacks from the right are treated later in the main text.

into constructive social action. In short, does it work as an instance of agit-prop? Thus, the West Coast art magazine *High Performance,* published in association with the California Institute of the Arts, recently announced that it would no longer carry reviews of art exhibitions and performances because such reviews ultimately tend to emphasize critical determinations (i.e., critical judgments as to the work's artistic merit or quality) rather than to explore the work's success or failure in terms of the artist's activist intentions.[35] No matter how "well done" it may be, a work of art that fails to accomplish such intentions can scarcely be said to be successful.

There is growing feeling amongst artists and a broad range of cultural critics that it is no longer sufficient for art to express the artist's inspired creativity if that work fails to resonate beyond the art world. It is no longer enough for the work to succeed in art world terms if it fails to have relevance to the broader context in which that work is created. The artist as iconoclast is being replaced by the artist as citizen.[36]

At its most extreme, this rejection of quality as a principal consideration in the evaluation of works of art goes beyond questioning what weight it should be given to question whether the concept is itself in any way meaningful. To the critic Benjamin H. D. Buchloh, for example, quality is fundamentally a social issue rather than an aesthetic one. The "abstract concept" of quality, he wrote, is "the central tool which bourgeois hegemonic culture (that is, white, male, Western culture) has traditionally used to exclude or marginalize all other cultural practices."[37]

In July 1990, the *New York Times'* then-critic Michael Brenson published a widely discussed article that exposed this debate over quality to a larger than art-world public.[38] In it he suggested that it was primarily those on the political left who rejected the notion of "quality" in the visual arts while those on the political right tended to "embrace it." That seems, however, too simple.

35. Editorial, *High Performance* 15 (Summer–Fall 1992), 11.

36. Ibid., 10.

37. "The Whole Earth Show: An Interview with Jean-Hubert Martin by Benjamin H. D. Buchloh," *Art in America* 77 (May 1989): 158.

38. Michael Brenson, "Is 'Quality' an Idea Whose Time Has Gone?" *The New York Times,* July 22, 1990.

Although there are undoubtedly conservative critics who have made quality central to their approach to art—the previously quoted Hilton Kramer is certainly one—the politicians of the right have been no less zealous than the artists of the left in singling out content or subject matter rather than any evaluation of quality to be the predominant element of the art that they find abhorrent. This was certainly the case in the recent controversies over the work of Andres Serrano and Robert Mapplethorpe. That Serrano's photograph *Piss Christ* might have been an image of great formal appeal availed naught in the eyes of its critics. The obscenity charges that arose from showing Mapplethorpe's photographs, likewise, were all content-based. If we look to an earlier time—back, for example, to that most deliciously ludicrous of all descriptions of modern art that Michigan's art-bashing Congressman George A. Dondero gave to the press some forty years ago—we will still find that same narrow focus on content. Listen carefully to Dondero's words:

Modern art is Communistic because it is distorted and ugly, because it does not glorify our beautiful country, our cheerful and smiling people, and our material progress. Art which does not glorify our beautiful country in plain, simple terms that everyone can understand breeds dissatisfaction. It is therefore opposed to our government, and those who create and promote it are our enemies. [39]

This is scarcely the position of somebody for whom questions of artistic quality are central or even interesting. That it so faithfully parallels and almost exactly reproduces the antiformalist stance of Dondero's principal nemesis, the Stalinist Soviet Union, is, to say the least, deeply ironic. [40] Brenson to the contrary, left and right seem indistinguishable in their insistence that works of visual art ought be judged by what they say rather than how they say it.

Closely linked to this issue of quality is that of taste—the ability to distinguish, as Barr put it, "quality from mediocrity." Indeed, in the small world of the art museum, an individual may sometimes achieve considerable renown for being thought to have what is colloquially called an "eye"—the instinctive ability to recognize in advance qualities in a work of art that those

39. Quoted in William Hauptman, "The Suppression of Art in the McCarthy Decade," *Artforum* 12 (October 1973): 48. The extract comes from an interview with Emily Genauer of the *New York World-Telegram*.

40. See Hellmut Lehmann-Haupt, *Art under a Dictatorship* (New York: Octagon Books, 1973), 231–235.

without such an eye will only much later discern. Something of the same sort happens at the institutional level. The public's perception of a particular museum's excellence will vary with what it believes to be the ability of the museum's staff to separate out from the great mass of art that it confronts those few examples that embody the greatest artistic value. This notion, too, has recently been challenged.

Of particular interest is a line of inquiry that was initiated by Duchamp's comment that "taste" was really nothing more than "a habit. The repetition of something already accepted."[41] If so, what would it then mean to be considered by one's peers to be a person of superior taste, to have an eye? The critic Thomas McEvilley suggested an answer. If the canons of taste are "not . . . eternal cosmic principles, but . . . transient cultural habit formations," then for somebody to be considered to be a person of superior taste, he said, would be "for that person to sense and exercise the communal habit-system with unusual attention and sensitivity."[42]

Curiously, it was the economist John Maynard Keynes who left us a clue as to how such line might be taken still a step farther. In a well-known passage dealing with professional investment, Keynes likens the successful investor's choice among competing possibilities to

those newspaper competitions in which the competitors have to pick out the six prettiest faces from a hundred photographs, the prize being awarded to the competitor whose choice most nearly corresponds to the average preferences of the competitors as a whole; so that each competitor has to pick, not those faces which he himself finds prettiest, but those which he thinks likeliest to catch the fancy of the other competitors, all of whom are looking at the problem from the same point of view. It is not a case of choosing those which, to the best of one's judgment, are really the prettiest, nor even those which average opinion genuinely thinks the prettiest. We have reached the third degree where we devote our intelligences to anticipating what average opinion expects the average opinion to be.[43]

41. Cabanne, *Dialogues with Marcel Duchamp*, 48.

42. Thomas McEvilley, *Art and Discontent: Theory at the Millennium* (Kingston, N.Y.: McPherson & Co., 1991), 68.

43. John Maynard Keynes, *The General Theory of Employment, Interest and Money* (New York: Harcourt, Brace & World, Inc., 1936), 156.

Is there not possibly some rough analogy here to the situation of those museum workers reputed to have so special an eye? Might it not be the case that what is actually special about them is their ability to anticipate an emerging habit-system before it becomes evident to their less sensitive and less far-sighted colleagues? Might it not even be the case that they sometimes participate in the shaping of such an emerging habit-system? These may be no less impressive talents than to be blessed with some optical superiority, but they are most certainly different ones.

The notion that mere exposure to works of art can, in and of itself, confer a moral benefit on the viewer has by now fallen to such low repute that we can pass it by with only a brief comment. Suffice it to say that such a view was still widely held in the mid-nineteenth century when the first American art museums were established. Robert Hughes quoted the following from an 1855 editorial in *Crayon,* one of the leading art magazines of its day:

The enjoyment of Beauty is dependent on, and in ratio with, the moral excellence of the individual. We have assumed that Art is an elevating power, that it has *in itself* a spirit of morality.[44]

Hughes's reaction to this seems exactly on point. "We know, in our hearts," he wrote, "that the idea that people are morally ennobled by contact with works of art is a pious fiction. The Rothko on the wall does not turn its lucky owner into Bambi."[45]

Moving on from these quarrels about artists and art, about taste and moral uplift, to the other category of charges to be examined—questions about the art museum itself and doubts about its importance as an institution—we find a similarly troubling erosion of what once seemed a solid cluster of premises about the museum's objectivity, value, and purpose.

44. Quoted in Hughes, "Afterword," 220. A similar view prevailed in England. See Mark Goodwin, "Objects, Belief and Power in Mid-Victorian England—The Origins of the Victoria and Albert Museum," in Susan Pearce, ed., *Objects of Knowledge* (London: The Athlone Press, 1990), 29. Goodwin quoted Sir Henry Cole, one of the founders of the Victoria and Albert Museum, as having said in an 1884 address,

> One way, I believe, to meeting the devil . . . is by a Museum of Science and Art, and I shall be much surprised if the clergy do not think so. I am looking forward to the time when . . . you will have a Museum Sunday. This will be defeating Satan by an indirect process. Religion will co-operate with Fine Art I am sure.

45. Hughes, "Afterword," 220.

Some of the accusations against the art museum will scarcely be surprising. Over the past several decades, it has been charged with being racist, sexist, elitist, largely Eurocentric, an instrument of capitalist exploitation, and a good deal more.[46] It is not to be expected that any enterprise of such visibility, wealth, patrician bearing, and apparent authority—an enterprise, moreover, so deeply interwoven with other aspects of American life—might be spared such charges. Neither is it to be expected that the art museum will, with respect to such matters as race and gender, in fact differ very much more than marginally from the surrounding community from which, necessarily, it draws much of its staff, many of its board members, all its volunteers, and the bulk of its financial support.

In a like manner, it is charged that the art museum is not now nor has ever been the neutral and disinterested institution that it claims to be. Notwithstanding its claims to be pure, autonomous, and beyond worldly things, it cannot be otherwise than deeply colored by its social, economic, and political setting. Again, the artist Hans Haacke:

Irrespective of the "avant-garde" or "conservative," "rightist" or "leftist" stance a museum might take, it is, among other things, a carrier of socio-political connotations. By the very structure of its existence, it is a political institution. . . . The question of private or public funding of the institution does not affect this axiom. The policies of publicly financed institutions are obviously subject to the approval of the supervising governmental agency. In turn, privately funded institutions naturally reflect the predilections and interests of their supporters.[47]

46. See, for example, Maurice Berger, "Are Art Museums Racist?" *Art in America* 78 (September 1990): 69–77. Describing the art museum as "one of America's most racially biased cultural institutions," Berger argued that they "have for the most part behaved like many other businesses in this country—they have sought to preserve the narrow interests of their upper-class patrons and clientele." For a discussion of Eurocentricism, see Carol Duncan and Alan Wallach, "The Universal Survey Museum," *Art History* 3 (December 1980): 448. ("In today's . . . American museums, exhibitions of Oriental, African, Pre-Columbian and Native American art function as permanent triumphal processions, testifying to Western supremacy and world domination.") To similar effect is David Chapin and Stephan Klein, "The Epistemic Museum," *Museum News* 71 (July–August 1992): 60–61. ("The grand halls of art museums are reserved for prestigious European paintings while the art of marginalized groups occupies marginal spaces.") For the museum depicted as an instrument of capitalist exploitation, see Jean Clay, "Some Aspects of Bourgeois Art," *Studio International* 179 (June 1970): 266.

47. Quoted in Charles Harrison and Paul Wood, eds., *Art in Theory, 1900–1990: An Anthology of Changing Ideas* (Oxford, England: Blackwell, 1992), 904.

Addressing the American Association of Museums' Midwest Museum Confer-
ence in September 1986, the University of Chicago's Neal Harris observed
that the "museum's voice is no longer seen as transcendent. Rather it is
implicated in the distribution of wealth, power, knowledge and taste shaped
by the larger social order."

These, however, are but general charges that might be and have been made
with equal validity against any large institution—certainly, for example, against
the university. The art museum, however, is also charged with many more specific
failings. One of the most serious of these is that it allegedly destroys—at least in
aesthetic terms—the very works of art for the preservation and appreciation of
which it was putatively established in the first instance. In an essay entitled "The
Problem of Museums," the poet Paul Valery, after acknowledging that he was "not
overfond" of such institutions, laid this charge out in some detail.[48]

The finer a work of art might be, Valery argued, the more distinct an object
it must be. It is a rarity whose creator envisioned it to be unique. To jumble
such works of art together in the galleries of a museum, he said, is the
equivalent of having ten orchestras playing at the same time.

Only an irrational civilization, and one devoid of the taste for pleasure, could have
devised such a domain of incoherence. . . . Egypt, China, Greece, in their wisdom
and refinement, never dreamed of this system of putting together works which
simply destroy each other: never arranged units of incompatible pleasure by order
of number, and according to abstract principles.[49]

This same point about the jangling interaction of the works of art gathered
together in the museum's collection was made earlier in the Futurist Mani-
festo of 1909. Comparing the museum to a cemetery, F. T. Marinetti had
suggested that they were

identical, surely, in the sinister promiscuity of so many bodies unknown to one an-
other. Museums: public dormitories where one lies forever beside hated or un-
known beings. Museums: absurd abattoirs of painters and sculptors ferociously
slaughtering each other with colour-blows and line-blows.[50]

---

48. Included in the collection *Degas, Manet, Morisot* (New York: Pantheon Books, 1960),
202.

49. Ibid., 203, 204.

50. Included in Umbro Apollonio, ed., *The Documents of 20th-Century Art: Futurist Manifestos*
(New York: The Viking Press, 1973).

While the late American artist Robert Smithson was to draw virtually the same parallel between museums and cemeteries—actually, he described museums as "graveyards" and "tombs"—it was because he thought that removing works of art from the context for which they were originally created destroyed whatever vitality they might once have possessed. He wrote in 1967:

Visiting a museum . . . is a matter of going from void to void. Hallways lead the viewer to things once called "pictures" and "statues." Anachronisms hang and pro-trude from every angle. Blind and senseless, one continues wandering around the remains of Europe, only to end in that massive deception "the art history of the re-cent past." . . . Museums are tombs. . . . Painting, sculpture and architecture are finished, but the art habit continues. [51]

In a 1972 text, Smithson again addressed what he perceived to be the devastating impact that the art museum has on a work of art:

A work of art when placed in a [museum] gallery loses its charge, and becomes a portable object or surface disengaged from the outside world. . . . Once the work of art is totally neutralized, ineffective, abstracted, safe, and politically loboto-mized it is ready to be consumed by society. All is reduced to visual fodder and transportable merchandise. [52]

In Europe, an astonishingly eclectic range of commentators have taken more or less the same position. They range from Pablo Picasso ("Museums are just a lot of lies, and the people who make art their business are mostly impostors. . . . We have infected the pictures in our museums with all our stupidities, all our mistakes, all our poverty of spirit. We have turned them into petty and ridiculous things." [53]) to the journalist/novelist Bruce Chatwin ("An object in a museum case must suffer the de-natured existence of an animal in the zoo. In any museum the object dies of suffocation and the public

51. Robert Smithson, *The Writings of Robert Smithson: Essays with Illustrations* (New York: New York University Press, 1979), 58.

52. Ibid., 132.

53. Quoted in Alfred H. Barr, Jr., *Picasso: Fifty Years of His Art* (New York: The Museum of Modern Art, 1946), 274.

gaze."⁵⁴) to the Frankfurt School critic Theodor W. Adorno. Commenting on the negative overtones of the adjective "museumlike," Adorno observed that it is used to describe

objects to which the observer no longer has a vital relationship and which are in the process of dying. They owe their preservation more to historical respect than to the needs of the present. Museum and mausoleum are connected by more than phonetic association. Museums are the family sepulchres of works of art.⁵⁵

A different twentieth-century variation on this theme is the notion that, regardless of whether they enter the museum or not, works of visual art by their very nature lose their vitality over time. The French wine merchant turned artist Jean Dubuffet once likened art products to Beaujolais:

I don't think they have a bouquet unless drunk during their first year. . . . Away with all those stale canvases hanging in dreary museums. . . . They *were* paintings: they no longer *are*. What is the life expectancy of an art product? Ten years? Twenty, thirty? Certainly never longer.⁵⁶

Dubuffet's compatriot Marcel Duchamp held a similar view. "I think painting dies," he said. "After forty or fifty years a painting dies, because its freshness disappears. . . . Men are mortal, pictures too."⁵⁷

All these attacks on the museum and its underlying premises appear, however, as so much nit-picking in comparison with that first launched nearly

54. Bruce Chatwin, *Utz* (New York: Viking Press, 1988), 20. Because this is a novel, one can only speculate that Chatwin's eponymous hero is speaking on the author's behalf. The passage continues, "Ideally, museums should be looted every fifty years and the collections returned to civilization."

55. Quoted in Douglas Crimp, "On the Museum's Ruins," in Hal Foster, ed., *The Anti-Aesthetic: Essays on Postmodern Culture* (Port Townsend, Wash.: Bay Press, 1983), 43.

56. Jean Dubuffet, "Author's Forewarning," in Jean Dubuffet and Mildred Glimcher, *Jean Dubuffet—Toward an Alternative Reality* (New York: Pace Publications and Abbeville Press, 1987), 33.

57. Cabanne, *Dialogues with Marcel Duchamp,* 67. As for the proposition that the disappearing "freshness" of a painting should be systematically forestalled through museum conservation practices, see the argument to the contrary made by Achille Bonito Oliva, "Respect the Body of Art and Not Its Corpse: A Modest Proposal to Bury the Artist along with His Works," in *Flash Art* 25 (Summer 1992): 140. Oliva asserted that we should respect the "real duration of what the artist has created."

a quarter-century ago and sustained ever since by the eminent French sociologist Pierre Bourdieu.[58] Although Bourdieu's principal target has been the continental European art museum and although Bourdieu himself acknowledges that the situation may be different elsewhere, there is no question but that his charges have at least some relevance to museums in this country as well as to those on the continent.

To Bourdieu, the art museum functions principally—and he takes this to be the case as well for other institutions of high culture, including the university—as a means by which the existing class structure is reproduced in each successive generation. "Art and cultural consumption," he wrote, "are predisposed, consciously and deliberately or not, to fulfill a social function of legitimating social differences."[59] They do so by providing occasions around which such notions as taste, inherent sensibility, and aesthetic discernment can be organized. In so doing, they participate in what Bourdieu termed the "consecration of the social order."

Bourdieu did not simply argue that works of art—independent of their intrinsic value—are susceptible to use by the dominant classes as a means to maintain their political and economic position. What he argued is that these works may not, in fact, have any fundamental value apart from such a use. What is designated to be art or not-art, what is judged to be good art or bad, may not even be matters of taste or habit. They might, instead, be wholly arbitrary. No more may be required for a work of art to be deemed of artistic quality than that a well-educated elite is able to agree that such a value ought be assigned to it. The critic Fredric Jameson has called this aspect of Bourdieu's work "one long implacable assault on the very rationalizations and self-justifications of culture itself."[60]

58. See particularly Bourdieu, Darbel, and Schnapper, *Love of Art*. Although this first English translation did not appear until 1990, the French text was first published by Les Editions de Minuit in 1969 and appears to have had a considerable influence with critics to whom it was accessible. See also Pierre Bourdieu, *Distinction: A Social Critique of the Judgment of Taste* (Cambridge, Mass.: Harvard University Press, 1984).

59. Bourdieu, *Distinction*, 7. See also Thomas Crow, "On the Public Function of Art," in Hal Foster, ed., *Discussions in Contemporary Culture: Number One* (Seattle: Bay Press, 1987), 4, in which Crow described the exclusion from the "republic of taste" of the "viewer who is unprepared by education or initiation in the protocols of high art to discover his centered self in an arrangement of pigment on canvas."

60. Fredric Jameson, "Hans Haacke and the Cultural Logic of Postmodernism," in Wallis, *Hans Haacke: Unfinished Business*, 44. For a speculative prognostication that something less than

For Bourdieu, in the end, the point of the art museum is neither to educate and preserve (as the museum itself would traditionally claim) nor to bestow value on the art it chooses to display (as its public might think to be the case). From his survey data identifying those who do and do not visit art museums and his investigations of how those who do visit such museums respond to their visits, he concluded with some combination of bitterness and irony that the "true function" of the museum in no way resembles what the museum claims it to be. Based on the effect that it actually produces on its visitors, the art museum's "true function," he said, is to "reinforce for some the feeling of belonging and for others the feeling of exclusion."[61]

It may be responded that Bourdieu's analysis is too reductive. The art museum is not so limited in its range of functions as he described it. Neither is the art that it exhibits. Although both may sometimes serve the purposes he proposed—nobody familiar with the American art museum can possibly deny that it may frequently serve as a site for snobbish display and social ambition—both the museum and its art can and do function in a variety of other and more important ways as well. Moreover, Bourdieu's proposition that the value to be found in art may be imputed rather than inherent need not necessarily be fatal to art's claims on public attention. The everyday life that each of us lives is laced throughout and around by any number of values that, when closely scrutinized, may prove to be nothing more than social constructs but that we nevertheless continue to find rewarding, sustaining, and even essential.

---

the entire edifice of art might one day suddenly fall apart, he confined himself to the issue of "modernism"—see the interview with "Jean Clair" (the pen name of the art historian Gérard Régnier) published under the title "How Vital Are Museums?" in *Art International* 10 (Spring 1990): 32–34. "The ruling dogma of modern art," he observed, "is nothing more than an intellectual postulation." Like any such postulation, however, "this whole dogma can collapse like a pack of cards. Its foundation is just a flimsy network of concepts. If you think of what has taken place in Eastern Europe and the Soviet Union you have a perfect example of how this can happen. Most modern art museums are built on the same kind of belief. All it takes is for someone to refute the dogma that Modernism begins with Cézanne and continues in a straight line to Beuys. This history of Modernism has no inherent meaning. In fact, it excludes many possible histories, not least of which is the one that sees Modernism as a blindfold which has cut us off from time and the rest of history."

61. Bourdieu, Darbel, and Schnapper, *Love of Art*, 112.

## III

Those, then, are but some—by no means all—of the criticisms, questions, and doubts that have been raised in recent decades to challenge the art museum. In just one generation, they have advanced from the periphery of critical opinion to become all but commonplaces of the center. Within another generation, they could well overwhelm the museum entirely.

Complicating the art museum's situation is a second and more insidious threat. In contrast to the relatively small group of critics who are hostile to the museum, the larger part of the American public thinks neither particularly well nor particularly badly about the museum but, rather, scarcely thinks about the museum at all. For this larger public, the art museum is neither a contested site nor the subject of controversy but simply a source of indifference, an institution increasingly irrelevant to its everyday life.[62] In formulating strategies to deal with its most hostile critics, the art museum would be well advised to address this question of relevance as well. A single-minded strategy that simply sought to refute each of its critics in turn would, even if wholly successful, fall far short of such a goal. Moreover, it is by no means clear that such a strategy could, in fact, be that successful. Although none of the many charges made against the art museum may prove to be wholly true, neither does any of them ring as entirely false.

Far better, perhaps, might be to seek to sidestep these various charges in such a manner that what seems valid in them might be acknowledged without thereby impairing either the vitality of the art museum or its future usefulness as an institution. Lawyers will at once recognize this as something akin to the entry of a demurrer, and so it is. How might the art museum say a thoughtful, responsive, and responsible "perhaps, but what of it?" to such charges, and then, albeit in some necessarily restructured way, go on about its business—

62. An October 1992 survey conducted for the National Cultural Alliance, an umbrella group for forty-one American arts organizations, found that only 31 percent of adults in the United States reported that the arts *in any form* played a major role in their lives (*The Washington Post*, February 17, 1993). This outcome appears consistent with Schuster's finding, in *The Audience for American Art Museums*, that 22 percent of adults had attended an art museum during a previous twelve-month period. For a remarkable study of "nonvisitors" to art museums, see *Insights: Museums, Visitors, Attitudes, Expectations: A Focus Group Experiment* (Los Angeles: Getty Center for Education in the Arts, 1991).

not just its business as usual but an amended, modified, and more broadly relevant business? How might we reconceive the art museum, an institution that appears today to rest on what has become a truly rickety foundation, in such a way that it can, first, survive the most damning of these charges and, second, underpin itself with a new and more considered set of premises that might better serve to shape its values, to extend its relevance, and to provide it with guidance for its future direction and growth?

Let me propose four elements that might be critical to any such reconception:

1. Beyond its publicly perceived role as a source of authority, the art museum can and should serve as a site of open discourse, of a discourse that may sometimes reach the level of contention and of a discourse that, if it is truly to be thorough, must extend beyond the museum's traditional subject matter, art and artists, to include a consideration of the museum itself.
2. There must be some rebalancing of the relative emphasis that the art museum gives to the aesthetic and the other-than-aesthetic aspects of the objects it displays so that there is some less exclusive focus on the aesthetic and some correspondingly greater recognition of the other-than-aesthetic.
3. In pursuit of the art museum's educational goal, the range of what is considered appropriate for display ought be expanded beyond those objects deemed to be meritorious works of art to include works of lesser merit or to include even objects whose visual interest may be other than purely aesthetic.
4. Most important, the traditional concept of the art museum as a temple in which to celebrate the human genius of the few must be expanded into a view of the art museum as a place in which to celebrate the human accomplishment of the many, a place where the visitor may come to gain a better appreciation of that uniquely human capacity for creative transformation, which, while so clearly embodied in the creation of works of fine art, is by no means confined to that activity alone. To accomplish this, works of art must be presented in all their fullness, *both* as aesthetic objects worthy of attention in their own right and, at the same time, as the work product of a uniquely human creative act.

To begin, then, with the museum's potential as a site for discourse: For it to be so, what is required, first, is something that is extraordinarily simple

but that still remains remarkably rare—that the museum's staff members be permitted to emerge from the institutional anonymity in which they have for too long and too often been cloaked. Wall labels, brochures, even catalogue entries ought be offered for what they are, individual opinions, not impersonal and institutional truths. It is long past the time when any art museum can honestly present itself to its public as a neutral, impersonal, and single-voiced conduit for the transmission of a body of knowledge that is at once universal, timeless, and homogenous.

The art museum should not fear to be seen for what it is: a sometimes turbulent workplace in which the not-always-unanimous judgments of its staff members are as time-bound, as culturally determined, and indeed, as potentially fallible as the judgments of its visitors. What is proposed is not the abdication of the museum's authority but rather the clarification—the making transparent—of the basis on which that authority might be asserted. When a museum directs a visitor's attention to a particular work of art, is it unreasonable for the visitor to know who it is that thinks the work worthy of his or her attention, and why?

The Field Museum of Natural History in Chicago offers an interesting example. There, each new exhibit is accompanied by pinned-up Polaroid snapshots of the curators, designers, and exhibit technicians who were responsible for the exhibition's script, assembly, and fabrication.[63] The message to visitors is clear. This exhibit did not fall from the sky, nor is it either the ultimate or the only view of its subject that this or any other museum might ever choose to offer. It is, rather, the view that we chose. And although that choice may be buttressed with arguments, seasoned by experience, and informed by extended study, it still is and must remain a fallible human choice. Feel free to question, discuss, or reject it, but we do hope that your curiosity will meanwhile be aroused and your interest spurred.[64]

63. Conversation, December 1992, with Michael Spock, then Vice President for Public Programs, Field Museum of Natural History.

64. In sharp contrast was the "anonymous-authority-with-a-human-face" approach that the Denver Museum of Natural History adopted when it opened its newly renovated Walter C. Mead Ecological Hall in August 1991. As part of an accompanying education program, the museum staff "conjured up a fictitious, world-class naturalist, artist, photographer, and writer specializing in Colorado ecology" to whom it gave the unisex name of C. Moore. As conceived by the staff, C. Moore was to be an "omniscient" but friendly guide who would help visitors to "see more" as they visited the exhibition. Although C. Moore (her- or himself) was never

Marcia Tucker of the New Museum in New York has urged a similar transparency for the art museum—not just in terms of its decision-making process but also in terms of its subject matter. Must knowledge, she asked, always be offered as single and settled, or does the museum better fulfill its self-proclaimed educational role by making it clear that there may ultimately be no objective base from which its educational pronouncements can be made? What museums "purport to disseminate," she wrote,

is not neutral; knowledge is not discovered, but is socially produced and reflective of the power relations of the society within which it is situated. It is therefore important to clarify the perspective from which knowledge is being presented and judgments made, and perhaps even offer alternative and conflicting knowledges and judgments as well.[65]

Professor Henry Louis Gates, Jr., of Harvard proposed to carry this approach one step farther. If there no longer exists a consensus to be taught about those matters with which the museum deals, he said, then so be it. Why not "teach the conflict" instead?[66] If the primary purpose of the museum is to be educational, then the full and fair exposure of conflicting views might well advance that goal far more effectively than if the museum were to continue

---

depicted, the staff did produce an introductory back-lit transparency of the naturalist's make-believe work-strewn desk and then, to accompany each of the Hall's eleven dioramas, larger-than-life-size pages from C. Moore's imaginary notebooks. These latter were intended to convey "first-person, informal observations about the ecological principles, species, and interactions" of which the visitor ought be aware. For a fuller description of this project, see Jennifer Dyer, "New Life for an Old Hall," *Curator* 35 (December 1992): 268–284.

65. Marcia Tucker, "'Who's on First?' Issues of Cultural Equity in Today's Museums," in Michaelyn Mitchell, ed., *Different Voices* (New York: Association of Art Museum Directors, 1992), 13. One of the earliest observers to propose the museum as an appropriate site for confrontation, interchange, and debate was the Canadian museologist Duncan Cameron in "The Museum: A Temple or the Forum," *Journal of World History* 14 (1972): 189–202. Cameron envisioned this as in addition to, not instead of, the museum's more traditional functions.

66. Henry Louis Gates, Jr., "The Transforming of the American Mind," in Mitchell, *Different Voices*, 83. For example, the British-based American historian David Lowenthal is quoted as having suggested that "the British Museum could mount an exhibition on the Elgin Marbles which showed the different sides to the argument about restoring them to Greece rather than censoring all mention of the subject." Robert Lumley, "Introduction," in Robert Lumley, ed., *The Museum Time Machine: Putting Cultures on Display* (London: Routledge, 1988), 13.

to pretend—as so many American art museums still do—that there are universal, timeless, and consistent values through which all works of fine art can be judged and understood. Some may still think so. Others disagree. To acknowledge that these values are not beyond discussion could enhance, not diminish, the museum's utility. Rather than continuing to stumble on as a site of increasingly dubious authority, the art museum might assume a reconceived role as a place of open and potentially useful discourse.

A similar approach was recently suggested in the widely circulated report of the American Association of Museums, *Excellence and Equity: Education and the Public Dimension of Museums.*[67] Urging that museums cultivate and express "a variety of cultural perspectives in the presentation and interpretation of their collections," the report continues:

Divergent points of view as well as different cultural perspectives can be given voice in the interpretive process. Fearing that the neutrality of the institution might be compromised, many museums are reluctant to present informed but differing viewpoints. Yet debate, even controversy, is integral to the scholarly endeavor, and it can stimulate a balanced interpretive message that can challenge the visitor to discover ideas and form opinions.[68]

Scarcely needing to be added is that such a reconceived museum—a museum in which one of the desired outcomes of a museum visit is that the visitor should discover ideas and form opinions—would be at a very far remove from its eighteenth-century predecessor, the museum envisioned as a place to which that visitor might instead come to "admire artists as the highest among mortals."[69] To take but the simplest example, it might instead be a place to which the visitor could come to learn the openly taught lesson that not every artist may be considered admirable, that there are artists who are admired by some but not by all, and that, even in the case of a universally admired artist, an artist may sometimes have had a bad day, bad year, or bad decade or, worse still, may have had a career that went straight downhill from start to finish.[70]

67. *Excellence and Equity.*

68. Ibid.

69. Danto, *Beyond the Brillo Box.*

70. One impediment to accomplishing anything even this simple is the prevailing art museum practice of assembling special exhibitions through short-term loans from private

Concerning the rebalancing of the relative emphasis that the art museum has traditionally given to the aesthetic and to the other-than-aesthetic aspects of the objects it displays, it is in no way proposed that aesthetic considerations be discarded entirely or even subordinated to some other single aspect of these objects. Least of all is it proposed that they be subordinated to political considerations. What is proposed, rather, is that aesthetic claims be put in perspective, that the very notion of a primarily aesthetic viewpoint toward works of art be understood to be in itself still another social construct and one of relatively recent origin and some geographic specificity.

What is required, for example, is that we be careful not to homogenize and present to the public as examples of a single class of objects a sixteenth-century portrait first made and used as an instrument of statecraft and a twentieth-century color-field painting conceived in the very hope that it might some day be hung in a museum.[71] To treat these as somehow alike—both consisting of painted marks on a flat rectangular surface, and both susceptible to a common standard of evaluation—would be, in almost every sense, truly remarkable. Yet, the art museum does it all the time.

What is it that drives the art museum to maintain so predominantly aesthetic a focus? Is it really the case that all paintings, no matter when made, belong to a single tradition? Or might it be the fear, as one critic has suggested, that—without such an overarching concept—the art museum, or for that matter any museum, would simply dissolve into a pointless collection of "bric-a-brac"? Museums, he said,

---

collectors and/or other institutions. In this circumstance, any real candor, in either the exhibition labels or accompanying catalogues, becomes virtually impossible. To put such borrowed works of art in other than a good critical light would be to jeopardize a museum's ability to obtain future loans. Likewise, a museum may find it difficult to use publicly derived funds to acquire what are generally conceded to be inferior works of art. Better positioned to mount such instructive exhibitions are those museums that have inherited large heterogenous collections of works of art that can be openly acknowledged to be of uneven quality. For a general discussion of the constraints on honesty in the art museum, see Stephen E. Weil, "Toward Greater Museum Integrity ('The Snodgrass Sermon')," in *Beauty and the Beasts* (Washington, D.C.: Smithsonian Institution Press, 1983), 56–68.

71. See Donald Kuspit, "The Magic Kingdom of the Museum," *Artforum* 30 (April 1992): 58. ("Every artwork . . . is produced with an eye to the imaginary, ideal audience of posterity. This fantasy audience is necessarily the museum audience, for it is here that art will live after the artist's death.")

are taken to exist only inasmuch as they can erase the heterogeneity of the objects displayed in their cases, and it is only the hypothesis of the possibility of homogenizing the diversity of various artifacts which makes them possible in the first place.[72]

Going on to term this hypothesis of possible homogenization as a fiction, he continued: "Should the fiction disappear, there is nothing left but . . . a heap of meaningless and valueless fragments."[73]

In fact, the art museum can no more be wholly homogenous than it can be wholly neutral. Far better than to try to make it so—than to insist that its enormously varied holdings are all manifestations of a single aesthetic impulse—would be to embrace the rich possibilities for exploration that every work of art can offer beyond the aesthetic. The mere statement that a particular work is "something once made by somebody" in itself opens a host of inquiries: Looking at it from simply the time of its creation, we might ask: How was it made? Out of what material? By whom? Under what circumstances? With what intention? Under what constraints? At whose behest? For what occasion? What was the relationship between the artist and the patron? When was it made, and how does it relate to other objects that were made at or about the same time? Where was it made, and how does it relate to other objects that were made in or about the same place? How does it relate to other objects made by the same artist? For the same patron? For the same purpose? Does it relate as well to such nonvisual phenomena as the music, literature, folklore, or philosophy of that particular time and place? What does it depict? How does it relate to other depictions of that same subject? How was it paid for? Where did the money come from? How was it received? How was it understood?

Nor need we stop there. Moving into the interval that separates the time of the work's creation from our own, we might further ask: When so much else was lost, how did this object come to be preserved? By whom? What physical changes did it undergo and when? What successive changes have occurred in the ways it was understood? In the ways it was appreciated? In

72. Eugenio Donato, "The Museum Furnace: Notes toward a Contextual Reading of *Bouvard and Pécuchet*," in Josué V. Harari, ed., *Textual Strategies: Perspectives in Post-Structuralist Criticism* (Ithaca, N.Y.: Cornell University Press, 1979), 221.

73. Ibid., 223.

how it was valued? What impact, if any, did it have on the creation of other works of art? What impact did its creation have on its own creator's subsequent career and development?

Finally, as we come down to the present moment, we can ask how the object appears to us now. Do we find it meaningful? Does that meaning emanate from the work, or is it a projection of our own personalities?[74] Do we react affectively as well? In what way? Can we explain why? What has the work lost or gained by removal from its original context? What has it lost or gained by its recontexualization in a museum? How should it be further preserved? And neither last nor least, how might we judge it aesthetically? On a scale of aesthetic merit from poor to indifferent to good, where might we place it, and why?

Although some of these questions may primarily address the context from which the object first came and might thus be thought more suitable to the university than the museum, most of them hew closely to the particularity of the object. And although many of these questions may be explored in exhibition catalogues or relevant scholarly publications, those are generally seen by only a small fraction of the museum's visitors. The means must be found, whether through interactive video or other emerging technologies, to bring these questions into the galleries themselves where the insights they offer can be made accessible to the more general visitor.

In doing so, the museum must still take care that the object itself does not drown in its surrounding information, that it retain its particularity. In a talk given in 1992 at the Smithsonian, Kirk Varnedoe, Alfred Barr's successor at the Museum of Modern Art, referred to that particularity as a "window" into

74. Concerning the complexity of this question of "meaning," see Edwina Taborsky, "The Discursive Object," in Pearce, *Objects of Knowledge*. Taborsky wrote on page 69:

> The analytic frame which determined the nature of museums for many years has been based on a belief in the uniqueness of the individual and the object, and on their separation from each other in time and space. This analysis decided that meaning is a separate unit, a message, which moves, intact, between spatio-temporal sites. Therefore, it rested in the object and was meant to move intact to the observer in the museum.
>
> Modern analysis of cognitive action is saying that this is not how meaning arises, by a straight path from site to site. The meaning of the object only becomes existent in an interaction between observer and object.

See also Charles Saumarez Smith, "Museums, Artefacts and Meanings," in Peter Vergo, ed., *The New Museology* (London: Reaktion Books, 1989).

the world from which a specific work of art originated. As such, he said, it allows us to look into that world with a kind of clarity that we can never find through such abstracted forms of knowledge as sociology or demography where the pungency and distinctiveness of such particularity might inevitably be buried within an aggregation of samples.

"That sense of the role of art," he said, "not to satisfy the urge to complacent abstraction but to constantly confound it, to bring us back to the particular in all of its difficulties, is one of the things I most value about dealing with objects."[75]

To deal thusly with an object, however, to permit it to function to its fullest as, in Varnedoe's term, a *window*—or, to use an alternate term, as a *prism*—the art museum must encourage an inquiry that, while incorporating questions of aesthetics, is not so largely limited to such questions. As noted earlier, viewed from within, the art museum considers education to be one of its principal roles. It pursues that role through the interpretation of objects.[76] Such interpretation will only be at its richest and most resonant when it enables the visitor to have a maximally expansive encounter with the objects that the museum displays. What is here proposed toward that end is, again, not a revolution but a rebalancing.

Should the art museum confine itself to the display of works of art deemed to be of the highest aesthetic merit? More broadly, should it confine itself to

75. A transcript appears in *Ideas and Objects: Toward a Definition of Museum Scholarship,* the report of a joint meeting of The Smithsonian Forum on Material Culture and The Smithsonian History Roundtable, February 26, 1992, 2–3.

76. For an excellent discussion of the complexities inherent in museum interpretation generally, see Saumarez Smith, "Museums, Artefacts and Meanings," in Vergo, *New Museology.* Concerning such interpretation, Smith said:

> It becomes clear that this is a highly fluid and complex activity, which is not susceptible to straightforward definition: that visitors bring a multiplicity of different attitudes and expectations and experiences to the reading of an artefact, so that their comprehension of it is individualised; that curators equally have a particular and personal representation of historical and aesthetic significance; that artefacts do not exist in a space of their own, transmitting meaning to the spectator, but, on the contrary, are susceptible to a multi-form construction of meaning which is dependent on the design, the context of other objects, the visual and historical representation, the whole environment; that artefacts can change their meaning not just over the years as different historiographical and insti-tutional currents pick them out and transform their significance, but from day to day as different people view them and subject them to their own interpretation.

the display of what are deemed to be works of art, regardless of their merit? Those questions cannot be answered without first inquiring into just what it is that the museum, in its educational role, is envisioned as educating its visitors about. If, for example, its principal subject matter is assumed to be artistic connoisseurship, perhaps it *can* best do that job—in the words of Alfred Barr—through "the conscientious, continuous, resolute, distinction of quality from mediocrity."[77] The museum so conceived might elect to display only what it deemed to be works of art of the highest quality. It might aspire to present nothing less than a parade of masterpieces. Likewise, if art history rather than connoisseurship were to be regarded as the museum's principal subject, then such a choice might suggest a boundary line that at least limited what the museum displayed to what were still deemed to be works of fine art, questions of merit aside.

There is, however—and most particularly for the museum that seeks to make itself relevant to more than that minority of potential visitors who are already interested in the visual arts—a third possibility. That is the notion that, regardless of its original or even recent intentions, one of the most important kinds of education that the art museum can and actually does provide is concerned with visual communication. In an art museum thus conceived, works of fine art would not necessarily exhaust the range of objects that the museum might find it useful to display.

To justify such an educational role for the art museum, agreement might be necessary on three underlying premises: first, that visual communication is a domain separate and apart from verbal communication and independently

77. Barr, *Painting and Sculpture*. It might also be plausibly argued to the contrary (i.e., that one of the best ways to make "quality" apparent is by contrasting works of art deemed to embody it with works of art that are deemed to lack it). How might one recognize an artist's successful work without knowing what his or her failed work looked like? David Hume's 1757 dissertation *Of the Standard of Taste* is to the point. "By comparison alone," he said, "we fix the epithets of praise or blame, and learn how to assign the due degree of each." Reprinted in George Dickie, Richard Sclafani, and Ronald Roblin, eds., *Aesthetics: A Critical Anthology*, 2nd ed. (New York: St. Martin's Press, 1989), 248. One of the few public instances of deliberately collecting what were considered "insignificant," "second-rate," or "immature" examples of an artist's work was Dr. Albert C. Barnes's activity in amassing the enormous collection of paintings by Pierre Renoir now in the Barnes Foundation. These were acquired in an effort to assemble a complete record of the artist's career and development. See Howard Greenfeld, *The Devil and Dr. Barnes: Portrait of an American Art Collector* (New York: Penguin Books, 1989), 178.

important; second, that visual communication skills are not innate but need to be learned; and third, that the art museum might be a site where such learning could usefully occur.

That the visual is, for those who are sighted, the most densely textured of all their sensory experiences is too evident to require elaboration here. The number, complexity, overlap, and variety of the elements that fall within our visual field during almost every waking moment—indeed, the intricate detail of many of the individual specimens or objects on which we regularly focus our attention—all but defy the possibility of any comprehensible verbal description. Without the ability both to capture and to comprehend aspects of the visual experience in some pictorial form, we have little or no ability to preserve or share it with one another in any meaningful or useful way.

William M. Ivins, for example, described the inability of the Greeks and Romans to develop a science of botany because they had no practical way to reproduce reliable images that would give intelligibility to their attempted verbal descriptions of the various plants they studied.[78] Likewise, he asked, could the industrial revolution have proceeded as it did unless the printed words that described its techniques and technologies had been accompanied by "adequate demonstrative pictures"?[79] Could one, for example, even begin to imagine how (at least in the precomputer world) a great cargo vessel could have been built without plans or blueprints or, once built, how it could have safely sailed away without any charts or maps? To have attempted to describe a rocky coastline through words alone might have required more space than the cargo itself.

Such examples, however, by no means exhaust the domain of the visual. Past the petunia, the complicated machine part or the coast of Peru—things that might only be extraordinarily difficult to describe—lie those things to which it may be truly impossible to describe. In his biography of Ludwig Wittgenstein, Ray Monk described the evolution of Wittgenstein's notion that there is ultimately a limit to what can be expressed through language. Beyond that limit, "at a point where explanations are superfluous," lie things that

---

78. William M. Ivins, Jr., *Prints and Visual Communication* (Cambridge, Mass.: Harvard University Press, 1953), 14, 15.

79. Ibid., 17.

cannot be said but only demonstrated or shown.[80] Certain relationships are among these, including—not least—many of those that we find in the arts. The category of the demonstrable but verbally undescribable must as surely include the effect of a pale orange form placed next to a light blue one as it does the sound of a harp and flute played simultaneously. To be without the ability to comprehend the visual—the ability to see those things that can only be shown, not said—is to be without access to the fullest richness that human life can offer.

Might not, however, such a visual ability be innate? Our experience suggests the contrary. Whatever our profession or hobby—whether the practice of medicine or of carpentry, whether watching baseball or watching ballet—we have all had the experience that, at such a concentrated level, we only begin to perceive important visual details after repeated exposure to the subject matter. Subtleties that might easily escape our attention on first sight only become clear as we develop expertise. Might not the case be similar for our visual sensitivity at a more generalized level. Many think so. As one commentator said,

We are not born with a knowledge of how to see, any more than we are born with a knowledge of how to speak English. We are born only with the ability to learn how to speak English. We are born also with an ability to learn how to see. We learn about English through training and study, but only rarely do we go through this same learning process, at home or at school, with the visual. . . . Without this learning process in speaking, we would make only unintelligible noises, and would lack any ability to communicate orally. Our ability to communicate visually is equally affected by any neglect of training or study. . . . Seeing is an act that occurs only with effort . . . [it] is not simply a matter of opening our eyes wider. We must think about what meets our eyes. The eye and the mind must both work together if we are to see.[81]

---

80. Ray Monk, *Ludwig Wittgenstein: The Duty of Genius* (New York: Penguin Books, 1991), 164, 302.

81. Bates Lowry, *The Visual Experience: An Introduction to Art* (Englewood Cliffs, N.J.: Prentice Hall, Inc., 1961), 13, 14. Among those most active in urging that it is the schools that should properly take the lead in providing such visual training has been the Getty Center for Education in the Arts, which proposes a discipline-based art education that would include elements of art criticism, aesthetics, art history, and art production. For examples of the kind of curricula that such an approach might generate, see Kay Alexander and Michael Day, eds.,

That the art museum, if it so chooses, can serve as a site for such learning is abundantly clear. In an address given at the joint meeting of the Canadian Museum Association and the American Association of Museums in Boston in 1980, the Harvard philosopher Nelson Goodman argued eloquently that it should so choose. The museum, he said, ought to function "as an institution for the prevention and cure of blindness." The works of art in such a museum contribute to that function when

by stimulating inquisitive looking, sharpening perception, raising visual intelligence, widening perspectives, bringing out new connections and contrasts, and marking off neglected significant kinds, they participate in the organization and re-organization of experience, and thus in the making and remaking of our worlds. . . . Works [of art] work when they inform vision; *inform* not by supplying information but by *forming* or *re-*forming or *trans*forming vision; vision not as confined to ocular perception but as understanding in general.[82]

What must be added, however, is this: If a museum *is* to treat visual communication as one of its primary educational goals, then the choice of what it displays in its galleries cannot be determined solely by a stringent aesthetic standard. It must in some instances be determined instead by what can best contribute toward that educational goal.[83] Likewise, to the extent that such an educational objective is deemed integral to the museum's long-range mission, it should be a factor in forming the museum's collection and may dictate certain inclusions that fall outside the traditional boundaries of art museum collecting.

---

*Discipline-Based Art Education: A Curriculum Sampler* (Los Angeles: The Getty Center for Education in the Arts, 1991). For a recent report on the art education research project (Project Zero) at the Harvard Graduate School of Education, see Jessica Davis and Howard Gardner, "Open Windows, Open Doors," *Museum News* 72 (January–February 1993): 34.

82. Reprinted in the collection *Of Mind and Other Matters* (Cambridge, Mass.: Harvard University Press, 1984), 179, 180.

83. John Cotton Dana, conceivably this country's greatest museum iconoclast, foresaw exactly this tension between educational utility and connoisseurship in his 1917 pamphlet *The New Museum,* an edited reprint of which appeared in *The Museologist* 51 (Winter 1988): 5–16. In Dana's ideal museum, which he called "An Institute of Visual Instruction," the unique and costly were to be shunned in favor of the practical. ("A scrap of printed cotton, accompanied by proper text, pictures, charts and suitably related objects, can throw more light, on the subject of textiles, for ninety-nine out of one hundred visitors, than can long rows of examples of the finest 'museum specimens' of old and rare fabrics.")

The fourth and final element critical to this reconception of the art museum might also be the most important of all in seeking to extend the art museum's relevance. It involves an expansion of the museum's scope beyond its traditional focus on the artistic production of a small group of uniquely talented individuals so that, first, it concentrates as much on the process of artistic creation as it does on the product generated by that process and, second, it considers this process of artistic creation as exemplary or paradigmatic of a widely practiced human activity and not merely as an activity uniquely characteristic of that same small group.

To treat a work of art as having this double aspect—as at once a physical phenomenon in itself and the outcome of a creative process—has several important implications.[84] For one thing, it might provide us with a useful supplement to that currently debatable term *quality*. Together with quality—a measure of the hypothetical aesthetic excellence that the work, treated as a physical phenomenon, might or might not be said to contain—this supplementary measure of value might be designated "artistry," a measure of the mental and physical abilities that were concentrated in the work's conception and execution. Parallel as these two measures of value may appear to be, they, in fact, are very different.

Quality, however little or much it might mean in describing the work itself, tells us nothing about the degree of imagination that went into its creation. In theory, a perfect copy should have every bit as much quality as the work of art from which it was copied. Neither does the notion of quality tell us very much about the constraints under which the artist created the work, about what precedents might have been at hand and the degree to which these were followed, ignored, or transformed, about what other choices were available

84. See Lowry, *Visual Experience,* 260. ("We have become conscious of the work of art as an accomplishment of its artist as well as an object to be experienced in its own right.") See also Denis Dutton, "Art Crimes," in Denis Dutton, ed., *The Forger's Art: Forgery and the Philosophy of Art* (Berkeley and Los Angeles: University of California Press, 1983), 175, 176. Tracing the idea back to John Dewey, Dutton argued that our perception of a work of art is always connected with our knowledge that it has a human origin, that it is the result of a human agency. He likened the creation of such a work to a performance. "As performances, works of art represent the ways in which artists solve problems, overcome obstacles, make do with available materials." What deprives the copy or forgery of value is not any lack of formal qualities but the threadbare level of the performance that produced it when compared with the performance through which the original was created.

and how the artist responded to these, or about the difficulties or advantages the artist had in working the material chosen for the work's execution. Neither does it clarify that the work has even met the initial test for its admission into the art museum, that it is a human product. An untreated piece of driftwood, no matter what its aesthetic quality, could never qualify for such admission.

Artistry, by contrast, not only includes these considerations but links the creation of works of art to the daily activities of the museum visitor. Artistry is a way in which most people can think about the grace, skill, persistence, and resourcefulness with which they themselves aspire to perform those daily activities. Artistry can relate to how they recall accomplishing some of those things already done of which they remain proudest. To cast a work of art in terms of artistry is to transform it from something wholly mysterious and apart, an exotic object that can only be judged by experts through the mysterious lens and language of quality, into something that relates more immediately to the visitor's own everyday activities and experience.

Robert Nozick envisioned an even more striking consequence. By looking through a work of art to consider the manner of its creation, the museum visitor is brought into contact with the creative process. This is a fundamental mode of human activity that is as much a part of the visitor's own life as it is of the artist's, an activity that is significant in itself and independently from the work of art in which it results. What gives it such significance is Nozick's view that the artist, in "shaping and crafting an artistic work" is simultaneously reshaping and integrating aspects of the self. It then follows that, in looking "through" the work of art to consider the manner of its creation, the museum visitor will also confront the possibility of "articulating and transforming" his or her *own* life and self.[85] Nozick continued:

---

85. Robert Nozick, *The Examined Life* (New York: Simon & Schuster, 1989), 39. Much to the same point is John Dewey's description of the creative artistic act as uniting "in one concurrent fact that unfolding of the inner life and the ordered development of material conditions." Quoted by Dennie Palmer Wolf and Mary Burger in "More than Minor Disturbances: The Place of the Arts in American Education," in Stephen Benedict, ed., *Public Money and the Muse: Essays on Government Funding for the Arts* (New York: W. W. Norton & Co., 1991), 128.

Creativity itself is important . . . because the personal meaning of such creative ac-
tivity is self-transformation in the fullest sense, transformation of the self and also
transformation *by* the self. The process of artistic creation stands for our own
autonomous recuperative and transformative powers. . . . Done creatively, the ar-
tistic product represents a more whole self we can get to under our own powers
of enlargement and repair.[86]

With that notion, we have in a sense come full circle. Just as a "missionary
desire to uplift" its visitors was fundamental to the original concept of the
American art museum, so too does the visitor remain central to this vision of
how that museum might be reconceived. What is wholly different is what we
might expect from the works of art and possibly other objects that would fill
this reconceived museum. No longer viewed as a potential means of moral
improvement, no longer necessarily valued as universal, timeless, and harmo-
niously connected to a single standard of aesthetic quality, no longer perceived
solely as unique and self-contained formal exercises capable of providing
pleasure to the initiated, these works of art might nonetheless play a powerful
role—perhaps all the more powerful a role for being shed of so much
baggage—in teaching vital things to the museum's visitors about both the
world they live in and the selves through which they live in that world.
Properly used, these works of art—displaced as objects of reverence—can
make the museum an extraordinarily important site for learning.

Whereas Goethe once spoke of the museum as "consecrated to the holy
ends of art," this reconceived art museum would be consecrated to the
no-less-noble end of developing the human potential of its visitors. Whereas
Tieck and Wackenroder saw the museum as a place where "one may admire
artists as the highest among mortals," this reconceived art museum would be
a place not primarily of admiration but of stimulation, a place in which what
was sought to be developed to its highest was the abilities and insights of its
visitors. Whereas Saint Simon sought to empower artists to lead humanity,
this reconceived art museum would seek to enrich its visitors and empower
them to lead themselves.

This reconceived art museum—more modest in its claims, perhaps, than
its eighteenth- and nineteenth-century ancestor, certainly more flexible, and

86. Nozick, *Examined Life,* 39.

one can hope, clearly more relevant to a larger and more diverse public—does not yet exist, although bits and pieces can increasingly be found in one institution or another. It may well take another generation or more before it emerges in a wholly recognizable form. As a vision, though, it seems compelling. The premises on which it rests should prove themselves to be solid, humane, and resistant to those questioning forces that have by now all but blown away the foundations on which its predecessor for so long rested. Thus reconceived, a brighter future may still await the American art museum.

❈ ❈ ❈

# CONCERNING

❈ ❈ ❈

# COLLECTING,

❈ ❈ ❈

# COLLECTORS,

❈ ❈ ❈

# AND COLLECTIONS

❈ ❈ ❈

# 9

# THE GREAT AND RENOWNED
# KELLY SOCK COLLECTION:
# A FABLE

Kelly had never seriously considered becoming a collector. Not that he lacked for exemplars. Many of his second-grade classmates had collections of this or that, skate keys or comic books, rag dolls or marbles. To Kelly, though—a preternaturally wise, widely read, and distinctly spiritual child—there seemed something coarse in so intense a concentration on material objects. His own preference was to spend his afternoons alone in his room, contemplating the great thoughts that had already been thought by others and considering how he might best add a few original ones of his own. Was not that, he sometimes wondered, precisely what Wordsworth had meant by "the bliss of solitude"?

It was on just such a rainy, spring afternoon when he was thinking about some of the more offhand writings of Walter Benjamin that an event occurred that was to change Kelly's attitude profoundly. He accidentally overturned the bureau drawer that held all his socks and several other things besides. Standing in the midst of the resulting jumble, he was struck by the aptness with which Benjamin had written about the all-but-equally jumbled agglomeration of books that had once constituted his library. "For what else," Benjamin had asked himself, "is this collection but a disorder to which habit has accommodated itself to such an extent it can be seen as order?"

What actually made a diverse group of things into a collection, Benjamin seemed to be saying, was not any thing-in-itselfness but a specific outside viewpoint, a particular way to look at what was in any case already there. It was more a matter of concept than of percept. But why, then, he wondered, had Benjamin been so passive (albeit it did seem annoyingly characteristic of the man) as to postpone the ordering of disorder until habit could exert its influence. Might not a sure, firm act of the will have been all the swifter and more certain? If so, then dizzying possibilities abounded. Might it not be, for example, that he, Kelly, could by a simple imaginative act, by nothing more than his own fecundity of mind, transform himself from an ordinary child on a wet drab afternoon into Kelly the Collector, Sole Proprietor of the Great and Renowned Kelly Sock Collection?

His reverie was interrupted by the sound of rain spatting against the window. Glancing up, he could see it beating down the spring flowers in his mother's garden. He remembered poetry. He thought again of Wordsworth, this time drifting lonely as a cloud, straying across some daffodils all clumped in a crowd. Clouds and crowds. Was that simply a convenient rhyme, or might there be some deeper connection? Might not clouds, for instance, be something like Benjamin's library: a temporary agglomeration (water droplets; books. Did it matter which?) that we have through habit accustomed ourselves to perceive as an order. Might not a cloud (like a collection) be a seemingly solid metaphor for things that were actually in only transient conjunction? Did that make a cloud (or a collection) any the less real because it was a relationship and not a thing? Clouds do provide genuine shade, he thought, and they do drop the truly wet rain he could hear pelting outside.

He chuckled ruefully. Despite his quest for originality, the thought he was thinking seemed to come straight out of William James. "*Tant pis,*" he mumbled, and pressed on. A relationship might be just as real as what it related. But what, then, of crowds? Were not those still another kind of temporary togetherness, something else that could form or disperse without the addition or removal of one more constituent element (this time human beings) than had been there to begin with? The crowd was nothing but a concept, yet its power still was awesome. It could raise kings and topple kingdoms. For all that, though, it still seemed to Kelly that crowds (and even clouds, and certainly Benjamin's library) smacked too much of happenstance, of afterthought. In none of them was there the glorious deliberation and intention-

ality that might undergird a collection. Missing was that engendering lightning bolt of the will that could summon being out of the void.

He was resolved. The Great and Renowned Kelly Sock Collection would happen. He and he alone would conceive it into being, establish its boundaries (meaning nothing more drastic in this instance than setting aside two pairs of mittens and a set of fuzzy blue earmuffs) and promulgate the rules by which to describe and arrange its contents. Kelly the Collector would bring order out of the disorder that now lay sprawled on the floor around his feet. Deity stirred within him.

No sooner had he so resolved, though, than there came a painful realization. He would have to make a choice. What kind of a collection should it be? In the different museums to which he had gone with his family he had seen all different kinds of collections, and he was not quite sure in which kind sixteen pairs of socks plus three odd ones (red, white, and green) would properly fit. Were there rules? Or, like Wordsworth floating lonely as a cloud—that sounded, he thought, like a lively sort of loneliness and not a lonesome one—was he free to float to wherever place his fancy might guide him? Were there limits to the possible of a collection?

How might, for instance, the Great and Renowned Kelly Sock Collection be organized on historical principles? One way, he thought, might be to classify his socks by their respective sources—gifts from his grandmother, gifts from his Great Aunt Doris, gifts from his parents, and so on. That seemed to him quite elegantly aristocratic, given its distinct emphasis on the origins of things, on where they initially came from. Or was that somehow snobbish? Alternately, but still in an historical mode, he might ignore such source data and emphasize instead how these socks had actually been used—which pairs he wore to school, which pairs were reserved to be worn as good on Sunday, and which one (a green) still had a faint blood stain from the recent time he cut his foot on some glass.

Perhaps, though, that was still too personal a way to organize his collection. Perhaps the art museum might offer a better paradigm. The aesthetic dimension of things had always appealed to him. What might matter most is not where these socks came from or how he used them, he thought, but the way they look. Organized as an art collection, they would offer limitless opportunities for connoisseurship, for what he recalled Alfred Barr once describing as "the conscientious, continuous, resolute distinction of quality from medi-

ocrity." Even now he was able to envision the delicious afternoons that might be spent (again, "the bliss of solitude") in the rapt comparison of one sock with another (perhaps its very pair), long afternoons of trying to construct a canonical scale by which the aesthetic perfection of all socks might ultimately be judged.

How, he wondered, might his socks be best displayed in such an art context. Some taxonomy would no doubt be necessary. But on what visual characteristics ought such a system be built? Shape and size at first seemed like possibilities until he realized that what he mostly had (in fact, entirely) was anklets. No, he thought, color and texture would be the more productive ways to go, with color considered above all. He would let the rainbow be his guide. To classify and show the Great and Renowned Kelly Sock Collection in its spectral order (with smooth examples always preceding the nubby ones) might make an especially gracious gesture toward nature.

The thought of nature, though, unexpectedly sent him off in still another direction. Socks were not natural. They do not grow on trees. Animals did not wear them. Socks were distinctly human in origin. Should the Collection be organized in another way entirely? Why had humans contrived to invent such a form of underwear for their feet? Was it for their feet's sake, or was it to protect their shoes from noxious secretions? Moreover, how were socks made? Of what? In what quantities? In what places? Since when? By whom? What significance was there to the union label on the dark blue all-cotton-with-ny-lon-reinforced-toe-and-heel specimen near the top of the heap? Where did socks go when you outgrew them? For one flashing moment, he had the vision that socks might be more constant than sovereigns, that the durability of their underlying form and function might be more fundamental than any dynasty or ideology or even religion. To tell that larger story (it smacked nicely, he thought, of Braudel) might truly be the most worthwhile focus for the Great and Renowned Kelly Sock Collection.

He paused and thought with exhilaration of what he was doing. In willing himself to be Kelly the Collector, he had also made himself into a sort of god, an Apollonian god, the god (in Nietzsche's rich phrase) of "individuation and just boundaries." Where once there had been only a helter-skelter pile of socks on the floor, he had—without once stirring beyond his own room—found the means within himself to create an infinity of bounded orders and to introduce within those orders any number of indices through which hierar-

chies of excellence might henceforth be established. To be a collector was to make a world.

His mother was calling him for supper. Without hesitation (although it did occur to him that his abruptness might suggest a welcome touch of the Dionysian to balance his normal tilt toward the Apollonian), he swept what had so recently been the Great and Renowned Kelly Sock Collection off the floor, dumped it back into his bureau drawer, and smartly slammed it shut. What the gods create, the gods may also destroy.

Tomorrow? If the rain stopped, he was supposed to go hiking with his class. If not, then perhaps he would try to recall some of the wonderful thoughts that he had thought today. Yes, that was it. He could gather his thoughts. Collecting had turned out to be a far more cerebral kind of fun than he had ever before imagined.

# COLLECTING A PRIVATE ART COLLECTOR: IN SEARCH OF THE IDEAL

Private art collectors are as varied as the works of art they collect. They range in skill from the frankly awkward to the most delicately discerning. In purpose, they span the gamut from those in pursuit of notoriety or financial gain to those who are motivated by a most honorable, disinterested connoisseurship. The activity that commonly engages them is neither single-minded nor simple. It is, rather, an impulse well described by Francis Henry Taylor as "a complex and irrepressible expression of the inner individual, a sort of devil of which great personalities are frequently possessed."[1]

Suppose, however, that rather than simply observe these private art collectors in action we choose to assemble a collection of them. Would we settle for a representative sampling, or (as good collectors ourselves) would we try to focus our collection around an ideal type? And, if the latter should be our choice, how in all the enormous diversity of such collectors could we identify

1. Francis Henry Taylor, *The Taste of Angels: A History of Collecting from Ramses to Napoleon* (Boston: Little, Brown & Co., 1948), ix.

First published in *Asian Art* 4 (Fall 1991): 2–7, where it served as the introduction to an issue devoted to collecting and collections. Reprinted with permission from Oxford University Press.

that type? What follows is a personal checklist (others may have their own) of the principal attributes that one might hope to find in such a specimen.

To start, this ideal collector must be adventuresome, independent, energetic, imaginative, and knowledgeable. Of taste I do not write, because taste, as has been well recognized since Roman times, transcends all disputing. Beyond these attributes, he (who may just as likely be a she) must be prepared—wisely and in a manner commensurate with personal circumstance—to commit the resources necessary (money, but more too than just money) to acquire and appropriately care for a collection. He must also be scrupulously observant of ethical norms in the acquisition of that collection, and he must clearly understand that his stewardship of it is only temporary. Above all, he must derive his pleasure in collecting predominately from that activity itself and not from whatever status or profit it might incidentally provide him.

Of these qualities, adventuresomeness might be the least problematic. Because most works of art are unique, the private art collector has little alternative but to take repeated risks. The stamp or beer can collector can collect exactly the same things that somebody else is collecting already. The art collector cannot. Genuine independence, though, requires more. It requires that, so far as humanly possible, the collector have the courage to slip out of prevailing fashions and explore what might otherwise be neglected (or even rejected). It is at this point that the need for energy comes into play. The neglected (or even the rejected) is rarely underfoot. It must often be ferreted out. For many collectors, it is here that the fun (yes, fun—a perfectly acceptable by-product of so elevated an activity) may truly begin.

Just as each work of art is unique, so there will come opportunities in the assembly of a collection when the works it contains can be juxtaposed as never before. It is here that imagination has its widest scope. Immutable in themselves, works of art can be connected to one another in an infinity of networks. Stamps must be affixed to their appointed pages in an album, but art collecting is gloriously without rules. A carved jade dragon, for example, might well be combined with other depictions (drawn, painted) of a dragon. It might, however, be combined just as well with carved jades of other subjects, with other objects of the same general color, contour, scale, or feeling, or with other objects from the same time period or the same geographic region. Even the visual artist, constrained by the very physicality of material, does not have the vast imaginative freedom of the private collector.

Of all the ideal collector's attributes, though, it is knowledge that plays the pivotal role. Knowledge is both the critical input and the critical output in the formation and enjoyment of a collection. In an article about the pleasures of collecting, the French art historian Louis-Antoine Prat provocatively described the three essential ingredients in the assembly of a collection:

This trilogy comes in the guise of money (allowing for the battle against other amateurs, yet also against certain temptations to acquire mediocre works solely because of their low cost); knowledge (which brings into play that mechanism one reverts to, at the core of any true collection: attribution); and time (that time one is constantly aware of, and that confers upon the collector's activity its fundamental—though quite illusory, by the way—aspect of the battle against death).[2]

To what kind of knowledge about works of art does Prat refer? More, certainly, than the historical or descriptive data that might be conveyed in verbal form (important as that is). Included as well must be the instinctual and visual knowledge that undergirds connoisseurship. It is the kind of knowledge that permits, in a phrase Alfred H. Barr, Jr., once used to describe the daily work of museum curators, "the conscientious, continuous, resolute distinction of quality from mediocrity."[3] As Prat suggested, such knowledge is certainly essential to resolve questions of attribution. Its use does not end there, however. Even among the most impeccably attributed of objects, the collector has further choices to make, choices that require an informed and discriminating judgment. What shall he or she acquire? What shall he or she display? What shall he or she be rid of? Knowledge both sustains and draws its sustenance from the collection. Through the investment of such knowledge, the collector further builds his or her collection. Through the continuous study of his or her collection, the collector further expands that knowledge. It is a grand and (for many) wholly gratifying circle.

What of the other two ingredients that Prat says the collector must commit: money and time? Should the money expended in acquiring a collection simply be considered a "sunk cost," or may it reasonably be treated as a once and future liquid asset only temporarily resident in a more tangible form?

2. Louis-Antoine Prat, "Collecting: A Minor Art," *Drawing* 12 (November–December, 1990): 73.

3. Quoted by Richard E. Oldenburg in his foreword to Alfred H. Barr, Jr., *Painting and Sculpture in the Museum of Modern Art* (New York: Museum of Modern Art, 1977), ix.

Figures here are lacking. Although it is (and quite prudently) an article of contemporary faith that most efforts to profit through investing in works of art are doomed to failure ("You should buy them only if you love them"), there has been little study to see whether this is really reflected on the bottom line or whether, considered in total, the rare successes do not outweigh the frequent losses. That aside, the losses potentially to be incurred through collecting art may not, in any event, be very different from the expense of some alternate (and in human or environmental terms, probably less benign) form of recreation. The case of time, however, is clearly a different one. As we shall see, the time devoted to assembling a collection is an investment from which the ideal collector can invariably expect a more than satisfactory rate of return.

What is meant by the need of the ideal collector to collect in an ethical fashion? Something more than that he or she obey the applicable (and considerable) laws that affect the art trade and refrain from sharp practices in transactions with dealers and others. At its ideal level, collecting ought to be restricted to objects already in legitimate public circulation. What it must avoid are those objects that can be obtained only through the destruction of their original context. Here some equivalent of the Hippocratic Oath might be in order. Do no harm. Or considering the damage already done by the despoliation of historical and cultural sites, do no further harm. To serve as an ideal specimen, the private art collector must be prepared to put humankind's need to preserve the past above his or her own impulse to possess its fragments. As Karl E. Meyer has so eloquently explained it,

One can manifestly contend that if the remains of the past should disappear, our lives will be poorer in ways that the statistician can never measure—we will live in a drabber world, and will have squandered a resource that enlivens our existence, offers a key to our nature, and, not least, acts as a psychic ballast as we venture into a scary future.[4]

More delicate is the requirement that the ideal collector be prepared to confront his or her own mortality. Has he or she carefully considered the disposition of the collection after his or her death? The world's stock of

4. Karl E. Meyer, *The Plundered Past: The Story of the Illegal International Trade in Works of Art* (New York: Athaeneum, 1973), 208–209.

collectible goods might be seen as a floating inventory that passes from generation to generation in constantly recombined and unexpected conjunctions, a permanent heritage of which successive cohorts of collectors are only the transient caretakers. Prat attributed to Edmond de Goncourt the sentiment that the works in an art collection ought to be auctioned at their owner's death so that each might "find the heir" to its departed owner's taste.[5]

In direct opposition is the view that a collection, once assembled, ought to be maintained in perpetuity (which is certainly a long time). In some instances, this view might be bottomed on the recognition that a collection is more than the sum of its parts. To disperse it would be to throw away the extra value that the collector's effort in assembling it may have added. In other instances, a collector may envision the posthumous preservation of his or her collection as a form of personal memorial. Should the latter view disqualify such a collector from meeting the ideal? Not necessarily if, first, the collection might in any event be deemed worthy of such preservation and, second, appropriate institutional arrangements (including financial provision for the collection's perpetual support) can be timely put in place. (For *institutional*, read *museum;* few other institutions can undertake such a responsibility.) The issue here is not so much what the collector decides but that he or she *does* decide and not leave the fate of his or her collection to happenstance.

Finally, we come to the question of pleasure. As we stipulated at the outset, the ideal private art collector must be one whose pleasure is derived from the activity of collecting itself. His or her reward comes through the acquisition and study of his or her collection, not from whatever incidental benefits that may provide. Such self-rewarding experiences are sometimes described as "autotelic," and their relationship to the experience of engaging with art itself has been explored by the University of Chicago psychologist Mihaly Csikszentmihalyi and his collaborator Rick E. Robinson.[6] Looking back to Csikszentmihalyi's earlier investigations of such autotelic experiences as rock-climbing, dancing, and amateur sport—so-called peak or flow experiences—the two found a series of parallels between those experiences and what they analyzed as the aesthetic experience. Among the most salient

5. Prat, "Collecting," 77.

6. Mihaly Csikszentmihalyi and Rick E. Robinson, *The Art of Seeing: An Interpretation of the Aesthetic Encounter* (Malibu, Calif.: J. Paul Getty Museum and the Getty Center for Education in the Arts, 1990).

aspects of both kinds of experiences was an intensification of focus on the instant moment and a corresponding weakening of the attention given to either past or future. (That borders on a description of bliss.)

If we can agree that, for the ideal collector, collecting art may be a flow or peak experience (i.e., an activity satisfying in itself and not merely as an instrumental step toward some further experience), then we will find ourselves moving toward a curious (but not in the least bit surprising) conjunction of ideas. To most of those who have experienced it, the pleasure to be derived from collecting art seems far more profound than the pleasure to be derived from collecting the likes of stamps or beer cans. Might this not be so because there is such a deep and sympathetic reverberation between our autotelic response to collecting as an activity and our response to art itself? Each (and almost uniquely) can call forth a focus so intense as to take us out of the past-present-future orientation of ordinary time and to provide us, if only for a moment, with a sense of the infinite. In collecting and in art, we can transcend ourselves entirely.

That, then, is the return that the ideal private art collector might hope to recapture on the necessary investment of his or her time: the yield of another and a greatly enriched time, a time potentially infinite in its extension and boundless in its delights. The reward is not power, not fame, not wealth, not the means to an end but an end in itself, an experience that has repeatedly proved itself capable of providing the deepest and most enduring pleasure.

# THE DEACCESSION COOKIE JAR

Should a museum be able to apply the proceeds from deaccessioning to meet some part of its operating expenses, or must its use of such funds be restricted, as many museum codes now require, to the replenishment of its collection?

Recent discussions concerning these alternatives have focused primarily on issues of legality, ethics, and professional standards. Boards of trustees and other governing authorities that find themselves confronting this question should, however, understand that how they respond to it may have important strategic implications as well. These implications extend well beyond the most immediate effect of such a decision (i.e., that observance of the replenishment rule will leave a museum's "capital" intact whereas the use of deaccessioning proceeds to meet some part of its operating expenses will diminish its underlying resources).

In brief, the museum that evidences its willingness to apply deaccessioning proceeds to meet operating expenses may ultimately be perceived, both by its community and its staff, to have made available to itself the functional equivalent of a cash reserve, a reserve equal in amount to the total market value of its collection. The consequences of such a perception may, in turn, have a significant impact on many of the most important aspects of its operations.

Before examining those consequences in greater detail, two background observations may be in order. First, museums—like most nonprofit organizations, governments included—are under a continuous pressure to expend to the very fullest whatever resources they may currently have available. A nonprofit organization that accumulates or maintains unrestricted reserves may be viewed (and not merely by the public but by the Internal Revenue Service as well) as not doing all that it possibly can do to carry out its charitable purpose. In consequence, most such organizations sooner or later tend to operate near (and sometimes even beyond) the edge of their available resources. To be hard-pressed for operating funds is the chronic and natural condition of most nonprofit organizations.

Second, in the particular case of museums, there is a grotesque disproportion between the estimated market values of their collections and the funds that they generally have available to meet their ongoing operating needs.

According to the Data Report of the American Association of Museums' 1989 National Museum Survey, the total fiscal year 1988 operating expenses of museums in the United States (after excluding such related but non-object-collecting organizations as aquariums, arboreta, planetariums, and zoos) was approximately $3.3 billion. These museums held something just over 700 million objects in their collections. Assuming—after averaging ploughshares and paintings, bedsteads and bugs—that these 700 million collection objects had an average market value of just $100 each, then their total value would have been upward of $70 billion. To take the art museums alone, if the average market value of the 13 million objects that they owned as of 1988 was as little as $5,000 each, then the total value of their holdings would still be at least $65 billion. Such collection values not only dwarf the funds that these museum have available for operations but are also considerably greater than their combined endowment funds, calculated in the Data Report to be just under $14 billion.

Against such a background, what attitudinal and behavioral consequences might museums expect—both externally and internally—if and when their publics and staff once began to perceive that this enormous value was not permanently set aside in the form of their collections but was potentially available to be used to meet their current operating expenses?

The external consequences seem plain enough. Virtually every museum is engaged in a constant competition with other charitable organizations of every

kind for the scarce resources of public funding, foundation grants, corporate sponsorship, and private contributions. Although the degree of an organization's need may only be one factor in determining how successfully it can compete, the public's perception that a museum is able to help itself through sales from its collection must inevitably make it a less appealing candidate for outside support than an equally worthwhile organization that has no such capacity for self-help. How long, for example, might the taxpayers of a community tolerate the use of their money to help support the operation of a local museum that was perceived as readily able to provide its own support by simply making a few additional sales from its collection? In these circumstances, might not many other community needs appear to be more compelling?

Not only do museums compete for support, but they are also themselves at the center of still a second kind of competition, a competition among those who look to them for the delivery of program services. The demands for such services can take many forms. A nearby retirement home would like an outreach program. The local school system is requesting more teacher training. A distant neighborhood would like a satellite facility. Under normal circumstances, a museum's ability to respond positively to all these competing demands will be constrained by the limited resources it has available. Program proposals must compete with one another and only a handful can eventually be funded.

The perception that a museum's collection constituted the equivalent of a significant cash reserve could transform that situation entirely. So long as the museum was perceived as a "deep pocket," there would be little to constrain the demand for new programs. Such demands might even be expected to grow. More ominously, such proposed new programs would not merely compete (as they do now) with one another but would also compete with the objects that still remained in the museum's collection. The argument to be expected—and it would most certainly be an argument conducted in the media—would be one that involved the relative value of people and things. Is the retention of the museum's fourth-best Rembrandt etching really more important than a proposed new program for preschoolers? Might not the disposal of one old fire engine be a truly modest price to pay to keep the museum open to the public three evenings a week? More often than not, when a public argument

is framed in terms of living people against dead things, the living people can be expected to win.

Internally, the consequences of the use of deaccessioning proceeds to meet operating expenses might in some ways be parallel. Staff members also compete with one another in putting forward program proposals. Economic constraints dictate that only a few such proposals can be adopted at any time. Except for an iron self-discipline, what would stand in the way of the museum that had seemingly unlimited resources from putting into place virtually every worthy program its staff could generate? More to the point, absent such an iron self-discipline, for how long would those resources remain unlimited?

A second internal consequence might involve staff compensation. To the extent that museum workers generally consider themselves (and frequently with ample reason) to be underpaid compared with their peers in the for-profit sector, on what grounds could their requests for more equitable compensation be resisted when the entire value of the museum's collection was available to support such compensation? Once again, the issue might be framed as people against things, and once again the more likely loser would be the things.

Regardless, however, of whether deaccessioning proceeds were used to increase staff salaries or merely to continue them at current levels, their use for this purpose—almost invariably the case in museums when "operating expenses" are at issue, because salaries and benefits generally make up anywhere from one-half to two-thirds of such expenses—may raise a second ethical question over and above the initial one involved in rejecting the replenishment rule. In terms of conflict-of-interest, what is the situation of a museum staff member who participates in a deaccessioning process that, as one of its end results, enables that staff member to continue to receive a salary that he or she might have otherwise lost? For that matter, might not a similar conflict-of-interest question be raised with respect to the member of a museum board or other governing body that initiated a deaccessioning process that, as one of its end results, discharged the board's duty to secure the resources necessary to maintain the institution?

Without preaching the virtues of poverty, it might still be argued that the austerity with which most museums in the United States have been forced to operate in recent years has imposed its own kind of managerial discipline. That museums have been successful in learning to do as much as they do with

constantly diminished resources has been a strong argument for continued public confidence. Could such discipline be maintained if museums were understood by their boards and staff alike to be in possession of a vast cash reserve that could always be used to the extent necessary to offset any extravagance, waste, or error? That collections can be used in such a way is not far-fetched. When Edinburgh University auctioned off its complete edition of Audubon's *Birds of America* in the spring of 1992, the proceeds were intended to cover a multi-million-dollar shortfall resulting from the University's immediately prior miscalculation of its anticipated revenues.

If this analysis has merit, then it may be an illusion to think that a museum faced with a shortage of operating funds can rectify that situation through the use of deaccessioning proceeds. Whatever relief such proceeds may provide is likely to be short-term at best. Once the barrier of a strictly observed replenishment rule has been breached, there may be compelling pressures, from both outside and inside the museum, to breach it repeatedly. Considered as a cookie jar, a museum collection has the peculiarity that, once the lid is removed, it may prove impossible ever to get it permanently back in place.

The museum that finds itself short of operating funds but still with its collection intact and still with at least a modicum of hope that the support it needs may be available tomorrow if not today may find that in the end, by recurring raids on that collection, it will still be short of operating funds but with its collection long gone and with no plausible reason remaining as to why the public ought support it further. Legality, ethics, and professional standards aside, the use of deaccessioning proceeds to meet a museum's operating expenses would appear to be an inherently self-defeating strategy. Worse, to the extent that such a use may affect the public's perception of not just one museum but all museums, it may also constitute a distinct threat to the entire community of museums.

# TESTIMONY PREPARED FOR THE FINANCIAL ACCOUNTING STANDARDS BOARD, NORWALK, CONNECTICUT

My name is Stephen E. Weil. Although I regularly serve as Deputy Director of the Hirshhorn Museum and Sculpture Garden, the Smithsonian Institution's museum of modern and contemporary art, my appearance this afternoon is as Co-Chair—with Daniel Herrick, who spoke earlier today—of the American Association of Museums' Accounting for Contributions Task Force. I will be specifically discussing the Financial Accounting Standards Board's proposal—it appears in paragraph 19 of the Exposure Draft—that current market value might be used as one of the methods by which previously acquired objects held in museum collections could be retroactively capitalized.

In offering museums this option to use current market value as an alternative to its originally proposed yardstick of cost or fair value at the date of acquisition, the Board undoubtedly intended to be helpful in eliminating or

Testimony presented by the author as one of several witnesses on behalf of the American Association of Museums before the Financial Accounting Standards Board, Norwalk, Connecticut, July 18, 1991. At issue was the Board's proposal (from which it subsequently receded) that museums be required to capitalize their collections to receive unqualified audits of their financial statements.

at least mitigating the enormous difficulties museums had indicated they would encounter in attempting to reconstruct historical data that might be many decades or even a century old. We are grateful for such good intentions. Unfortunately, though, at least in the case of works of art, the class of objects with which I happen to be most familiar, the adoption of current market value as the basis for such retroactive capitalization would simply substitute one set of problems for another. Some of these problems have been alluded to earlier. They involve both the enormous *internal* burden that museums would have to shoulder in managing such a vast appraisal effort as well as the *external* difficulty they would encounter in raising the funds necessary to support that effort, in locating the necessary number of qualified appraisers, and in completing those tasks on any reasonable timetable.

Let us assume, however, that those obstacles could somehow be overcome. Let us further assume that whatever problems of consistency might be engendered by intermixing current appraisal values with historically determined acquisition costs could be dealt with. Let us even assume that those resulting figures might retain some use after their currency had inevitably faded with the passage of time. What the Board must still, however, understand is the sheer, utter—I am even tempted to say dazzling—speculativeness of the numbers that this prodigious effort would generate. In its own temperate way, the U.S. Tax Court, the principal judicial forum that regularly considers questions of valuation concerning works of art, has referred to such valuations as "inherently imprecise" (*Messing v. Commissioner,* 48 T.C. 502, 512, 1967). Less judiciously, we might better describe them as essentially guesswork.

Except for prints and similar multiples, art is in no way like such other subjects of appraisal as real estate in which there may be genuine comparables to support a valuation. Art is most treasured when it is most unique, when it is incomparable. That very incomparability is what makes any estimate of its value so thoroughly speculative. In some realm of the ideal, to combine the work of the dozens of different appraisers required to evaluate a major museum collection might, in the end, provide you with a finely crafted mosaic in which the collection's aggregate value was fairly reflected. In the realm of the actual, what you would really have in the end is little more than a smorgasbord of guessed-at values, a potpourri of estimates so profound in its speculativeness that its incorporation into an otherwise objectively prepared set of financial reports would have to be seriously questioned.

How speculative would that speculation be? Let me suggest at least two contexts that might provide the Board with some insight. The first involves the Commissioner of Internal Revenue's Art Advisory Panel, a body initially created in 1968 to assist the Internal Revenue Service (IRS) in reviewing and evaluating the art and similar appraisals submitted by taxpayers in connection with their federal income, estate, and gift taxes. During the course of any year, some twenty or more museum curators, art historians, dealers, and other art professionals participate in the work of the Panel. An annual summary report of the Panel's deliberations is issued through the IRS's national office in Washington. The figures that follow are taken from the Panel's report for the calendar year 1990. They are not substantially different from those for previous years.

In 1990, the Art Advisory Panel reviewed 1,421 appraisals of works of art or similar items. These had an aggregate appraised value of just over $88 million. Thirty-five percent of these appraisals were found to be acceptable. Two percent were returned to the IRS staff to develop further background. The remaining 63 percent, nearly two-thirds of the total, were rejected.

More striking still was the extent to which the Panel found that these rejected appraisals required adjustment. In the case of charitable contribution deductions claimed by taxpayers on their income tax returns, the Panel recommended that the values provided in the rejected appraisals be reduced by 55 percent. In the case of the rejected estate and gift tax appraisals, the Panel recommended that those values be increased by 66 percent.

The auction process provides a second context in which to understand the accuracy with which the value of works of art can be estimated. Unlike a fair market value appraisal, which generates a number by scrupulously examining what one writer described as "a transaction that has not occurred between two people who do not exist," the auction process does, in fact, generally culminate in an actual sale. How accurately is an auction house able to predict the price at which such a sale will be made? While taxpayers may have a motive to seek out the most favorable appraisals, the auction houses do not. Their ability to obtain consignments is clearly and directly dependent on their ability to advise a potential consignor with some accuracy as to what his or her property might fetch in the auction room.

To be recalled here is that the major auction houses do not, in fact, provide single, specific figures as their estimates. They only give ranges, and those are

broad ranges at that. Sometimes, the top of the range will be one-third or so above the bottom (as in the range of $75,000–$100,000). More often it will be a full one-half above (as in $100,000–$150,000). Sometimes (as in a range of $300,000–$500,000) the top may even be two-thirds above the bottom. Nonetheless, given those broad ranges and given also the enormous expertise that they have developed over the years, the major auction houses are not particularly successful in their ability to predict an actual salesroom price.

At the 1990 sales of modern and contemporary art at Sotheby Parke Bernet in New York, only 37 percent of the lots offered for sale were, according to Sotheby's own figures, actually sold within the auction house's published estimates. For impressionist works sold in those same salesrooms during 1990, the rate was even less: 33 percent of all lots. The results were similar at Christie's salesrooms in New York. A compilation of art sales in all categories over the past six months—decorative arts, furniture, and prints, as well as nineteenth- and twentieth-century painting and sculpture—showed that approximately 33 percent of actual sales fell within the auction house's presale estimates. In neither Sotheby's case nor Christie's do these figures include buy-ins—works that did not sell at all—which would reduce those percentages even further.

To reiterate: for all the paraphernalia that surrounds them, appraisals of the current market value of the art works held in museums can never be more than guesswork and, more often than not, substantially inaccurate guesswork at that. Because most works of art are not fungible and, more to the point, because what might most particularly determine the price at which any individual work can be sold is the elusive and perhaps even subjective factor we call "quality," those guesses must be understood to be inherently less reliable guesses than the guesses that appraisers regularly make about real estate or jewelry or even small family-held businesses.

That, though, is still not the end of the speculativeness that paragraph 19 would require. To capitalize the value of a museum's collections, at least as approached through the option of current market value, the accumulation of such guesses would be only the initial stage. At a second stage, considerations would have to be given to a concept first recognized in the securities market, the concept of blockage. Is the market value of a museum or any collection merely the mechanical sum of its one-at-a-time parts, or must that total then be adjusted downward to reflect the hypothetical impact on a hypothetical

market of so many works of art being hypothetically offered for sale at one hypothetical time?

As I pointed out in my written submission, the Tax Court recognized as long ago as 1972 that the concept of blockage is just as applicable to the art market as it is to the stock market. In the case of the sculptor David Smith, it permitted his estate a substantial discount in the one-at-a-time fair market value of his art to reflect the fact that there were 425 works that hypothetically had to be sold all at once and that those 425 works could not possibly be sold for 425 times the estimated price of one. Most recently, it reached a similar conclusion concerning the work of Alexander Calder.

What, then, are we to do about adjusting the value of museum collections that may consist of thousands, of hundreds of thousands, or even of millions of objects? We can only make more and more complicated guesses—guesses about how to massage other guesses into some number that an auditor could ultimately, and with whatever certainty is required, certify as having been arrived at in accordance with generally accepted accounting principles. Calculations bottomed so wholly on a foundation of guesswork may in the long run be no more useful or stable than a structure built on sand.

None of us are in disagreement about the duty of museums to care for and be accountable for their collections. The difference that brings us together today springs, rather, from the different ways in which we have responded to a seemingly simple and certainly well-justified question: "How can it be that what is possibly the single most valuable resource that a museum possesses, its collection, is not reflected in its financial statements?" For my own part, and for the American Association of Museums, I would urge this answer: A museum's collection is not reflected on its financial statements because, no matter how sound its inclusion might or might not be in principle, there is really no satisfactory way in which to reflect it, at least in terms of a number.

Such an answer should generate a further question: Which way would we then be better off? To pursue that principle regardless, no matter how unsatisfactory the outcome or—acknowledging finally that a museum's stewardship of its collection is not a relationship that can be adequately expressed in numbers—to describe that relationship instead by some narrative or similar means? If there is no right number we can get for our financial statements, then it seems to me that no number at all would be infinitely preferable to the use of a number that we knew from the start to be wrong.

# REVIEW: *OBJECTS OF KNOWLEDGE*

(New Research in Museum Studies: An International Series, Volume I). Susan
Pearce, Editor. London and Atlantic Highlands: The Athlone Press, 1990. U.S. and
Canada distributors, Atlantic Highlands, N.J.: Humanities Press. 235 pp., £28.

Although packaged as a book (and a costly one at that), *Objects of Knowledge* is
actually the first volume of an international journal proposed to be published
annually and intended to serve as a forum for the discussion and dissemination
of new research in museum studies. Would-be users are cautioned: Most of
the research on which it concentrates is at a highly conceptual level, and a
great deal of the material included may prove of only modest use to active
museum practitioners or any but the most advanced students in museum
training. As museology (a discipline that, in contrast to the more practical
subject of museography, is claimed to be one of the social sciences), some of
it can be a very dense read.

In large measure, the concepts used stem from what Susan Pearce (the
editor of the series and director of the Department of Museum Studies at

Reprinted with permission from *Museum News* 70 (July–August 1991). Copyright 1991,
American Association of Museums. All rights reserved.

England's University of Leicester) refers to as "the continental and related North American critical tradition." More specifically, says Pearce, the approach taken is one that tends to assume

a post-modernist, or broadly structuralist and post-structuralist tone, a central tenet of which is the conviction that all knowledge, and all value—aesthetic or social—have no external reality but are socially constructed.

This first volume includes eight papers that follow this approach more or less closely. Included also is a group of brief and considerably less weighty (some actually light-weight) reviews of exhibitions, books, and recent training conferences. Five of the papers come from England: one by Pearce and the others by Mark Goodwin, Ghislaine Lawrence, Margriet Maton-Howarth, and Anthony Alan Shelton. Two, those by Michael M. Ames and Edwina Taborsky, are from Canada. One, by Peter van Mensch, comes from the Netherlands. Not surprisingly, in view of the editor's approach, a number of the contributors assume some prior familiarity by the reader with the work of such postwar twentieth-century European writers as Bakhtin, Barthes, Baudrillard, Bourdieu, Derrida, Eco, Foucault, and so on, down the alphabet to Saussure. The one American figure who looms large in this background is the philosopher and mathematician Charles S. Peirce, often regarded as a founder of semiotics.

As its title suggests, the book is centered on the object, the knowledge that may or may not be derived from it, and the various ways in which its value and meaning may be regarded as social constructs rather than intrinsic properties contained within the object itself. Concerning the aesthetic value of a work of art, for example, Shelton (citing Bourdieu as his authority) takes the position that the source of such value is not in the artist who created the work but in the museum or other validating institution by which the work is consecrated. "Value," he says, ". . . is accrued by an object according to its insertion into a classification legitimated by an institutional signatory, and not as popular ideology supposes, derived from its creator."

Perhaps the most provocative of these papers, particularly for those in museums that seek to serve a multicultural constituency, is Taborsky's entry, "The Discursive Object." To simplify vastly, Taborsky argues—in a lively yet still tautly reasoned semiotic romp—that every object is inherently meaningless and that those objects that *do* acquire some meaning do so only in the

interactive process of being observed. Because each observer must of necessity belong to one society or another, it follows that the meaning of an object for each observer must necessarily relate to the specific social framework out of which that observer comes. Thus, observations of the same object by different observers may produce different meanings, none of which can be any more "right" than any other, although, presumably, one may still be closer than another to a meaning originally intended by the object's creator. Taborsky is fully aware of the acute problem that such an analysis poses for museums that exhibit the artifacts created by one society to observers who come from another.

Using Australian tribal totemic symbols as an example, it must be clear that the twentieth-century Western viewer will never be able to view these objects through the social reality of those seventeenth-century individuals by and for whom such objects were made. Nevertheless, although there may be a limit on the museum's ability to inform, it still has a social responsibility not to misinform. Toward that end, it must try to provide these totemic symbols with a sufficient framework of other objects and data for an observer to understand the different analytic bases from which the observer and these objects come and further to understand that such objects cannot be simply disregarded, through contemporary eyes, as either evidence of "a primitive and unscientific culture" or "only as artistic representations." How museums may best do this, Taborsky acknowledges, is something that still requires considerable exploration. (To which we might all add a heartfelt amen.)

Also of substantial interest to museum practitioners, especially those concerned with questions of conservation, should be van Mensch's crisply argued paper "Methodological Museology; or Towards a Theory of Museum Practice," which is expanded from a presentation given at the International Council of Museums' 1989 triennial meeting in The Hague. Van Mensch begins by reviewing some of the recent museological literature on the complex nature of museum objects and proceeds to propose a distinction between what he characterizes as static preservation and dynamic preservation.

In essence, van Mensch says, those responsible for the care of objects are not invariably faced with preservation as a given; frequently they must make a choice. In some instances, they may preserve the physical fabric of these objects (static preservation); in others, it may be considered preferable to preserve their function (dynamic preservation), notwithstanding that this might require periodic repairs or even some adaptation to conform to

changing legal requirements. In some instances—and here van Mensch cites the case of collected musical instruments that are occasionally used for concerts to preserve their tone—it might even be possible to do some of each. In still other instances (a windmill, for example), the continuation of an object's use will require that all its original parts be replaced eventually.

One instance he cites in which previously static preservation may already be yielding to new notions of dynamic preservation is in the care of anthropological collections. In Australia, the United States, and Canada, van Mensch says,

some museums with collections that are still relevant to descendants of the original native people are beginning to consider their objects, especially religious ones, as loans. The traditional owners are allowed to use these objects for their religious festivals . . . , and afterwards the objects are returned to the custody of the museum.

Working with native people also is the subject of Ames's paper dealing with cultural empowerment. In a relatively straightforward narrative, Ames describes in some detail several exhibitions and programs developed by the Museum of Anthropology at the University of British Columbia since the mid-1980s.

Unfortunately, not all the papers in *Objects of Knowledge* are so immediately stimulating or useful. Several tend more toward diagnosis than prescription. Pearce's own paper, for example, takes as its point of departure a British infantry officer's jacket that was worn at the battle of Waterloo and is now on exhibit in London's National Army Museum. Likening the object to a text, she provides a Saussurian analysis of its possible meanings, how these arise, and the uses to which they might be put. This makes for a dazzling academic exercise; many readers will long for a coda that relates these insights to the everyday requirements of museum practice.

Such reservations notwithstanding, a series such as this is badly needed. As Pearce herself observes, existing museum publications (English language ones, at least) offer little opportunity for studies in such depth or even of such length. Museum professionals who are interested in offering or discussing papers for future volumes should contact Pearce at the University of Leicester. The series is to be refereed, and proposed papers will be submitted to an editorial committee and/or others for review and comment. The subject and title of the second volume of the series is *Museum Economics and the Community.* The third volume is to be *Museums and Europe 1992.*

❋ ❋ ❋

# CONCERNING

❋ ❋ ❋

# PUBLIC POLICY

❋ ❋ ❋

# 14
# TAX POLICY AND PRIVATE GIVING

The chapter that follows is bottomed on the premise that the arts in all their breadth constitute an important public "good" and that, to the extent they cannot be fully supported through the marketplace, the federal government should furnish some form of supplementary support.[1] The question it addresses, thus, is not "whether," but "how." Although it touches as well on direct federal funding for the arts, it does so chiefly to provide a better perspective on what remains its central focus—the use of the federal tax code as an incentive for private giving.

In the early 1980s, there were many who urged that federal support for the arts, if such support was to be provided at all, should be channeled entirely

1. For many of the principal arguments for and against this premise, see Dick Netzer, *The Subsidized Muse: Public Support for the Arts in the United States* (Cambridge: Cambridge University Press, 1978). For a distinctly negative view, see Edward C. Banfield, *The Democratic Muse: Visual Arts and the Public Interest* (New York: Basic Books, 1984).

This text was prepared as a working paper for the symposium "The Arts and Government: Questions for the Nineties" convened by The American Assembly, November 8–11, 1990, at Arden House, Harriman, New York. Together with other such papers and a report on the symposium, it subsequently appeared in a slightly longer version in the volume *Public Money and the Muse: Essays on Government Funding for the Arts,* edited by Stephen Benedict, and is reprinted with permission of W. W. Norton & Company, Inc. Copyright 1991, The American Assembly.

through some centrally administered agency where funding decisions could be made in the full light of public scrutiny. "Specifically," asked Feld, O'Hare, and Schuster, "why should aid to the arts be shielded from the legislative review to which the food stamp program or national defense are subjected?"[2]

To be curtailed, in this view, was the then (and still) current system of tax incentives through which the cumulative and decentralized decisions of a myriad of taxpayers ultimately determined how a substantial number of forgone tax dollars (the tax savings generated by charitable deductions) would be distributed in support of the arts.

As argued in the pages that follow, the arts in the United States would have been dealt a serious blow had that view prevailed. If the arts in all their breadth are to be stimulated and made available in this country—not merely the polite and gentle arts, but also those that may be fierce or impudent—then the continued encouragement of private giving would appear essential for their support. To provide that encouragement, a system of tax incentives was first introduced into the Internal Revenue Code during World War I. Unhappily for the arts, changes made to the Code during the past decade would now appear to be eroding those incentives, and further such changes may lie in store. It is critically important to the arts community that it understand what is at stake, that it be in a position to resist what may be avoided, and to the extent possible, that it be able to take the initiative to recapture what might be restored.

The first four sections of this chapter discuss the arts generally and address the current plight and prospects of direct federal funding. The fifth section briefly considers the location for tax purposes of cultural organizations within the larger nonprofit sector. The sixth and seventh sections examine the theory and recent history of tax policy as a stimulus to private giving, and the final section sets forth some summary conclusions. The opinions expressed throughout are mine and do not represent the views of any organization with which I am or have been affiliated.

## ART OF TWO KINDS

We tend for the most part to discuss the issue of public funding as if the arts constituted a single domain, separated certainly into a number of disciplines

2. Alan L. Feld, Michael O'Hare, and J. Mark Davidson Schuster, *Patrons Despite Themselves: Taxpayers and Arts Policy* (New York: New York University Press, 1983).

(poetry, dance, painting and sculpture, music, theater, and so on) but none-theless reasonably homogenous throughout. For the purposes of this analysis, however, works of art will be roughly divided into two distinct and polar categories based on two sharply contrasting ways in which they might from time to time be perceived to function: either (a) as agents of social cohesion and continuity, or (b) as agents of social disruption and change.

While cutting across all disciplinary boundaries, such a division is not intended to have aesthetic implications. Works of art of equal merit may be found in either category. Neither would such a division be intended as fixed. With respect to any given work of art, its categorization would depend on a perception of how that particular work was principally functioning in a specific setting and at a specific time.

As scarcely need be added, works of art can function in manifold ways, and any such categorization must necessarily be oversimplified and to a degree arbitrary. Moreover, in grouping works of art around just these two opposing functions, several overlapping paradoxes must be taken into account:

Works of art themselves combine elements of continuity and change. ("Good music," Martin Gardner wrote, "like a person's life or the pageant of history, is a wondrous mixture of expectation and unanticipated turns.") It is not the predominance of one or the other of these elements, however, that will determine how a given work might be categorized at a given time, but rather how the surrounding society is using that work at that time.

At any particular time, a given work of art may simultaneously be functioning as an agent of social cohesion and continuity in one milieu but as an agent of social disruption and change in another. In one setting, Boris Pasternak's *Dr. Zhivago* could make its way as a romantic fiction and commercial film. In another, it was suppressed for many years as posing a threat to the established authorities.

The principal function that a particular work of art performs may change (and change more than once) over time. It may ultimately function in a way far removed from the artist's original intention or achievement. Consider Beaumarchais's *Marriage of Figaro* and its transformation over two centuries (with some help by Mozart) from a revolutionary statement into an opera house standard.

## Art as an Agent of Social Cohesion and Continuity

Like language, the arts are one of the principal means by which a society binds itself together and transmits its beliefs and standards from one generation to another. The arts perform this function when they embody, reinforce, and celebrate the values of their society, when they confirm and exemplify the lessons simultaneously taught by the family, by the formal structures of education, and by the various mass media in all their variety. In this function, the arts play a critically important role. Not only do they provide a kind of social "glue," but they also furnish a means by which a society can identify and distinguish itself from others.

The use of the arts today, and especially the visual arts, is not wholly continuous with the past. The critic Robert Hughes has pointed out the enormous extent to which the mass media have taken over the celebratory function once performed by art, particularly the officially patronized art once used to glorify the reigning authority.[3] No longer do those who govern require, as did Napoleon, a Jacques-Louis David to serve as first painter and popularize the ruler's image to the very corners of France. That function today has been all but completely usurped by the evening newscast and the morning paper. So, too, has the official presidential photograph replaced the sculpted portrait busts that once served to decorate the public buildings of Rome and its successor empires. Without an ongoing stream of such officially patronized art, much of the art that functions today to give a society its cohesion and continuity is older art.

By no means was all the older art that now plays such a binding role originally intended to perform that function. Some was specifically created to question or provoke. Nonetheless, as a work of art is preserved over time and folded into a society's accumulated heritage, it tends to take on the function of providing that society with an element of stability. In the 1990s, the audience for *Faust* (the opera, anyway) is more likely to be focused on its own social solidarity than on the question of whether one should make deals with the devil.

To some extent, the arts in this first category are able to support themselves through market demand. Because of widely varying production costs, though,

3. Robert Hughes, "Art and Politics," in Robert Hobbs and Frederick Woodward, eds., *Human Rights / Human Wrongs: Art and Social Change* (Iowa City: The University of Iowa Museum of Art, 1986).

the situation may vary greatly from one artistic discipline to another. A novel for which ten thousand readers are prepared to pay $19.95 can be a commercial success. A Broadway musical for which no more than ten thousand theater-goers will pay $50 for a ticket would be an economic disaster. Nonetheless, a substantial segment of the art in this category continues to be successfully organized on a commercial for-profit basis. Publishing, the recording industry, much of film, network television, and the Broadway theater would all be examples. To be noted is the extent to which these arts are contiguous with (or may even overlap) what we might also categorize as "entertainment."

Where the market demand for these arts has not been adequate to sustain them, we have still considered their maintenance as sufficiently important to justify providing them with supplementary federal support. Initially, such support was provided indirectly through the system of tax incentives first introduced during World War I and described in the sixth section of this chapter. Since 1965, those incentives have been supplemented by direct assistance in the form of grants from the National Endowment for the Arts (NEA) and, to a lesser degree, the National Endowment for the Humanities. These grants have been intended not only to stimulate the creation of new works of art but also to provide greater access to and understanding of the older works of art that have achieved the status of heritage.

### Art as an Agent of Social Disruption and Change

Just as the arts, in some instances, may be used to embody, reinforce, and celebrate the values of their society, in other instances they may come to function as the vehicle by which those values are confronted and questioned. It is in this second and more "romantic" function that the creative individual is sometimes seen as the rebel, outsider, or artiste provocateur who uses his or her art to wage guerrilla warfare against established forms, authorities, values, institutions, and truths.

Functioning as agents of social disruption and change, the arts in this use may intrude rudely on our everyday sensibility, force us to consider the most extreme possibilities of the human condition, and prod us to think more profoundly than is comfortable about ultimate matters of life, death, and our own contingency. Just as the evening newscast may have usurped some of the once celebratory function of the arts, so in turn may the arts, especially as

they seek to address moral and ethical issues, have usurped some of the traditional roles of religion and philosophy.

The arts in this category use an enormous variety of strategies to challenge the dominant culture and the prevailing ideologies in virtually every area of human activity. Sometimes they approach this task through gentle persuasion. At other times, they will be strident and harsh. Sometimes, instead of probing for truths, posing questions, or seeking to undermine deeply held assumptions, they may instead provide us with—the phrase comes from the Swiss writer Martin R. Dean—"utopian correctives" by which we can compare what is with what might be.

Moreover, the arts here may function to agitate, to aggravate, to provoke. When they address matters of immediate public concern, they may give every appearance of being political. In modes that can range from the bawdy humor of an Aristophanes to the Spartan minimalism of a Samuel Beckett, they may summon us to resist or even revolt against inherited attitudes and the complacent acceptance of things as they are. The arts in this function may even question the validity or meaning of art itself.

The arts that function in this manner are no less vital to the well-being of our society than those that function as agents of social cohesion and continuity. Whereas the one provides us with stability, the other provides us with the stimulus to grow. Thus, for example, Secretary Robert McCormick Adams of the Smithsonian Institution, addressing the issue of controversial art, wrote as follows in the August 1990 *Smithsonian* magazine:

Surely art has always—and perhaps cumulatively—extended the boundaries of insight and perception, providing much of the ambience of individual liberty and cultural diversity toward which, to our pride and pleasure, the whole world now strives. From this viewpoint, I am even tempted to suggest that some part of art may belong precisely along the shifting boundaries that successive ages assign to the morally abhorrent or legally impermissible. By evoking the extremes, it helps us all to find a context for the prism of changing norms through which we view the human condition.

Terser, but to the same effect, is another observation by Robert Hughes. "Art," he wrote, "is the mole. It works below the surface of social structures. Its effects come up long after it has been seen. . . . It is done for us, not to us."[4]

4. Ibid.

In this same vein are the words of the American playwright Terence McNally. Writing in the July 19, 1990, *New York Times,* he said:

It's not easy to be an authentic grown-up. Our national divorce rate and romance with alcohol and drugs attest to that. But if we are to mature fully, we need to be told the truth about ourselves and the society we live in. Wise men have always depended on artists to tell us those truths, however painful or unpopular they may be. Society needs artists, even if it doesn't realize at the time how much it does.

Society needs artists, and it needs art. The art that it needs, though, is not merely yea-saying art. It does need that, but it also needs an art that is free to say "no," to be taken to whatever lengths or whatever new places it must go to do its job—to tell society the truths, sometimes painful, that it needs to know if it is ever to grow and become mature.

How is such art supported? To some extent, the arts in this second category are also able to support themselves through market demand, albeit not always as successfully as art that functions in a more affirmative mode and may provide greater entertainment. There is not, however, universal agreement that the arts in this category ought be supported in this way. Some commentators, in fact, have expressed concern that the search for such market support might actually be self-defeating by putting into jeopardy the very integrity that makes this art important. Paul J. DiMaggio of Yale, for example, suggested two reasons why this might be so.

First, the logic of the marketplace is in many ways inimical to the efforts of nonprofit arts organizations to present innovative productions and exhibitions of the sort favored by many artists, curators, and critics. Second, the marketplace is unsupportive of policies that expand the social range of the audience for the arts, serve the poor, or pursue the goal of public education.[5]

Where market demand has not been adequate to support art in this second category, then federal subsidies have been provided—indirectly through tax incentives and, more recently, by programs of direct grants. (It should not, incidentally, be assumed that the quest for these subsidies is any less competi-

---

5. Paul J. DiMaggio, "The Nonprofit Instrument and the Influence of the Marketplace on Policies in the Arts," in W. McNeil Lowry, ed., *The Arts and Public Policy in the United States* (Englewood Cliffs, N.J.: Prentice Hall, 1984).

tive than the search for support in the marketplace; the competition is simply for a different source of approval—from patrons in the case of indirect funding or from peer-group panel reviewers in the case of direct funding.) It was just at this point, however, in connection with such direct grants to support art that was perceived by the public to be "confrontational," that the support system began to show severe signs of strain in the late 1980s.

## STRAINS ON THE SYSTEM

In a more ideal world, the American public and its political representatives might accept a concept of artistic freedom that in some measure paralleled the tradition of academic freedom that has, by long effort, been established in this country's institutions of higher learning. Implied by such a concept is that funding agencies ought to maintain a stance of neutrality toward the content of the work produced by the arts organizations and artists chosen to receive their grants. Central to such a concept would be a more clearly drawn distinction between sponsorship and endorsement. That the NEA, for example, had sponsored an activity need no more imply any federal endorsement of that activity than a university's sponsorship of a lecture need imply that it necessarily approved the content of that lecture. Art works would be sponsored for what was judged to be their aesthetic excellence or interest, not on the basis that they functioned either to affirm or to question some element of the status quo.

That ideal is still far off. Repeatedly, first in the late 1930s when the several fledgling art programs launched by Franklin D. Roosevelt's New Deal were either terminated or eviscerated and again in the late 1980s when the NEA first came under fire in connection with the work of Robert Mapplethorpe and Andres Serrano, critical politicians and members of the public alike have bypassed questions of aesthetic value (or even of procedural regularity) to concentrate their hostility on works of art that (in some combination of their style and content) were perceived as subversive, blasphemous, pornographic, or otherwise in conflict with mainstream values.

As might be expected, this response has been triggered most frequently by art that was intended from the outset to function as an agent of social disruption and change. In both its manner and matter (i.e., its language and content), such art is far more apt to provoke such hostility than the art of

cohesion and continuity. Whether as a strategy to attract attention or as a symbol of its breaking away from established norms, its language (verbal, musical, pictorial) may be unfamiliar and novel    at the extreme, even crude, abrupt, or vulgar—and genuinely offensive to many. Most often provocative in content, it may pose a direct threat to those whose authority it questions.

To the extent that the direct federal funding of such art is involved, the hostility it provokes generally finds expression in a pair of linked questions:

Why should taxpayers have to pay for art that most of them find repugnant? Why should this or any country support art that seeks to undermine its values?

Those are scarcely new questions; they go back half a century and more.[6] Their very familiarity notwithstanding, to this day the American arts community seems to have a difficult time providing a compelling set of responses.

One response, and perhaps one of the best, is that in a democracy public monies may eventually wind up being spent on many things that one or another taxpayer might find repugnant or at least of no interest—Star Wars, tobacco subsidies, electric chairs, and baseball stadia all come to mind—if the majority so wishes. Art perceived as repugnant may differ only in its profound ability to seize the public's (or at least the media's) attention.

Another answer might be procedural. A grant-making process, like any other process, will tend to produce a bell curve of results in terms of public acceptability or even of freedom from error. In that, it resembles our system of democratic elections that occasionally produces a genuine aberration, or our system of military procurement that from time to time will produce a remarkably expensive wrench. That is simply a condition endemic to systems. Unless and until a system begins to produce more than a tolerable number of what might be considered aberrant results, then that system ought not to be lightly discarded or set aside. The point to be stressed to the public, rather, is that any system can be made to appear preposterous by concentrating on the few examples that lie at its extremes and by ignoring the far more numerous ones that can be found under the heart of the bell curve.

Not so compelling (and even, to a degree, dangerous to the future of direct federal funding) are some other answers that those within the arts estab-

6. Gary O. Larson, *The Reluctant Patron: The United States Government and the Arts* 1943–1965 (Philadelphia: University of Pennsylvania Press, 1983).

lishment have occasionally offered. One of these involves the so-called Van Gogh fallacy (i.e., that the greater the initial rejection of a work of art, the more wholehearted will be its eventual acceptance). Although it is true that many works of art that the public initially found baffling or repugnant have since become cherished parts of our cultural heritage, it is equally true that many more of such works have either remained to this day baffling or repugnant or, not infrequently, have been forgotten entirely.

Related perhaps is the response that the recipients of federally subsidized arts grants have been selected by panels of disciplinary experts. Because those experts understand their subjects more profoundly than does a lay public, their choices ought therefore to be respected. That this, too, is true may be beside the point. Authority no longer carries the weight it may once have borne, and those who most strongly advocate an art that functions as an agent of social disruption or change can scarcely complain when the public, itself to a degree rebellious, refuses to bow before the opinions of "experts."

In this same line is the "castor oil" response—that even though the public hates the taste of something, it should nevertheless swallow it for its own long-term good. Once more, that may be both true and beside the point. Taxpayers are mostly adults and simply will not tolerate being put in such a childish position. That such an answer might also (and rightfully) be perceived by them as arrogant does not help the argument.

Finally, there is a response that argues for a sort of "proportional representation" in grant-making. The public, so this argument goes, has a wide range of preferences. Even though a majority may find something repugnant, a minority may favor it. This minority has its rights, too. A form of this argument has been advanced, for example, by Tim Miller, one of the four performance artists (Karen Finley, Holly Hughes, and John Fleck were the others) whose panel-recommended grants were vetoed by the NEA's chair in June 1990.

Responding angrily in *Theater Week* (July 16, 1990), Miller said that he ought to have "the full power to create art about my identity as a gay person, art that confronts my society, art that criticizes our government and elected officials, and maybe even some art that deserves a few tax dollars from the 20 million lesbians and gay men who pay the IRS."

Notwithstanding how just that may appear to some, the fact is that our democratic system, for better or worse, simply does not work that way. The majority is not entitled to merely a majority of the spoils. Within constitu-

tional limits, the majority gets all the spoils. It is for precisely that reason that the decentralized system of subsidy through the charitable deduction is so vital to maintain. It provides an important counterbalance to what some may (rightly or not) perceive as majoritarian repression.

Unless and until there is a better public understanding of the distinction between government sponsorship of the arts and government endorsement, we may no longer be able to protect the federal grant-making process against what threatens to become an annual round of political sniping. Given the nature of the arts in this century and given also that thousands of such grants are made each year, there will always be some number at the extremes of the process that can be used as targets.

In the case of funding by the NEA, for example, it may be irrelevant for potentially controversial art (a) whether that sniping ultimately destroys the agency entirely; (b) whether it eventually results in the inclusion in NEA grants of specific restrictions on content; (c) whether the imposition of a floor on the size of NEA grants operates to exclude support for individual artists and for the smaller groups that tend to be more experimental; (d) whether such incessant sniping simply frightens the staff, peer review panels, chair, and national council into a state of chronic timidity; or (e) whether it induces such a state of self-censorship in artists and arts organizations who might otherwise apply for grants that their work will, in any case, be drained of provocation. In any one or more of those events, such sniping will have succeeded in cutting off such potentially controversial art from a major source of support (not just financial support but also the opportunity to receive the nationally recognized imprimatur that NEA approval confers).

Paradoxically, the threat to such funding may not come only from those who reject provocative or controversial art because they see it as an attack on the status quo. Such funding may also be threatened, albeit in a different way, by those who themselves most strongly believe that the status quo is in need of change. This second threat involves the debate over whether "quality" and "aesthetic excellence" exist as discernible qualities in works of art or whether these have become code words that conceal what Michael Brenson described as "artistic and cultural repression."[7] (For a second and contrary opinion as to

7. Michael Brenson, "Is Quality an Idea Whose Time Has Gone?" *New York Times,* July 22, 1990, sect. 2, p. 1.

this, also see Hilton Kramer.[8]) Unless quality or excellence or some similar term of comparison is acknowledged as an appropriate basis for judgment, however, on what other grounds may NEA or state council peer review panels recommend which grants are to be awarded? Moreover, unless works of art (by definition, it is what keeps them from being spoons or mousetraps) include an identifiable aesthetic dimension, not even "aesthetic interest" would be available as a criterion on which to base such decisions. Certainly, grant panels could scarcely give awards on the basis of content. In the case of both federal and state grant programs, that would most likely raise such a host of First Amendment questions as to bring down such programs entirely.

The fight to keep programs of direct federal support in place and open to art of every kind, both art that affirms and art that questions, must be conducted with all the vigor that the arts community can command. At the same time, however, it must be understood that this fight may not be won or wholly won—it was entirely lost at least once before—and that attention must be given to maintaining and strengthening the other principal means by which the federal government can provide or stimulate support for the arts. That brings us, finally, to the nonprofit tax status of most arts organizations and to the use of tax policy as a stimulus to private giving.

## THE NONPROFIT SECTOR

Notwithstanding that some part of the arts activity in the United States can be supported through market demand, the overwhelming preponderance of such activity (beyond, again, what may be classified as "entertainment") is carried on through thousands upon thousands of privately governed, privately supported, and wholly unrelated nonprofit organizations, some formed as charitable trusts but most as not-for-profit corporations. These organizations include more than half of the country's museums and virtually all its symphony orchestras, dance companies, experimental theaters, chamber music societies, opera troupes, and literary magazines. To suggest the magnitude of this activity, the aggregate annual operating expenses of these organizations was estimated in the mid-1980s to be $10 billion. It has surely grown since.

---

8. Hilton Kramer, "A *Times* Critic's Piece about Art Amounts to Political Propaganda," *The New York Observer*, August 13–20, 1990.

This constellation of cultural organizations is, in turn, just a part of the larger nonprofit sector, a category of so-called tax-exempt organizations that includes major parts of this nation's systems of higher education and health care, its recreation and human service organizations, and religious congregations of every description. So vast and sprawling is this nonprofit sector that efforts to map it with any accuracy are still at an early stage. A "Statistical Portrait" that appeared in the January 9, 1990, issue of *The Chronicle of Philanthropy* estimated that as of the end of 1989, it included some 907 thousand active nonprofit organizations with an aggregate operating expense of more than $325 billion and more than 7 million paid employees.

In relation to this nonprofit field, cultural organizations play a relatively small role. Whether measured by the number of entities, by annual expenditure, or by paid employment, they constitute something less than 5 percent of the total universe. In terms of the private contributions they receive, they are only slightly more weighty at 6 to 7 percent. Thus, although cultural organizations have played a critical role in shaping such programs of direct federal aid as the NEA's, they have been a relatively minor factor in shaping the tax provisions of the Internal Revenue Code relevant to charitable contributions generally. Historically, their fortunes have ebbed and flowed with those of the greater charitable community.

Whether and to what extent cultural organizations might ever obtain separate tax treatment focused specifically on their own particular problems and needs is by no means certain. Art museums, for example, have fought unsuccessfully for two decades to reverse a provision of the 1969 Tax Reform Act that deprived artists of a full fair market value charitable deduction for gifts of their own art works. They have been equally unsuccessful to date in reversing a 1986 change (discussed in the next section) in the tax treatment accorded to gifts of works of art from donors other than artists.

## THE CHARITABLE DEDUCTION IN THEORY

Notwithstanding its name, the principal benefit of federal tax exemption to a nonprofit cultural organization is not exemption from federal tax. That is mostly an incidental benefit. In general, the operating results of these organizations are not such that they would generate any substantial income to tax even if they were not exempt. The real significance of tax exemption is in the

fact the contributors to tax-exempt organizations are entitled to deduct the value of their contributions in computing the amount of their income that will be subject to federal income tax.

The effect of this charitable deduction is to make the federal government, in essence, a cocontributor. If $1,000 is contributed to a nonprofit cultural organization by a taxpayer whose marginal tax rate—the rate, that is, at which his or her topmost dollar of taxable income would otherwise be taxed—is 31 percent, then the after-tax cost of such a gift to the donor is only $690. The remaining $310 represents revenue that will be forgone by the federal government. It is that $310 (multiplied many times over) that will hereafter be referred to as an indirect federal subsidy. It is also sometimes referred to as a "tax expenditure," a designation coined by the late professor Stanley Surrey of the Harvard Law School in an effort to emphasize that it was actually a tax-related forgone revenue and, in his view, came just as surely out of the federal government's coffers as if it had been spent directly.

Income tax deductions generally serve one of two purposes. They may either be compensatory for a taxpayer's diminished (and usually involuntary) ability to pay the tax that would otherwise be due at a particular level of income (for example, the deduction for substantial medical expenses or for casualty losses) or may serve as a stimulus toward some activity that those who formulate tax policy consider to be socially desirable. First introduced in 1917, the deduction for charitable contributions to educational, health, and cultural organizations was clearly intended to fall under this second heading (i.e., to serve as a stimulus).

How strong a stimulus it might be at any given time depends on the tax rates then in effect. Because giving to cultural organizations tends to come principally from the most affluent taxpayers, the most critical of these tax rates would be the maximum marginal one. Over the past three decades, that rate (except for the 3 percent upward blip in the 1990 budget settlement) has moved steadily downward. As recently as the 1960s, this rate still stood at 77 percent. That meant that a $1,000 contribution from the most affluent taxpayer might have an after-tax cost of only $230 with the remaining $770 to be provided as a federal subsidy or tax expenditure. Since then, the maximum marginal rate has fallen to 70 percent, then to 50 percent, under the Tax Reform Act of 1986 (TRA '86) to 38.5 percent in 1987, and 28 percent for the three years subsequent, and then come back to 31 percent. To

recapitulate: The $1,000 charitable contribution that in the 1960s carried an after-tax cost to the taxpayer of $230 (and triggered a tax expenditure of $770) will, beginning in 1991, have an after-tax cost to the taxpayer of $690 (and trigger a tax expenditure of only $310).

Given the breadth of its impact and its persistence through every administration since John F. Kennedy's, there is little reason to believe that this downward movement in the maximum marginal tax rate has been particularly motivated by animosity toward the nonprofit sector (although the periodic discovery of questionable practices in foundations and other charitable organizations has not warmed public feeling toward that sector). Impelling it, rather, has been a new two-pronged strategy toward tax writing that has sought (a) to simplify and lower tax rates, while simultaneously (b) eliminating or constricting the deductions that might otherwise be available to reduce the income base to which those lowered rates would apply.

Thus far spared from the second prong of this strategy has been the itemized charitable deduction for contributions of cash (but not contributions of appreciated property or contributions by nonitemizers, both of which are discussed below). It would nonetheless appear, in theory at least, that the value of the charitable deduction as an incentive for private giving has been substantially eroded simply by the ongoing reduction in the maximum marginal tax rate. (The actual outcome is considered in the next section.)

Moreover, as both the administration and the Congress began a more earnest search for additional tax revenues in 1990, one of the earliest trial balloons to be floated was the notion that a further shrinkage of deductions, possibly including the charitable deduction, might be a more politically palatable way of proceeding than an increase in the existing tax rates. One model of this balloon involved a tighter percentage cap on deductions. Another would have imposed a floor similar to the one that has eliminated most job-related and miscellaneous deductions in recent years. In the end, just such a floor was adopted. Although its impact is expected to be modest, it does represent a further erosion of the system of deductions previously in place.

Concerning the charitable contribution of appreciated property—stocks, bonds, and most important for museums, works of fine art—TRA '86 substantially dampened the considerable incentive that had existed previously. Before 1987, the donor was entitled to deduct the full fair market value of

such property at the time of its gift. TRA '86 changed that radically. It required that the portion of any such contribution representing the appreciation over the donated property's original cost basis be included as a so-called tax preference item in the computation of an alternative minimum tax (AMT). (The AMT is a complicated device intended to ensure that no one can use tax shelters or extensive deductions to escape payment of income taxes entirely.) In a worst-case scenario, that might reduce the federal tax benefit that the donor could derive from any such contribution to just 21 percent (24 percent after 1990) of his or her original cost basis. That such a change occurred just as the art market was experiencing an enormous upward surge meant that potential gifts of works of art might be affected with particular severity. Although the application of this rule is to be suspended for 1991 for gifts of works of fine art (but not stocks or bonds), it is scheduled to reverse in 1992.[9]

For a brief period, from 1982 through 1986, a charitable deduction was also permitted to taxpayers who did not otherwise itemize any other deductions. Although initially subject to modest limitations (the maximum deduction permitted for each of the first two years of its gradual phase-in was $25), its only limitations by 1986 were the same percentage caps that applied to taxpayers who did itemize. It is unclear, however, whether this deduction for nonitemizers ever provided any important incentive for contributions to cultural organizations.

Studies of charitable contribution patterns conducted in the 1970s[10] strongly suggested that the overwhelming share of such contributions by lower and even middle income taxpayers was directed to religious organizations and to community funds. Given the fact that this pattern was already in place before 1982, there is considerable doubt as to whether the charitable deduction for nonitemizers actually served as an incentive or whether such a pattern of giving would not have continued in any event. That cultural organizations nonetheless continue to lobby actively for the restoration of this nonitemizer deduction may be principally a matter of politics. It reflects more clearly their

9. It was reversed still again effective January 1, 1993, so that donors were once again permitted to deduct the full fair market value of their contributions.

10. Stephen E. Weil, "The Filer Commission Report: Is It Good for Museums?" in *Beauty and the Beasts: On Museums, Art, the Law and the Market* (Washington, D.C.: Smithsonian Institution Press, 1983).

need to maintain good relationships within the larger charitable community than any substantial benefit they might hope to receive.

One federal tax provision that does still provide a substantial incentive for gifts to cultural organizations is the charitable deduction that has been available under the federal estate tax since 1918. Unlike the income tax, the estate tax's marginal rates are still sufficiently high to provide a substantial reduction in the after-tax cost of charitable gifts that take effect at death. First cutting in at a 37 percent level on an estate (other than one left to a surviving spouse) with total net assets of more than $600,000, the rate rises rapidly to 55 percent for estates of more than $3 million (with an extra surcharge of 5 percent for estates between $10 million and $20 million). At those levels, more than 50 percent of the full fair market value of a charitable bequest could still be recouped in the form of a tax subsidy or expenditure. In the case of a gift of appreciated property, treated identically to a gift of cash, that contrasts sharply with a gift made during the donor's lifetime for which the total subsidy might be as little as 21 percent (24 percent after 1990) of his or her original cost basis.

Too complex for extended consideration here is the cluster of sophisticated tax devices generally gathered together under the term *planned giving*. Included under this heading are a variety of split-interest trusts, various life insurance packages, and a number of pooled income or annuity arrangements. Common to all these is a (two plus two makes five) combination of tax savings to the donor and benefits (sometimes deferred) to the charitable donee. The extensive paperwork required for some of these devices often limits their use to substantial gifts of, for example, $25,000 or more.

Many of these devices first came into being under the Tax Reform Act of 1969. In general, colleges and universities were well ahead of cultural organizations in exploring their use. More recently, particularly because TRA '86 cut off so many other paths to tax minimization, independent financial advisers have begun aggressively promoting these devices as being among the last remaining forms of tax shelters still available. Fears have been expressed by several experts in this area (university development officers in particular) that the zealousness of such efforts may eventually attract negative congressional attention and in time trigger reconsideration of the very substantial tax incentives that these devices can currently provide.

Also beyond the scope of this presentation are the tax incentives for private giving offered by the great majority of states and many localities that impose

income taxes. Suffice it to say that, in both their application and in the policy considerations shaping them, these vary considerably both from the federal tax incentive and from one another. Common to all, however, is the intention to serve as a stimulus to charitable giving (sometimes local giving in particular), not to achieve tax equity.

What are the objections raised by those who would either eliminate or substantially modify this system of providing indirect federal support to the arts? For one thing, they point to the fact that the bulk of giving to cultural organizations comes from a relatively small handful of affluent taxpayers. Through their control of what may be more than $2 billion of tax expenditures annually (a fair estimate for 1989, and some ten times as much as the federal government provided to the arts that same year in the form of direct funding), this handful of taxpayers is in essence able to spend the public's money without any of the administrative safeguards or democratic participation that would normally accompany such a public expenditure.

If procedural regularity were the most important desideratum in providing support for the arts, this criticism might carry considerable weight. Most observers, however, would probably agree that what is more important still is to ensure that support can be provided for the arts in all their breadth, whether functioning as agents of social continuity or as agents of social change. That seems far more likely to occur when funding decisions are decentralized to a myriad of taxpayers and not monopolized by a central bureaucratic agency that by its very nature must be guided by majoritarian prejudices and a tropism away from controversy. In the same vein, these observers might also argue that such decentralization gives the best possible assurance that this important source of funding will remain free from government interference.

If tax incentives for charitable giving are nonetheless to be retained in some form, then critics of the present system have urged that, at the very least, they should be modified to produce greater tax equity. Because the charitable deduction reduces the amount of income that is to be taxed rather than the tax that is to be paid and because the progressive rate structure of the federal tax system (although greatly flattened today from what it was previously) makes such a deduction more valuable to a high-income taxpayer than to one in a lower bracket, these critics argue that the incentive offered for individual giving to organizations should at least be in the form of a credit against tax rather than as a deduction from income. As such, it would provide the same

dollar benefit to every taxpayer, regardless of his or her tax bracket. "A fair tax code," said Teresa Odendahl, writing in *The Chronicle of Philanthropy* (April 17, 1990), "would provide such a deduction for all citizens or none."

If the genesis of the charitable deduction was an effort to produce "fairness," this might be a convincing argument for such a change. As noted earlier, however, the charitable deduction's origin was a public policy determination to stimulate financial support for a category of organizations thought to be important to the society at large. That this stimulus should be aimed at those most able to provide that support is in furtherance of that policy. An alternate system might be more fair, but it would also be self-defeating unless, in the aggregate, it stimulated the same dollar amount of contributions as does the present system. Tax incentives, to be effective, should be targeted to where the money is.

Less theoretical is a third criticism that concerns the tax treatment of gifts of appreciated property, particularly works of fine art. In such cases, the work's fair market value at the time of the gift must be determined through an appraisal process that may necessarily involve a considerable degree of subjective judgment. Appraisal is also a process that may be (and, beyond question, on occasion has been) abused.[11] In fact, concerns about abusive valuation practices were voiced as early as the middle 1960s and, among other things, resulted in the establishment of the Internal Revenue Service's Art Advisory Panel in 1968.

To meet these concerns, the Congress amended the Internal Revenue Code in 1984 to introduce a rigorous new substantiation requirement in the case of any such gift for which a value in excess of $5,000 was claimed by the donor. Under that law, substantial penalties may be levied against the taxpayer whenever such a valuation is proved to be excessive by 50 percent or more. In such an instance, disciplinary action may also be taken against the appraiser. (A fuller explanation of these safeguards can be found in the booklet *Gifts of Property: A Guide for Museums and Donors,* published jointly by the American Association of Museums [AAM] and the Association of Art Museum Directors [AAMD] in 1985.) This valuation problem may have been (or may ultimately be) rendered moot by the change introduced by TRA '86 requiring that the

11. For a chronicle of actual abuses, as well as a summary of other criticisms directed at the fairness of the full fair market value deduction, see W. M. Speiller, "The Favored Tax Treatment of Purchasers of Art," *Columbia Law Review* 80 (1980): 214.

appreciated portion of the fair market value of such a gift be included as a tax preference item in the calculation of the donor's AMT. Over the long term (and notwithstanding the suspension of this rule for 1991), that is expected to reduce substantially the number and aggregate value of these gifts of appreciated property.

A final criticism of the system of charitable deductions as a conduit for indirect federal support is that the system's incentives are directed at stimulating the support of arts organizations and not artists themselves or art activities directly. (The system of direct federal support through the NEA, by contrast, can channel grant funds either to arts organizations for programmatic support or directly to writers, painters, musicians, and other creative individuals. Not incidentally, it is these latter grants that have most often attracted the sharpest criticism.) The consequences of such exclusively organizational support may differ from discipline to discipline.

In the visual arts, for example, the introduction of another level of decision-making (such as the museum or art center) may work beneficially to dilute the public's sense that a particular activity or event has been funded in part by foregone tax revenues. The controversy over the Robert Mapplethorpe exhibition organized by the University of Pennsylvania's Institute of Contemporary Art swirled entirely around the direct support that the institute received from the NEA specifically for that exhibition. The fact that the institute (both directly and through the university) was also the recipient of indirect federal support for its general operating expenses (and undoubtedly in a far larger amount than was received directly from NEA) did not occasion the same adverse response.

However, in disciplines not traditionally institutionalized—modern dance is sometimes cited as an example[12]—the fact that the system of indirect federal aid requires an organizational channel through which the funds must flow may have had a more negative impact. Is it the best use of a dancer's talents to have to create a corporate framework through which to work? Once assembled, do the institutional imperatives of that framework (a truly representative board of trustees, charitable registration, an increased emphasis on fundraising) stand in uneasy balance with the ongoing creative interests of the

12. D. Erb et al., "A Symposium: Issues in the Emergence of Public Policy," in Lowry, *Arts and Public Policy*.

artist? To the extent that the current system of charitable deductions adds weight to the organizational side of that balance, then this last criticism might deserve some closer consideration.

## CHARITABLE DEDUCTION IN CURRENT PRACTICE

When TRA '86 was enacted, there was considerable speculation as to its impact on the level of charitable contributions. On the one hand, there were those who believed that the increase in the after-tax cost of giving would lead to an overall reduction in such contributions. On the other hand, it was argued that affluent taxpayers would be left with considerably more disposable after-tax income than they had previously enjoyed and, accordingly, would be well inclined to increase their contributions over what they had given in prior years.

What, in fact, has actually happened? The evidence to date is sparse. What it suggests, however, is that while no enormously dramatic change has yet occurred with respect to gifts of cash and that such charitable giving (both in nominal and inflation-adjusted terms) has continued to grow, the rate of that growth has slowed somewhat. It is not clear whether and, if so, how deeply that reduction in growth is connected to any change in incentive. However, gifts of appreciated property appear to have declined substantially. This evidence comes from scattered sources.

The most widely used figures in the field are those compiled annually by the American Association of Fund-Raising Counsel (AAFRC) based in New York. TRA '86 took effect at the beginning of 1987. For the three years before and the three years after, AAFRC estimated total charitable giving as follows:

| Year | Charitable giving (in billions) |
|------|--------------------------------|
| 1984 | $ 70.55 |
| 1985 | 80.07 |
| 1986 | 90.90 |
| 1987 | 95.15 |
| 1988 | 103.87 |
| 1989 | 114.70 |

AAFRC has also broken out separate figures for contributions to arts and culture. Although these have also continued to increase, as in the figures above, this increase appears to have been more vigorous in the years 1984–1986 than in the years 1987–1989. AAFRC's figures are:

| Year | Charitable giving (in billions) |
|------|---------------------------------|
| 1984 | $4.50 |
| 1985 | 5.08 |
| 1986 | 5.83 |
| 1987 | 6.31 |
| 1988 | 6.79 |
| 1989 | 7.49 |

Independent Sector (IS), a Washington-based nonprofit coalition of seven hundred corporate, foundation, and voluntary organizations with national interests in philanthropy, has studied the contribution patterns of taxpayers with incomes of $1 million or more. It found that the average contribution per donor in this group had dropped from $200,000 in 1986 to $93,000 in 1987, the first year that TRA '86 was in effect. It is not clear to what degree both those figures may have been skewed by donors accelerating planned 1987 contributions into 1986, as many tax advisers were then recommending that they do. In general, IS appears to believe that the impact of the lowered tax incentive on donors of cash is not so much to reduce the number of donors as to reduce the size of their individual gifts.

More conclusive, perhaps, are figures compiled by the AAM concerning the value of objects and other appreciated property donated to American museums during the two years before and the two years after TRA '86 took effect. These suggest that the change in the tax treatment of such contributions (i.e., the classification of appreciation as a tax preference item in calculating the donor's AMT) may thus far have had a stronger negative impact on this kind of gift than the reduction in the maximum marginal tax rate has had on gifts of cash. Of particular interest in the following figures is the comparison between 1985 and 1988 that should be relatively

free of whatever skew might have been caused by gifts being accelerated from 1987 into 1986:

| Year | Objects (in millions) | Other appreciated property (in millions) |
|---|---|---|
| 1985 | $ 79.125 | $12.815 |
| 1986 | 103.825 | 17.414 |
| 1987 | 72.363 | 9.701 |
| 1988 | 40.251 | 8.622 |

A survey covering those same four years by AAMD found a comparable decline in gifts of appreciated property following 1986. Notwithstanding a rising art market, the value of gifts received by art museums in 1988 was reported as 28.8 percent below the value of those received in 1987 and 63 percent below the value of those received in 1986.

At least one ghost, however, may haunt those figures. The extent to which fluctuations in overall charitable giving may be affected not simply by tax incentives alone but also by general economic conditions is unknown. For example, during the eleven-year period ending in 1985—a period in which there were also significant changes in the federal income tax, including a sharp reduction in the maximum marginal tax rate—the annual total of charitable contributions, as a percentage of the gross national product, never varied by more than plus-or-minus 5 percent from an average of 1.93 percent. The range was from a low of 1.84 percent in 1979 to a high of 2.0 percent in both 1984 and 1985.

Although the relative constancy of those figures in the face of declining tax rates might be attributable to a concomitant increase in the sophistication of fund-raising techniques, it also suggests what a complex set of variables may be involved. Full deductibility, maximum marginal tax rates, and the treatment of appreciated property would all appear to be factors, but these may only be some of the dimensions of tax policy that have an effect on charitable giving. With respect to appreciated property, the treatment of capital gains must certainly play some role as well. Beyond that, most important of all may

be the Internal Revenue Code's general impact on the national economy. In that respect, American cultural organizations might in the future do well to address themselves to tax policy in broader terms than they have sometimes done in the past. To concentrate simply on maintenance of the charitable deduction in its present form might be too parochial a focus.

## SOME CONCLUSIONS

How might the present situation concerning federal support for the arts be summarized?

Direct federal funding—while the less significant component in terms of dollars, still vitally important as a model and an imprimatur—may be severely threatened in its ability to support the whole spectrum of the arts. That is particularly so with respect to those vitally needed arts that function as agents of social disruption or change. Even if the life of the NEA is indefinitely extended (and extended without restrictions), the danger seems very real that the agency may have a period of real timidity in prospect. It could well become what its then-Acting Chair Hugh Southern referred to at the AAM 1989 annual meeting in New Orleans as the "National Endowment for Nice Art." (More recently, National Council on the Arts member Lloyd Richards expressed a similar fear that NEA might come in time to stand for "National Endowment for the Agreeable.") In view of such a possibility, the maintenance of a strong system of indirect federal funding must be considered all the more essential.

The system of indirect federal funding through tax incentives may have been weakened to a degree over recent decades. Nevertheless, it still appears to work, albeit more so for gifts of cash than gifts of contributed property. Some of the most useful of its remaining incentives may involve planned giving, an area that cultural organizations might productively explore further than they thus far have done.

Such indirect funding may nevertheless face a further diminution, not because the arts are in any particular disfavor, but because the entire system of tax deductions may be slowly eroding as the Congress reshapes the tax laws toward something more politically palatable and/or administratively sim-

ple. Although the arts community will resist this erosion, it can only do so effectively by making common cause with the larger charitable world.

Proactive strategies through which the arts community could work to strengthen the tax incentive might include (a) finding allies to join in seeking permanent restoration of the pre-TRA '86 treatment of gifts of appreciated property in the same manner as it was restored for 1991; and (b) reviving an idea originally advanced in the 1970s, the calculation of the charitable deduction for cash gifts, at least for lower and middle income taxpayers, at some multiple (double or less) of the amount actually contributed.[13] In all likelihood, however, neither of these initiatives can advance very far unless and until the tax climate has changed greatly from what it is at this writing. A combination of domestic and international events has put the federal budget process under enormous strain. Until this can be eased, it is no more realistic to expect that programs of indirect aid (not merely to the arts, but across the entire spectrum of federal assistance) will be enhanced by the relinquishment of tax revenues than that programs of direct aid will be the recipients of substantially increased appropriations.

Finally, it ought not be concluded that direct funding through the NEA and tax code incentives to private giving exhaust all the possible ways in which the arts are or might be publicly supported at a national level. There still appears to be widespread agreement that the arts, at least as an abstract concept, constitute an important public "good" and that they contribute in unique and vital ways to the quality of our national life. We need to explore further how best to translate that good will into active programs of federal assistance that can help stimulate and provide access to the arts in all their many manifestations: pleasing and nice, outrageous and nasty, gaudy or grand, and everything that is neither or both or in-between or none of the above, just as the arts have always been and still can be.

13. Weil, "Filer Commission Report."

# EXCELLENCE, AUTONOMY, AND DIVERSITY: THE CASE FOR TAX-EXEMPT CULTURAL ORGANIZATIONS

Why should an art museum (or a symphony orchestra, or any similar not-for-profit cultural organization) be eligible for federal income tax exemption? This chapter alludes briefly to the two more or less traditional (and, to a degree, related) arguments that are generally advanced. For the most part, however, it concentrates on another and perhaps more compelling rationale, albeit that this rationale may not be equally applicable across the entire range of noncultural organizations that are similarly tax-exempt.

## TRADITIONAL ARGUMENTS

Underlying the two more or less traditional arguments for federal income tax exemption is the notion that tax-exempt status ought to be

aimed either at encouraging private organizations and public instrumentalities to take on a task that must otherwise be met by governmental

This text was originally delivered on October 11, 1991, at the conference "Rationales for Federal Income Tax Exemption" sponsored by the New York University School of Law Program on Philanthropy and the Law.

appropriation or at fostering some activity regarded as fundamental or as socially desirable.[1]

Section 501(c)(3) of the Internal Revenue Code reflects these goals in its enumeration of the purposes that may (in conjunction with the Code's other requirements) qualify an organization to be exempt from tax. Of those enumerated purposes, the two most relevant to an art museum are "charitable" and "educational."

The argument that an art museum serves a charitable purpose might rest on one of several definitional grounds.[2] To the extent, for example, that an art museum may either provide its services without charge or charge a fee that is less than the full cost of such services, then it may be said to resemble a traditional philanthropy. Also arguable is that a museum is charitable because it advances education (see the next paragraph, however, for a simpler argument on that point) or because it has erected and continues to maintain a public building. Finally (and perhaps most important), if we believe that—in Carol Duncan's (ironic) phrase—"public art museums are important, even necessary, fixtures of a well-furnished state,"[3] then the ongoing operation of a museum may be regarded as lessening a burden of government. Questionable, though, is whether this charitable argument would be equally persuasive for such other cultural organizations as opera or dance companies, particularly those that did not maintain their own premises.

More direct is the argument that an art museum (or similar cultural organization) is entitled to tax exemption because it serves a socially desirable purpose (i.e., it is "educational"). Most museum practitioners would contend that, more than merely a storehouse for objects or a place of public recreation, the museum today functions primarily as a site for education. This is particularly so in the United States. As one authoritative publication argued:

1. Paul E. Treusch and Norman A. Sugarman, *Tax-Exempt Charitable Organizations* (Philadelphia: The American Law Institute, 1979), 3.

2. *Charitable* is defined in Treas. Reg. §1.501(c)(3)–1(d)(2) to include, among other things, relief of the poor and distressed or of the underprivileged, advancement of education, erection or maintenance of public buildings, and lessening the burdens of government.

3. Carol Duncan, "Art Museums and the Ritual of Citizenship," in Ivan Karp and Steven D. Lavine, eds., *Exhibiting Cultures* (Washington, D.C.: Smithsonian Institution Press, 1991), 88.

Public education is the most significant contribution that this country has made to the evolution of the museum concept. . . . If collections are the heart of museums, what we have come to call education—the commitment to presenting objects and ideas in an informative and stimulating way—is the spirit.[4]

Here, the Treasury Department's own regulations conclusively echo this argument from the field. Among the specific examples the regulations offer of organizations that per se satisfy the educational test of section 501(c)(3) are "museums, zoos, planetariums, symphony orchestras, and similar organizations."[5] Although not per se exempt, opera and dance companies ought more persuasively be able to justify their tax-exempt status as educationally "similar organizations" than as charitable ones. So might repertory and other noncommercial theaters as well as "little" magazines and "small" presses, notwithstanding that these organizations might also qualify as "literary," another of section 501(c)(3)'s enumerated qualifying purposes.

## WHY TAX EXEMPTION MATTERS

In one sense, the fact that not-for-profit art museums and similar cultural organizations are exempt from federal income tax is, *in itself,* almost wholly irrelevant. For a variety of reasons, such organizations generally operate at the very limit of their current resources. Rarely are they able to show even a negligible surplus or to accumulate any substantial reserves.[6] Even without such a tax exemption, they would have little or no income available to be taxed.

The most important consequences of tax exemption for not-for-profit cultural organizations lie elsewhere. They are to be found, rather, first, in Section 501(c)(3)'s requirement that, in order to secure the benefits of tax

4. *Museums for a New Century* (Washington, D.C.: American Association of Museums, 1984), 55.

5. Treas. Reg. §1.501(c)(3)–1(d)(3)(ii), example (4).

6. As noted by Mary M. Wehle of Idmon Associates, Chicago, such organizations may be perceived by the public as not doing everything possible to carry out their charitable or educational purpose when they fail to use all their available resources on a current basis (conversation with the author). Beyond that, an arts organization accumulating reserves may have difficulty both in persuading potential donors of its need for current contributions and in persuading its staff to accept salaries that are frequently below those that private sector employers pay for comparable work.

exemption, such organizations must maintain themselves in such a configuration that no part of their net earnings "inures to the benefit of any private shareholder or individual"; and second, in the interplay of tax exemption with the system of charitable deductions initially introduced into the Internal Revenue Code in 1917.

The impact of the so-called inurement rule has been to reduce sharply (if not eliminate altogether) the impact of marketplace considerations on the arts as practiced through not-for-profit cultural organizations. This, in turn, has profoundly shaped the development of these arts so that they are today substantially distinct (as distinct, for example, as public broadcasting is distinct from its commercial cousin) from their kindred art forms as practiced in the entertainment industry. So recently as World War I, there was perhaps little difference between the artistic presentations of various voluntary associations and those of commercial theater and concert producers, publishers, gallery owners, and other individual entrepreneurs. Over the seventy-five years since, however, that difference has become a gulf.[7]

Of no less impact than the inurement rule has been the Revenue Code's system of charitable deductions. Under that system, individual taxpayers are in effect able to direct a portion of the federal government's foregone tax revenue to the tax-exempt recipients of their choice.[8] The outcome is a unique form of indirect public subsidy in which the choice of beneficiaries is shifted from a single and centralized decision-maker to a decentralized multitude of taxpayers. For tax-exempt cultural organizations, the total amount of this indirect federal subsidy is many times (perhaps as much as ten times in recent

7. The width of this gulf can perhaps best be grasped in fantasy. Imagine, for example, that the situation was otherwise and that for-profit considerations had universal applicability. Time-Warner, Inc., having just acquired as subsidiaries both the Martha Graham Dance Company and the Balanchine Troupe (ex-New York City Ballet) for its Dance Division, determines that costs could be reduced if the dancers were freely interchangeable between one unit and another. "It's only a matter of style," as one corporate spokesperson happily explained. "With a few legs, arms, and torsos adjusted, this could be a far better performing profit center."

8. This is the so-called tax expenditure theory as first developed in the 1960s by Stanley S. Surrey. For a discussion of how this might apply in a charitable context (including several of the arguments urged against it), see *Giving in America* (Washington, D.C.: Commission on Private Philanthropy and Public Needs, 1975), 107–110.

years) greater than the amount of subsidy they receive directly from such centralized federal agencies as the National Endowment for the Arts and the Institute of Museum Services. In 1989, for example, such *indirect* subsidies (by my estimate) may well have exceeded $2 billion in contrast to a *direct* federal subsidy of some $200 million.[9]

To be argued in the pages that follow is that not-for-profit cultural institutions (and the case may be similar for colleges and universities) provide a public benefit through their aspirations to excellence, their autonomy, and their diversity and that such aspirations, autonomy, and diversity are, in turn, directly rooted, first, in the organizational form in which the Internal Revenue Code requires them to configure themselves and, second, in the workings of the charitable deduction system whereby the indirect subsidy generated by forgone tax revenue is allocated through the broadly dispersed decision-making of the taxpaying public.[10] Such an argument must in the first instance rest on the premise that the arts, in fact, do make an important contribution to our public life.

## THE ARTS IN SOCIETY

The arts that today fall within the province of not-for-profit cultural organizations are part of a continuum. Adjacent to one side (but with, as noted above, a considerable gulf between) is the far larger, market-driven, and generally congenial world of commercial entertainment: films, television, commercial publishing, radio, popular music, video, and more. At the opposite side, these arts shade into a relatively small and austere world of aesthetic speculation,

9. See Stephen E. Weil, "Tax Policy and Private Giving," in Stephen Benedict, ed., *Public Money and the Muse* (New York: W. W. Norton & Co., 1991), 173. A similar figure can be calculated for 1990, a year in which *Giving USA* estimated that $7.9 billion was contributed for "arts, culture and humanities." Assuming an average 30 percent marginal tax rate, the foregone federal tax revenue would have amounted to nearly $2.4 billion. Meanwhile, the level of direct federal subsidies was little changed from 1989.

10. As some commentators on the charitable deduction point out, however, it is not the *entire* tax-paying public that participates in such decisions but primarily the more affluent portion. See, for example, the discussion of this point throughout Alan L. Feld, Michael O'Hare, and J. Mark Davidson Schuster, *Patrons Despite Themselves: Taxpayers and Arts Policy* (New York: New York University Press, 1983).

essentially philosophic in nature and not necessarily intended to reach any substantial public.[11]

What most distinguishes the arts that fall within the not-for-profit segment of this continuum is the degree to which virtually all those who create, present, consume, fund, criticize, or think about them have come to share the belief that their principal purpose is to provide important forms of insight and experience, not to serve primarily as a source of diversion. To be valued as well, in this view, is the utopian capacity of the arts, their ability not only to reflect what already is but also (at their most subversive) to imagine and to suggest what else might be. Widely believed as well is that the arts are all but unique in being able to perform these tasks.

From such a perspective, the free practice of the arts must be seen to have an enormous value to any society. What else can provoke those critical and life-central questions that can rarely be touched on, if touched on at all, in either the give-and-take of the political arena or in the marketplace of commerce? Only from its responses to such fundamental questions can a society generate its values, shape its vision of the common good, and arrive, ultimately, at its public decisions as to how, by whom, and for what purposes it wishes itself and its affairs to be governed.

As the American playwright Terence McNally wrote in *The New York Times* for July 19, 1990:

It's not easy to be an authentic grown-up. Our national divorce rate and romance with alcohol and drugs attest to that. But if we are to mature fully, we need to be told the truth about ourselves and the society we live in. Wise men have always depended on artists to tell us those truths, however painful or unpopular they may be. Society needs artists, even if it doesn't realize at the time how much it does.

---

11. To a similar effect: "One way to comprehend the broad spectrum of art in America is to divide that spectrum into two separate and unequal parts: the commercial, with its media stars and its seven-figure incomes, and the noncommercial, more unassuming, more serious, less concerned with 'entertainment.'" *The Arts in America: A Report to the President and the Congress* (Washington, D.C.: National Endowment for the Arts, 1988), 7. No suggestion is intended that the various art forms have sorted themselves out on this continuum in any logical way. As speculated earlier, what is more likely is that the very different ambiences that prevail in the for-profit and not-for-profit sectors have, with the passage of time, profoundly affected the nature of the arts each sector has produced.

Art that seeks to deal with such fundamental issues must often do so in ways that are neither pretty nor refined. As often as not, it must do so at the sacrifice of commercial appeal. *King Lear* is not a nice story. Goya's images of Saturn devouring his young or of the horrors of war are anything but ingratiating. Picasso's *Guernica* was never intended to please. But nonetheless, those are the works that endure and continue to provide value long after the hurly-burly of day-to-day politics has run its course and the marketplace has been swept clean. As George Sadek, the one-time Dean of the Cooper Union in New York, was accustomed to ask, "How many people can name the Mayor of Moscow during the year that Dostoyevsky finished writing *Crime and Punishment?*"

Unclear in retrospect (and most likely irrelevant) is whether and, if so, to what extent the cultural organizations that deal with the arts in this mode were initially located in the tax-exempt sector through foresight or simply by happenstance. To the extent that such organizations are descended from those nineteenth-century volunteer associations by which the arts were first introduced into the United States, the fact that they were not initially organized for profit may suggest an original purpose to maintain that pattern. Very clear, however, is the degree to which the location of the arts in the tax-exempt sector has enabled them not merely to flourish but also to take on a particularly distinctive character.[12] Two reasons can be suggested.

First, the embodiment of the arts in organizations of the so-called third sector (an alternative to both government and commerce) has largely insulated them, on the one hand, against political and bureaucratic bullying and, on the other, against the pressure to maximize their profitability. Second, this relative autonomy has, in turn, permitted the arts to achieve an unprecedented diversity. Through their embodiment in thousands on thousands of separately governed not-for-profit cultural organizations, they are able to reach out in every direction and to the very limits of the imaginable in stimulating new inquiries and new responses, inquiries and responses that

---

12. For a partially contrary view, see the discussion at p. 149 and following in W. McNeil Lowry, ed., *The Arts and Public Policy in the United States* (Englewood Cliffs, N.J.: Prentice Hall, 1984). An argument is suggested there that the requirement to configure themselves as not-for-profit organizations may actually be detrimental to certain performing arts groups, particularly those in which a charismatic, creative personality serves as the group's dominant figure.

touch on every realm of our private and public lives. Arguably, the autonomy of the cultural organizations that serve as their vehicles has, by facilitating such diversity, provided the arts as practiced in the United States with their very greatest strength.[13]

## AUTONOMY AND EXCELLENCE

It should be self-evident that the arts cannot, however, truly function as important instruments of inquiry (including inquiries that may be critical of the existing order of things) unless they are free of governmental restraint.[14] In the United States, at least, the Constitution provides a shield. As a general rule (albeit a remarkably recent one), the arts have been held to fall within the ambit of the First Amendment's protection of free speech.[15] Although that protection may at one time have been limited to those arts that involved actual or symbolic speech or that, regardless of their media, in some manner addressed matters of broad public concern, it now seems to cover the full expanse of artistic expression including even "art for art's sake."

As a corollary, the arts may also be disabled from functioning as instruments of free inquiry when they become too dependent on direct governmental assistance, whether through actual patronage (such as the General Services Administration's Art-in-Architecture Program) or through the distribution of direct public subsidies (such as those awarded by the National Endowment

13. That such autonomy and the diversity it permits are critically important not only in the arts but across almost the entire nonprofit sector is forcefully argued by Waldemar A. Nielsen, *The Endangered Sector* (New York: Columbia University, 1979). Nielsen (p. 4) described tax-exempt organizations as essential "to embody the countervalues and complementary beliefs of our competitive, capitalistic, materialistic, egalitarian culture."

14. For a compelling account of the fate of the arts in authoritarian societies, see Hellmut Lehmann-Haupt, *Art under a Dictatorship* (New York: Oxford University Press, 1954).

15. Notwithstanding that the outcome of the case may be viewed as a setback for free expression, eight of the nine Justices recording their opinions in *Barnes v. Glen Theatre,* 111 S. Ct. 2456 (1991), the Indiana nude dancing case, appear to have agreed that artistic expression in general (and dancing in particular) is protected by the Constitution. Justice Scalia's concurring opinion suggests, however, a different view. Two important decisions on this point from the 1980s addressing the constitutional protection of, respectively, the visual arts and music are *Piarowski v. Illinois Community College,* 759 F. 2d 625 (7th Cir., 1985) and *Ward v. Rock Against Racism,* 102 S. Ct. 2746 (1989). For a general discussion, see Barbara Hoffman, "Law for Art's Sake in the Public Realm," *Critical Inquiry* 17 (Spring 1991): 540.

for the Arts).[16] If the First Amendment stands as a guardian of the arts against the danger of *pro*scription, then their best protection against *pre*scription may be through their location in the tax-exempt organizations of the third sector. In many ways, such a situation is ideal. Through the mechanism of the charitable deduction, they are able to receive at least a modicum of government assistance while at the same time maintaining their distance from legislative scrutiny of the kind that almost inevitably follows when such assistance is distributed in the form of a direct subsidy.[17] In the end, tax exemption creates a situation in which government, although it may partly pay the piper, is still unable to call the tune.

Full autonomy, however, requires still more. Although the arts may thus be protected (at least to a degree) from the influence of government, to function as instruments of free inquiry they must also be protected (again, at least to a degree) from the need to maximize their profits in the marketplace. In this connection, there is a curious (and perhaps not widely understood) interplay between section 501(c)(3)'s "inurement" rule and the manner in which not-for-profit cultural organizations generally operate, most particularly their traditional dependence on contributed income to supplement what they are able to earn from user fees.

First, because such an organization can only retain its tax-exempt status so long as no part of its net earnings "inures to the benefit of any private shareholder or individual," it is able to operate on a no more than break-even basis without coming under outside pressure to pursue some greater return. Second, as pointed out previously, because such an organization generally finds it a poor strategy to accumulate reserves for future programming, there may be little internal pressure to maximize revenues through programming

16. The infinitely varied relationships that governments have maintained with the arts are well documented in Jane Clapp, *Art Censorship: A Chronology of Proscribed and Prescribed Art* (Metuchen, N.J.: The Scarecrow Press, 1972).

17. Thus, for example, during the 1989 controversy over the Robert Mapplethorpe exhibition organized by the University of Pennsylvania's Institute of Contemporary Art, objections were raised in the Congress and elsewhere to the direct federal subsidy which the National Endowment for the Arts had provided to underwrite a relatively modest portion of the exhibition's total budget. That another (and in all likelihood larger) portion of that budget had been underwritten by the indirect federal subsidy provided through tax-deductible charitable contributions to the University itself did not appear to trigger any comparable objections.

designed to appeal to some broader or more upscale market. Third, because the income earned from fees charged to users constitutes only a part of such an organization's total support (a relatively minor part in the case of art museums; more in the case of performing arts organizations), program decisions must take into account not only what is likely to attract an audience but also what is likely to attract the approbation of potential contributors.[18] There really can be such a thing as too many *Nutcracker Suites* or *Christmas Carols*.

Experience strongly suggests that it is the perceived excellence and creativity of a cultural organization's ongoing programming, not its broader popularity or special appeal to a more affluent audience, that is more likely to attract substantial support from individual and foundation donors. Excellence and creativity are also more likely to prove attractive to the peer review panels that recommend how direct public subsidies are to be allocated.[19] That is wholly different from the situation of those commercial enterprises that operate at the entertainment end of the arts continuum and for which the fees charged to customers are their only source of income.

Marketplace considerations may, moreover, be not merely superfluous for nonprofit cultural organizations; they may actually be pernicious. As Paul J. DiMaggio pointed out in a 1984 paper that addressed this issue:

At least two conclusions are worthy of confidence. First, the logic of the marketplace is in many ways inimical to the efforts of nonprofit arts organizations to present innovative productions and exhibitions of the sort favored by many artists, curators, and critics. Second, the marketplace is unsupportive of policies that ex-

---

18. Imagine, for example, how negatively the traditional supporters of a Cadillac-class museum might respond if the museum, in pursuit of an additional market segment, were to open a midline branch in which to exhibit its hitherto-in-storage Chevrolet-class paintings to a less discriminating audience at a reduced admission fee and under less than optimal conditions.

19. In some instances, "excellence" may, in fact, be the mandated legislative standard. See, for example, section 5(c)(1) of the National Foundation on the Arts and the Humanities Act of 1965, which authorizes grants-in-aid to productions that emphasize "the maintenance and encouragement of professional excellence." Similarly, section 5(c)(3) refers to the achievement by individual artists of "standards of professional excellence." The perceived excellence of its programming may also be critical to a cultural organization's ability to recruit and retain a talented staff.

pand the social range of the audience for the arts, serve the poor, or pursue the goal of public education.[20]

Although this freedom from both governmental and marketplace pressures may enable not-for-profit cultural organizations to pursue their own development, such autonomy in itself does not demonstrably provide a public benefit. Without something further, it might offer little more than an opportunity for institutional self-indulgence. Its importance lies, rather, in the degree to which it permits an infinitely greater diversity than the arts could achieve under any system of central administration (including even a hypothetical and equally autonomous not-for-profit central administration). Autonomy coupled with the charitable deduction system of dispersed decision-making is what permits tax-exempt cultural organizations to act not merely as alternatives to governmental and market-driven entities but as alternatives to one another as well.

## DIVERSITY AND EXCELLENCE

Some of the reasons why diversity is important ought be self-evident. If the arts are to provoke us toward broader horizons, then—in a world not of one horizon but many—they must of necessity provoke us in not one direction but many. What we seek through the arts is a richness of possibility, not a narrow propriety, and diversity can serve as a principal means toward that end. Similarly, if we expect the arts to engage our hearts, imagination, and intellect in the broadest possible ways, they can far better do so when they are vigorously and independently variegated, not when they are standardized, official, and gray. Diversity is again the key. The importance of diversity, though, goes still further. If the arts are truly to embody what Waldemar A. Nielsen called "countervalues and complementary beliefs,"[21] then diversity is essential for that task. Moreover, if we believe that the arts best fulfill their public function when they aspire toward excellence, then consideration must also be given to the relationship between diversity and the ever-vexing question of artistic "quality."

20. Paul J. DiMaggio, "The Nonprofit Instrument and the Influence of the Marketplace on Policies in the Arts," in Lowry, *The Arts and Public Policy in the United States, 79.*
21. See Nielsen, *Endangered Sector.*

To the extent that the arts are supported by direct federal subsidies, those distributing such subsidies must ultimately (in some degree) be responsive to majoritarian views.[22] Works of art that forcefully position themselves against such views can scarcely be expected to share greatly in such subsidies. By contrast, the charitable deduction system offers something akin to a form of proportional representation. It permits the considerably larger indirect federal subsidy that is generated through the charitable deduction system to be allocated in ways that more nearly reflect the widely varying tastes, personal choices, and individual opinions of the entire taxpaying public, not simply the majority.[23] With richness as a goal, the inclusion of such minoritarian inputs is essential. Whereas art that explores such controversial issues as abortion, sexual preference, or the justness or unjustness of particular wars will rarely (except when impeccably "correct") receive direct public funding, the indirect public funding of such art can provide a desirable alternative.

The relationship between diversity and our aspirations for artistic excellence is a more complicated one. The very notion that quality might be an inherent property of a work of art has recently been under attack,[24] and even those who must passionately argue in its defense find themselves hard-pressed to formulate a definition.[25] Nonetheless, no satisfactory substitute has yet been proposed, and quality (or something very like it) continues to be the prevailing basis for making artistic decisions and, most particularly, decisions as to how public funds ought be allocated.[26]

22. Thus, in *A Report to Congress on The National Endowment for the Arts* submitted by The Independent Commission (Washington, D.C.: 1990), 57, 60, the theme is developed that "to support art from public funds entails considerations that go beyond artistic excellence" and that, in providing such funds, the government must "be sensitive to the nature of public sponsorship."

23. Beyond ensuring that the arts will benefit by the reflection of these tastes, choices, and opinions, this also seems a matter of some basic fairness to these taxpayers.

24. See, for example, Michael Brenson, "Is 'Quality' an Idea Whose Time Has Gone?" *The New York Times,* July 22, 1990. For a response, see Hilton Kramer, "A *Times* Critic's Piece about Art Amounts to Political Propaganda," *The New York Observer,* August 13–20, 1990.

25. Its indefinability should not in itself put *quality* in any worse a position than *love, sadness,* or *delight.* As Eugene Ionesco once observed, "Not everything is unsayable in words, only the living truth."

26. To wit: "Although the National Endowment for the Arts encourages a diversity of artistic perspectives, the principal criterion for making grants must be artistic quality." *Report*

One suggestive approach to the question of quality was offered by Albert Elsen. Likening its elusive nature to Potter Stewart's frequently quoted observation about obscenity (i.e., that without being able to define it, he would still know it when he saw it),[27] Elsen suggested that what might constitute quality in a work of art was its "esthetic durability," the fact that it did not wear out "its intellectual and emotional welcome."[28]Thus defined, the question of whether any particular work of art has quality is one that can only be answered over time.

To tie this back to the value of diversity, Elsen's notion can be usefully combined with one advanced several years ago by Richard A. Posner.[29] Posner also argued that "the 'test of time' is the closest we seem able to get to an objective measure of artistic value." He then went on, however, to suggest, by an analogy to biological evolution, that the best hope of having art of excellence emerge from any period was by ensuring the greatest possible variety out of which history could subsequently make its selection.[30]Diversity, in other words, might function as a means to expand the gene pool, thereby increasing the likelihood that some number of specimens will turn out to be sufficiently hardy and well adapted to survive, to prove their "esthetic durability." Here, again, the diversity achievable through the decentralized decision-making of the charitable deduction system would appear to provide a considerably greater public benefit than either a more centralized system of direct support or the profit-oriented strategies of the marketplace.

A final reason to consider diversity important stems from the observation that the arts seem to attain their greatest creativity when they achieve some critical mass. That appears to be most particularly so when there is a body of artists working in a variety of styles that are sufficiently distinct to encourage aesthetic (rather than simply political) competition for patronage and to stimulate the development of an informed and discriminating audience. Set

---

to Congress, 57, 58. It might be argued that, absent such a criterion, the Endowment would have no other valid basis on which to allocate its funds among competing applications. To do so on the basis of viewpoint, for example, would clearly seem constitutionally prohibited.

27. *Jacobellis v. Ohio,* 378 U.S. 184, 197 (1964).

28. Essay in the catalogue *Bruce Beasley, An Exhibition of Bronze Sculpture* (Sonoma, Calif.: Sonoma State University, 1990), 7, 9.

29. Richard A. Posner, "Art for Law's Sake," *American Scholar* 58 (Autumn 1989): 581.

30. In accord would seem to be Marcel Duchamp's observation that most works of art "die" after thirty years. The corollary would be that some of the hardier ones *do* survive.

in motion is a kind of dialectic by which new artistic possibilities are synthe-sized out of the clash of earlier styles, and the "scene" becomes a magnet that attracts successive waves of artists, all striving to improve on and supplant their predecessors. Again, diversity is the condition most conducive to such a vigorously creative situation.

## CONCLUSION

It may be objected that the arts in this country are at no point so truly free from either censorship (including self-censorship) or marketplace considera-tions as the foregoing sketch would suggest. That may be the case. Nonetheless, nobody has yet proposed a more suitable place in which the arts might be located than the not-for-profit cultural organizations of the third sector—a location made all the more advantageous by the eligibility of such organiza-tions for tax exemption. If still greater autonomy is thought to be desirable, that ought not be incompatible with such a locus.

It may also be objected that the arts have flourished under other systems of support—particularly direct government patronage, as still practiced in parts of Europe and elsewhere—and that those systems should not be rejected out-of-hand as alternative models for the United States. To be questioned, though, is whether any particular feature of one social or legal system can simply be plucked out of context and grafted onto another. Also be to be questioned is whether those other funding devices—seen perhaps at their most attractive in support of great opera, dance, and symphonic organiza-tions—are truly as able as our own to accommodate the persistently dissent-ing, impudent, scruffy, frequently rude, and often seminal art that prowls on the fringes of the mainstream or sometimes, even, squares off directly against it. The entire range of art needs to be taken into account, not merely what is polite or pleasing.

To conclude where we began: Why should an art museum (or a symphony orchestra or any similar not-for-profit cultural organization) be eligible for federal income tax exemption? The most compelling rationale would seem to be this:

More than being merely decorative or a frill, the arts provide an essential public benefit through their unique ability to provoke, stimulate, and

stretch us in ways that ultimately relate importantly to our future as individuals and to our destiny as a country

The arts can best perform those functions through their location in tax-exempt cultural organizations that insulate them (at least to a degree) from both the ideological pressures of government and the mediocratizing pressures of the marketplace while still, through the mechanism of the charitable deduction system, allowing them to receive at least a modicum of indirect public support

Through the consequent autonomy of these not-for-profit cultural organizations, the arts can enjoy an almost unbounded diversity—a diversity without which they would not be able fully to perform the functions for which we value them or to realize their greatest potential for excellence.

# TESTIMONY OFFERED BEFORE
# THE INDEPENDENT COMMISSION

To begin, let me put on the record that I am here in a personal capacity and not as a representative of either the Smithsonian Institution or the Hirshhorn Museum. The views I present are entirely my own and do not in any way reflect those of either the Smithsonian or the Hirshhorn.

My prepared testimony addresses two issues—the National Endowment for the Arts' grant-making procedures, and the question of whether the standards for publicly funded art should be different from those generally applicable to privately funded art.

Concerning grant-making, it has recently seemed to me that it would be highly salutary if the Endowment could establish and find broad acceptance for a concept of artistic freedom that would in some measure parallel the tradition of academic freedom as the latter has evolved and is today practiced in this country's institutions of higher learning. Implied by such a concept is

Testimony given August 1, 1990, during a hearing before The Independent Commission established by the U.S. Congress to review the grant-making activities of the National Endowment for the Arts. The author's views were most emphatically not reflected in the Commission's subsequent *Report to Congress* dated September 11, 1990.

that the Endowment would not merely maintain a stance of neutrality toward the work product of the arts organizations and artists chosen to receive its grants, but that it might also in some degree provide them with a shield against outside interference with those activities. Central to such a concept would be a more clearly drawn distinction between sponsorship and endorsement. That the Endowment has sponsored an activity need no more imply its endorsement of that activity than need a university's sponsorship of a lecture imply that it necessarily approves the content of that lecture.

Recent events have certainly suggested how pernicious can be the public confusion of sponsorship with endorsement. A useful analogue in addressing such confusion might be the policy statement proposed May 1, 1990, at the conclusion of a conference on academic freedom and artistic expression held at the Wolf Trap Farm in northern Virginia. Cosponsored by the American Association of University Professors, the American Council on Education, the Association of Governing Boards, and the Wolf Trap Foundation, the conference was asked to consider whether and to what extent the protections of academic freedom ought be extended to cover campus presentations of both the visual and performing arts. Although the situations are not wholly identical—in the case of the Endowment, the question may be one of funding rather than of the basic right to be seen or heard—you might nonetheless find the language of the conference's concluding statement suggestive:

Works of the visual and performing arts are important both in their own right and because they can enhance our experience and understanding of social institutions and the human condition. Artistic expression in the classroom, studio and workshop therefore merits the same assurance of academic freedom that is accorded to other scholarly and teaching activities.

If the federal government can today support higher education without the necessity to examine every last word spoken or each book assigned in the classroom, then perhaps it is not impractical to think that in time it could do something similar for the arts as well.

Meanwhile, looking at a shorter time frame, it seems to me that an effort ought be made to get the chairman out of the line of fire where hostile critics can take potshots at him or her on a grant-by-grant basis. Toward that end, it might make practical sense to strengthen, rather than diminish, the authority given to the Endowment's peer review panels. By diminishing or otherwise

limiting the authority of the chairman and the national council to "second-guess" panel recommendations, the latter two might be better insulated from what now seems to have become an inevitable and potentially incessant sniping.

Imagine, for example, a mechanism—somewhat parliamentary, I grant you, in its inspiration—by which the chairman or even the council might be empowered to reject a particular panel's grant recommendation only by rejecting *all* of that panel's recommendations and even by discharging the panel itself. In essence, this would be tantamount to a vote of "no confidence." To permit a potentially controversial grant to go through under those circumstances might be far more readily understood—and also might draw more allies, political and otherwise—than it would in the present situation in which the chairman can always be taken to task for not exercising what is in effect a line-item veto. Counterbalancing the chairman's diminished authority vis-à-vis panel recommendations might be some increase in the funds available to him or her for discretionary grants—grants for which he or she would still be solely responsible and publicly accountable. Reserved for the national council would be the larger questions of policy, not the minutiae of grant-making.

Finally, concerning process, it might be useful to be more forthright in making clear that the Endowment's grant-making process, like any process, will tend to produce a bell curve of results in terms of public acceptability or even freedom from error. In that, it is in no way different from our system of democratic elections, which occasionally produces some genuine aberrations, or our system of military procurement, which from time to time will produce an unduly expensive hammer. That is simply a condition endemic to systems. The public ought certainly be able to understand that any system can be made to appear preposterous by concentrating on the few examples that lie at the extremes and not the many that fall under the heart of the bell curve. More candor on this point might be helpful.

Turning second to the standards for publicly funded art, it seems to me arguable that, rather than being in any way narrower, these ought be even broader than those that prevail for privately funded art and certainly broader than those that prevail for the art that gets funded by corporations. Such a position was, in fact, suggested—again, not in terms of funding, but of protection from interference—by the recent Wolf Trap Conference:

Public funding for artistic presentations does not diminish (and indeed may heighten) the responsibility of the university community to ensure academic freedom and of the public to respect the integrity of academic institutions. Government imposition on artistic expression of a test of propriety, ideology, or religion is an act of censorship which impermissibly denies the academic freedom to explore, teach, and learn.

Consider a statement attributed to Goethe. "Do your utmost to cultivate the beautiful. The useful will cultivate itself." One might parallel that with, "Do your utmost to cultivate that art which is least likely to attract popular and commercial support. The popular and commercial will take care of itself."

It does, nevertheless, seem to me impractical to establish meaningfully different standards for publicly funded art, regardless of whether these were more or less restrictive than those for privately funded art. Moreover, the imposition of such different standards would appear to be wholly self-defeating—at least in the light of my own assumptions about why there ought be an Endowment in the first place and about the essential public role that the arts can and do play in this country.

What are those assumptions? Basically, that the arts, beyond whatever ability they may have to entertain or divert us, are a crucial necessity to our society and to any society. The arts uniquely raise—and raise again for each generation in the manner appropriate to that generation—those vital and life-central questions that can never be fully posed, if they are posed at all, in either the marketplaces of commerce or in the give-and-take of the political arena. The arts are our essential nourishment. Without them, we can never achieve our full growth.

Many have recently made this same point, and eloquently. Writing in 1989 to *The Washington Post,* my museum colleague Frank Robinson of the Museum of Art of the Rhode Island School of Design said:

Among the many things that art does for us all is that it challenges us, it demands that we rethink our assumptions about every issue in life, from religion to politics, from love and sex to death and the afterlife.

The critic Robert Hughes in 1986 wrote in a similar vein about the vital social role that art can play:

Art is the mole. It works below the surface of social structures. Its effects come up long after it has been seen. . . . Its great claim to attention is that it can give us a

mode of discussing experience which is specific, responsive, and free from the corporate generalizations of visual mass media, mainly TV. It is done for us, not to us.[1]

Even more directly to the point might be the words of the American playwright Terence McNally. Writing in July 1990 in *The New York Times*, McNally said,

It's not easy to be an authentic grown-up. Our national divorce rate and romance with alcohol and drugs attest to that. But if we are to mature fully, we need to be told the truth about ourselves and the society we live in. Wise men have always depended on artists to tell us those truths, however painful or unpopular they may be. Society needs artists, even if it doesn't realize at the time how much it does.

Society needs artists, and it needs art. The art that it needs, though, is not an art cut down and tailored to fit some ever-shrinking standard of what may be broadly acceptable. It is an art—frequently, in fact, broadly acceptable but sometimes not—that is free to be taken to whatever lengths or to whatever new places it must go to do its job—to tell us the truths, sometimes painful, that we need to know if we are to grow and become mature.

This becomes all the more clear when we consider what the alternative might be. Polite art? Comfortable art? Nice art? At the 1989 annual meeting of the American Association of Museums in New Orleans, Hugh Southern, then the Endowment's Deputy Chairman, suggested that it might be preferable to have no National Endowment for the Arts at all than to have a National Endowment for Nice Art. His point, I think, was that art might flourish better left to itself in the wild than if reduced to some form that was tame, domesticated, and officially approved.

More recently, that same theme was taken up by the cartoonist Phil Frank in his newspaper strip *Farley*. Farley himself is seated before his easel. He is reading a letter:

Dear Mr. Farley: The National Endowment for the Arts has funded many aspiring artists in the past. Two of our evaluators recently visited your studio to review your work-in-progress . . . "Soggy Cheerios with Red Wine." We find your work to

1. "Afterword: Art and Politics," in Robert Hobbs and Frederick Woodward, eds., *Human Rights / Human Wrongs: Art as Social Change* (Iowa City: Museum of Art, The University of Iowa, 1986).

be derivative, trite, pedantic and naive with virtually no artistic merit. You offer little challenge to the established powers in government, business and education. Enclosed is a check for $2,500. Congratulations.

Is such a derivative, trite, and pedantic outcome what we really want from the Endowment? More importantly, is that the kind of art that this country truly needs? I think not.

❈ ❈ ❈

# THREE

❈ ❈ ❈

# MUSEUM

❈ ❈ ❈

# TRAINING EXERCISES

❈ ❈ ❈

1 7

# DANGEROUS HYPO/THETICOL

At the start of the day, before his frustration had commenced to take over, Curtis Haupt, now in his fourth year as Director of Boston's Oriental Heritage Museum (OHM), had found himself reflecting on the remarkable neatness with which the roots of the OHM's most recent problem could be arranged into a formal and even aesthetically pleasing pattern: down, up, up again, and then again down. Remarkable, too, was the broad range of museum concerns with which it intertwined.

The initial "down" had involved the collection. Some five years before, a new and virulent form of bronze disease had suddenly begun to appear throughout New England. Some unidentified environmental factor seemed to be involved. Traditional methods were unable to arrest it. One of the earliest victims had been OHM's collection of Han Dynasty bronze mirrors, a collection unparalleled in the United States. Unless treated promptly, the collection might be lost entirely.

Three years later came the first "up." It was a breakthrough in research. Hoxup Quimica, the big Spanish chemical firm, introduced Hypo/theticol. Properly applied (a delicate process requiring that each application be varied depending on the contour, composition, and degree of deterioration of the object being treated), Hypo/theticol was far more effective in arresting this new form of bronze disease than any treatment previously available.

Unfortunately, nobody on OHM's three-person conservation staff was trained to do this work, and no funds were available to add a new position. Haupt's alternate proposal to send a current staff member to Madrid to train at Hoxup Quimica collapsed when the budget committee of the board imposed a two-year moratorium on any outlays for training. The mirror collection continued to deteriorate.

The second "up," and just in time, was financial. Searching for another way to salvage the collection and pulling every string that he and his board members could find, Haupt had convinced the Creek Foundation to award the OHM an emergency $250,000 grant to cover the necessary treatment. It was to be a three-year project with the funds specifically earmarked to cover the salary of a temporary conservator as well as for supplies and overhead. Haupt had instructed the OHM's veteran chief conservator Alonzo Flint to fill this temporary position and to get the work underway as quickly as possible.

Unaccountably—and here was the return to "down"—this promising solution had quite suddenly evolved into a personnel problem that was now threatening to become a legal one as well. Haupt had that very morning received a letter from a local attorney representing one Arlette Jolicouer. It charged that Jolicouer had been a candidate for this new conservation position and that her candidacy had been rejected on unlawfully discriminatory grounds.

Although Haupt normally tended to dismiss such complaints as "sour grapes," he felt less confident of the OHM's position after that morning's hastily called meeting with Flint and a young man from the Personnel Department. The person from Personnel had little to contribute. The choice of a qualified candidate had been left solely to Flint's judgment. Personnel didn't understand chemistry. Flint, in turn, appeared at first to be wholly open. Oh, yes, he remembered Jolicouer's application perfectly. In fact, he was actually familiar with the young woman apart from the Museum. He'd met her several times at professional meetings and knew a few of her teachers at the institute. "She's a pretty young thing," he added. "Headstrong, too." "But how," asked Haupt, brushing aside Flint's personal observations, "would you rate her as a conservator on, say, a scale of one to ten?" "On pure technical strength, eight-and-a-half, at least," said Flint. "Maybe even nine." Then what about

Merton Floob, the person whom he'd actually hired? How would he rate? "A six, easily," Flint responded. "A very solid six. A different kind of a person, though. Not as versatile or well trained as Jolicouer but more than qualified to do the work that needs to get done. He's already been on board two weeks, and things couldn't go more smoothly."

It was only when the somewhat puzzled Haupt asked Flint to explain why he would hire a "six" when, at the same salary, he might have hired a person with even broader skills and more training, that Flint began to stammer and seemed evasive. He asked Haupt if they could perhaps meet again that afternoon, preferably alone. He would explain it then.

It was now the afternoon, and Flint seemed to have regained his usual dry composure. "The real problem," Flint began, "is with the Hypo/theticol. Not being in the conservation field, sir, you wouldn't know about it, but there's been a lot of rumors lately, even some allegations of a cover-up. At the annual meeting of our conservation group back in April, five or six of the people there formed an ad hoc committee to demand a federal investigation of its toxicity. They say the published data sheets are all wrong. They say Hypo/theticol can seriously mess up a woman's insides, if you know what I mean. There's one story, for instance, that two conservators in San Francisco both had miscarriages after they worked with it for only a few weeks. There's even some who suspect that ingesting it might eventually produce sterility. That's a story I heard from Chicago. No, sir," he said, shaking his gray head, "Hypo/theticol isn't exactly the risk-free miracle that everybody thought it was. At least, not for young ladies it isn't."

Haupt looked troubled. He dreaded decisions, whether his own or others', that were made on the basis of speculative or incomplete information. So far, Flint's story sounded like little more than an old wives' tale. He had a sense that rumors of this sort, particularly about new compounds, were always circulating among conservators. "When might you really know something, one way or the other?"

"Two, three years, maybe," Flint replied. "Maybe more. Hoxup Quimica isn't helping. The Department of Labor hasn't moved, but it might if it sees an OSHA problem. Decide to wait, though, and those mirrors are gone. That's for sure. If we ducked the risk entirely by using an outside lab—I checked some prices—then maybe that Creek Foundation money will stretch far enough to treat half the collection, possibly a little more. Believe me, though, I did look at alternatives before I went ahead with Floob."

Haupt momentarily felt some relief. "Let me try to summarize this," he said. "To save the whole collection there was no choice for us but to do this conservation work right away, to do it in-house, and to do it with Hypo/thetical. You were reluctant to hire a young woman to work with that substance—or, to put it more positively—given the stories you'd heard you thought it would be irresponsible to take such a risk, so you passed over Jolicouer and you hired Floob instead. That doesn't really sound so terrible. You were not only protecting her, but you were also protecting the Museum if anything happened to her. That's what you're supposed to do. Why can't I just explain that straightforwardly to Jolicouer's lawyer?"

Flint stirred uncomfortably. "Well, sir, you can. But he'll probably bring up that matter of the waiver."

"The waiver?"

"Yes sir, the waiver. Jolicouer knew all those rumors about Hypo/thetical—we were both at the same annual meeting—and she knew exactly why I wouldn't let her work with it. So she went to that lawyer and got him to draw up a piece of paper that says she waives any legal claims that she might ever have against the Museum if she gets sick from using the stuff. She was really insistent. It was her own body, she said, and she could do whatever she wanted with it. Even assume some risk of a miscarriage or sterility if that is what she decided to do. It was her choice, she said, not mine."

"Didn't that change your mind? After all, if she'd be willing to take the risk. . . ."

"No, sir, not one bit. Maybe it might've if I thought she'd really been acting out of her own free will, but no, I was positive she wasn't." Flint pulled his chair closer, and lowered his voice. "I probably should have said this right up front, sir, but I actually know Jolicouer better than I perhaps let on. It's a small world. My wife and I, we've been friends with her parents ever since they first came to Boston from Haiti thirty years ago. Political refugees, really fine people. They're both old and terribly sick now; it's cancer, and nothing's to be done. Arlette's their only child, and she's desperate to get any job she can that could keep her in Boston, at least so long as they're still here. That's one thing. The other thing is that she's engaged—that is, she *was* engaged when all this happened; now she's broken it off—to a graduate student at Harvard. It's been a secret because she didn't want her parents to know. But that's the other reason she wanted to stay here in Boston. To be with her fiancé. No, sir, that

was no voluntary waiver. That was the terrible grip of circumstance forcing a fine young woman to sign a foolish piece of paper and act against her own best interest."

That was when the frustration began to overtake Haupt. Flint's uniquely personal approach to filling this position seemed to have wholly subverted the orderly and objective employment process he'd tried to get Personnel to establish. That the museum's procedures had to be tightened and some policies reviewed was perfectly clear. His wife's recent suggestion that Personnel's name be changed to "Human Resources" might even make some sense. Something beyond the mechanical was clearly needed. Meanwhile, however, he had this immediate problem. He stared stonily at Flint. "Have you now told me everything?"

Flint squirmed. "Well, sir, to get it all out on the table, I should tell you that it's my boy Alonzo, Jr., that Jolicouer was supposed to marry. When I wouldn't hire her, she got mad, blamed it on him, and then broke off their engagement. I think that's why she went back to that lawyer. It's a kind of revenge. You know how women get. My guess is she'll cool down in a few weeks."

"Just a minute," Haupt said with his frustration changing to anger. "I think I'm just starting to understand something. Were you really worried about Jolicouer? Wasn't it you yourself that you were just as concerned about? Weren't you worried that Jolicouer would get all messed up and that you'd wind up the grandfather of a two-headed Alonzo III? Isn't *that* really why you hired Floob instead of Jolicouer?"

Flint looked hurt. "Well, sir, maybe that *was* part of it. But family's family and a job's a job and you can't rightfully confuse the two. Look at where I was, between a rock and a hard place. I urged Jolicouer not to apply. It had to be trouble, I said. But, like I told you before, she's headstrong. Now if I hired her, it would be a scandal when people found out that Alonzo, Jr., was planning to marry her. Favoritism, they'd all say. Not good for me, or for the Museum, or even for him or for her. And if I didn't hire her . . . well, look what happened. And then there's that nepotism thing. You know, that we're not allowed to have two people from the same family working in the same department at the same time. It's in the Museum's rules. Even if I'd hired her, then once she and my boy got married somebody would have had to be let go. If I made *her* go, my son would never have forgiven me, and besides, your mirrors might probably

have rotted. And if *I* was the one who had to go, who wants to hire a conservator at fifty-nine? Don't people have a right to look out for themselves? Truth to tell, I was relieved when all those Hypo/theticol stories began to circulate. It meant there was finally a way out of this that still might leave me with an easy conscience. It could all work out for the best. Floob *was* the right answer in the end. Still is. Curing that bronze disease right now as we two just sit here talking."

"Let's approach this another way," Haupt suggested with sudden weariness. "I'm not at all sure that I can still trust your motives, and I certainly wish that you and Personnel and whoever else knew about this had come to talk to me when this thing started, but okay, Floob's here and he's doing a good job and perhaps you're right that Jolicouer really should not be asked to handle Hypo/theticol until we know more about it and regardless of whether she'd take the risk or not. And maybe, if she and your son do get back together, we can still find a way to modify that nepotism rule. Maybe it doesn't have to apply to temporary employees. You said she's versatile. Couldn't we give her something else to do in the lab? Isn't there room for that in your budget?"

"Not unless you let somebody go," Flint said. "Remember those numbers we talked about this morning. Let's still say that Jolicouer rates a nine. Well, nine's a lot higher than you'd rate either of the assistants whom I've got now. Edna Watson's a five or six, and Fred Wu's maybe a seven. People didn't get such good training in the old days. But they've each got twenty years with the OHM. I know, because I hired 'em. Does one of them suddenly get bounced the minute a pretty little nine comes along? And what then? Is little Ms. Nine only secure until that day when handsome Mr. Ten comes knocking on the OHM's door? You tell me, sir, what number does this museum put on loyalty and long service? In my lab, at least, those things certainly count for something."

Haupt, finally exhausted of questions and still without any answers, sent Flint back to his lab and sat quietly. That first pattern he'd sensed—down, up, up, down—seemed so deceptively simple compared with everything that had since unfolded. When it came time to review the OHM's policies and procedures, toward what ends were these to be directed? And what should he do meanwhile about Flint and Floob, about Jolicouer, about Watson and Wu, about the Creek Foundation, about those rotting Chinese bronzes? He needed to establish a pattern that would somehow relate all the different considerations that were now jostling one another for priority. How could he best define

and sort these out? What priority should he give to what? What mattered most, what least?

Help Haupt. See the questions that follow.

## DISCUSSION QUESTIONS

1. How do the various members of your group feel about Flint? Positively? Negatively? Does he seem like (a) an essentially good person who, in a difficult situation, has tried to do his best for the Museum, or (b) a meddlesome and insensitive person who, confronted by a dilemma, has taken too much authority into his own hands and caused the Museum considerable damage by improperly mixing his personal life with his work life? Or does he seem like neither, a little of each, or something else? Is there any feeling common to your group, or do its members respond to Flint in a variety of ways?

2. Regardless of how your group's members may feel personally about Flint, what action, if any, would the group (by consensus or a substantial majority) recommend that Haupt take with respect to Flint? Is Flint to be officially rewarded, reprimanded, retired, offered training, something different, or none of the above? On what basis?

3. If Jolicouer does begin a law suit, the Museum's lawyer believes that there is a 50/50 chance that the Museum will ultimately (in three years, perhaps) have to pay a total of $250,000 in damages, court costs, and the legal fees for both sides. The other 50/50 chance is that (if the case goes to trial and the Museum should win) the Museum will only have to pay its own legal fees of approximately $50,000. She also thinks that the Museum could settle the case immediately (with a stipulation that the details not be disclosed) for $125,000. From the Museum's point of view, what are the relative merits (financial and otherwise) of (a) proceeding with the law suit in the hopes of winning it, versus (b) settling the matter as promptly as possible?

4. Haupt might try to avoid the hard choice between either a protracted law suit and an expensive money settlement by offering a job to Jolicouer right away. This may also be the preferred solution of the Museum's board (which has yet to be fully informed of this problem). Given that Jolicouer is basically "better" qualified as a conservator than either Watson or Wu

because of her more recent and extensive training, what arguments might be made (a) for and (b)against his directing Flint to replace one or the other of these other conservators with Jolicouer? Which argument does your group find more compelling?

5. Alternately, should Haupt accept Jolicouer's willingness to assume the risk of working with Hypo/theticol at face value and direct Flint to replace the newly hired Floob with Jolicouer? Is the question of whether he would have any "right" to do this different from whether it would be "responsible" of him to do so? Toward whom or what ought Haupt be expected to be responsible?

6. As still another alternative, Haupt might ask the board's budget committee for the authority to create either a new conservation position or a collection-related nonconservation position for which Jolicouer might still be qualified. In Haupt's view, the latter might be the least costly solution to his problem consistent with maintaining the orderly operation of the conservation laboratory. What costs (financial and otherwise) might this entail? What benefits might it provide?

7. Given that Jolicouer had every "right" to apply for the temporary conservation position and to seek legal redress when she failed to get it, does your group have a common view as to whether—given (a) the uncertainties about the safety of Hypo/theticol and (b) Jolicouer's potential family relationship to Flint—her conduct was also "responsible"? Toward whom or what ought Jolicouer be expected to be responsible?

8. How do you envision that the Museum's board will respond to this problem once it is fully informed? What values are most likely to animate its preferred solution? Where might it tend to place any blame?

9. Rank order (by consensus or a substantial majority) the priority in importance you would assign to the following (alphabetically listed) thirteen considerations as they might be applicable in a typical museum setting. Your rank order need not be absolutely precise but can indicate which considerations your group would include in the top four, which in the middle five, and which in the lowest four.

Rank

(a)  Avoiding or eliminating conflicts of interest          _____

(b)  Creating and sustaining high public regard             _____

(c)  Keeping personal secrets                               _____

(d) Maintaining fair employment practices     ————

(e) Making the most efficient use possible of scarce resources   ————

(f) Operating within budget     ————

(g) Preserving the collection     ————

(h) Providing staff with ongoing training     ————

(i) Recruiting and maintaining staff of the highest possible
competence     ————

(j) Respecting individual autonomy     ————

(k) Rewarding loyalty     ————

(l) Protecting staff morale     ————

(m) Assuring workplace safety     ——

# SOME PERPLEXING ADMISSIONS

On Saturday, December 26, 1992, *The New York Times* carried a front-page story about the increase in illegal ticket scalping for sports and cultural events in New York City. Among the tickets that it reported as being "scalped" were those for the Henri Matisse retrospective exhibition at the Museum of Modern Art (MOMA). Visitors wishing to avoid the approximately two-hour wait in line for same-day admission could buy tickets normally priced at $12.50 from such sidewalk scalpers as were successful in evading the local police. The ticket prices charged by these scalpers ranged from $20 up to $50 apiece. Richard H. Thaler, an economist at Cornell University, was quoted as follows:

You don't have to put a very high value on your time to pay $10 or $15 to avoid standing in line for two hours for a Matisse ticket. Some people think it's fairer to make everyone stand in the line, but that forces everyone to engage in a totally unproductive activity, and it discriminates in favor of people who have the most free time. Scalping gives other people a chance, too. I can see no justification for outlawing it.

## HYPOTHETICAL 1

On the following Monday morning, the Director of MOMA received three communications with regard to this situation, each enclosing a clipping of the

*Times* story. The first was a note from one of his long-time board members. "I am puzzled by our policy," the note read. "If some of our visitors (quite reasonably, if they only have a limited amount of time) are really prepared to pay a premium for immediate admission, why are we not collecting that ourselves? Why should it go to these scalpers? How can I ask potential donors to assist us when we are so obviously unwilling to assist ourselves? I am also troubled that (inadvertently, I am sure) we have created a situation in which unlawful acts are being committed immediately adjacent to the MOMA premises. I also dislike the fact that, as a result of our failure to address this, some of our visitors feel themselves compelled to deal with an undesirable criminal element. That can only reflect poorly on us. Something must be done. To take this admission opportunity for ourselves should both signal our ability to control this situation and also drive these scalpers from our door. Shall I propose this to the board when it meets next week, or can you suggest a better alternative?"

The second communication came through interoffice mail. It was from the head of museum security. From his perspective, he said, this situation had to be corrected immediately. He proposed to move quickly on three fronts. First, the bootleg tickets had to be cut off at their source. A simple sting operation ought do the trick. A few staff people might have to be let go, but the rest would get in line. Second, for any tickets already out there, he needed to cool down the market. Visitors presenting bootleg tickets should be refused admission. Getting their money back would be their problem, not MOMA's. Perhaps a few of these visitors could also be escorted out through the lobby with a maximum show of force. Humiliation, he noted, can be a grand deterrent. If one or two might possibly be arrested with some attendant newspaper coverage, so much the better. Third, it would be good to put some additional heat on the scalpers themselves. He had friends in the New York Police Department who could manage that. Funny things can happen in a station house, and word gets around quickly. At most, it might cost MOMA an extra table or one of those anonymous full-page program ads at next April's Patrolmen's Benefit Ball. Could he proceed on these lines, or would the Director like to suggest something better?

The third communication was a note from the business agent for Local 2XY, the union local that represented MOMA's stationary engineers. MOMA's current contract with Local 2XY was to expire in several months.

The note read as follows: "During our forthcoming collective bargaining sessions, I fully expect to hear—it's always the same refrain—that even if MOMA was to grant the undeniable justice of our demands, the money just isn't available to meet them. Without intending to interfere with your sacred management prerogatives or presuming to understand the gentility of the art world, my highly mechanically minded members will very much want to know why the dollars that should and could be going into their paychecks are being ripped off instead by those low-life sleazeball scabs out there on West 53rd Street. Don't bother to reply now. I'll expect MOMA's answer when we sit down to bargain."

Help the Director formulate his responses to these several communications. Imagine (which was not the case) that the Matisse exhibition still has ten weeks left to run.

## HYPOTHETICAL 2

The Alameda (Arizona) Contemporary Art Center (ACAC), now under construction on city parkland with funds raised through largely local private contributions, will open next year. Not intended to be a collecting institution, it plans to present four exhibitions a year—some self-organized, the balance coming from other sources. Each year's major exhibition will be planned to coincide with the winter tourist season.

Based on attendance at a nearby natural history museum (also in the park), the first year's admissions revenue for ACAC has been estimated for budget purposes at $200,000. However, several currently unfunded projects could easily absorb any admissions revenue that might be realized in excess of that figure. The board of trustees is scheduled to meet shortly to determine exactly how the ACAC's admission charges are to be imposed. Among the suggestions that have thus far been advanced by members of the eleven-person board are the following:

One trustee, a real estate dealer active in local politics, has suggested that, in recognition of ACAC's free use of city land and in the hope of future municipal benefits, Alameda residents should be charged a substantially lower admission than visitors who come from outside the city. He thinks that this would contribute importantly to an increased sense of local pride

and ownership. Also, it should not be administratively burdensome. A driver's license or similar document could be shown at the admissions desk as proof of residence.

A second trustee, herself the artistic manager of the neighboring nonprofit community theater, has suggested that the ACAC follow her theater's traditional practice of charging a 25 percent higher ticket price on weekends when the demand is highest. She is perplexed, she says, as to why this is not a more common practice in the museums she has visited.

A third trustee, a high school principal, disagrees in principle that the ACAC ought try to get *any* substantial revenue through admissions. Admission, he says, should be free or as close to free as possible. Anything else will limit accessibility. When the ACAC seeks funding for its four first-year exhibitions, every request should include (over and above exhibition costs) an item of $50,000 as a payment in lieu of admissions. When admission must be charged for a particular exhibition, then it should be openly linked to the exhibition's cost so that the public will understand that the charge is a fair and necessary one. His impression is that this was how MOMA in New York was able to justify the $12.50 it charges for its current Matisse exhibition. People will always be happy to pay what is fair.

A fourth trustee, a local stockbroker, disagrees completely with the principal's principle. She thinks that every exhibition ought have some admission charge. People tend to have more respect for what they have to pay for than they do for what they get for nothing. Moreover, cost is irrelevant. Demand is the key. Admission charges should be adjusted upward for those exhibitions expected to be most popular, reduced for those expected to be least. She cited the current Matisse exhibition in New York where MOMA had been able to charge an unprecedented $12.50 because it was sure the exhibition would be such a hit. She had even heard that midway through the exhibition MOMA was able to set up a separate window where visitors who paid $50 for a special twelve-hour museum membership did not have to wait in line at all. Some of her Wall Street colleagues had used it and thought it was great.

A fifth trustee, a local painter and printmaker, thinks that the process of setting admission ought begin by first considering what the ideal conditions would

be under which visitors could see works of art in an optimum way. How many people at once? Staying how long? The board could then work backward to find an admission structure likely to produce the desired effect. She described this as putting the end ahead of the means. What was the point of ACAC except to provide a quality aesthetic experience? To be avoided at all costs, she said, was what she had experienced when she recently saw the Matisse exhibition in New York. First, people were made to stand in the cold for two hours. Then they were jammed into the galleries like cattle—another five hundred admitted every half-hour! It was completely self-defeating.

A sixth trustee, a local surgeon and art collector, thinks that, rather than depending on something as "iffy" as admissions revenue, the ACAC ought seek an endowment in lieu of admissions. Four million dollars at a yield of 5 percent would exactly supply the $200,000 called for in the budget. Coincidentally, that was very close to the sum currently under discussion with the Alameda Foundation to endow the directorship and two curatorships. Perhaps those potential endowment funds could better be used to ensure both that admission would always be free (he agreed with his friend the high school principal on this) and that the ACAC would always have a steady stream of unrestricted income.

A seventh trustee, the publisher of a national magazine, thinks that would be a mistake. The principal consideration in establishing an admission charge, she says, ought be the degree to which it could help in selling annual memberships that would, in turn, include free admission as a benefit. She likens this to selling magazine subscriptions by maintaining a high price for single copies. She also thinks such a membership program would be additionally important in beginning to build a donor base. That is where the real money will be, she says, not in admissions.

An eighth trustee, the executive director of a family counseling center, favors voluntary contributions in lieu of any fixed admission charge. If that is good enough for the country's largest art museum—the Metropolitan Museum of Art—it is good enough for him. He would also prefer, however, that (unlike the Met) no contribution level be suggested because he considers that to be potentially intimidating, particularly to those who are least able

to contribute. He also questions whether the board should be dealing with this issue at all. A director and staff will shortly be in place, and this sort of technical matter might better be left to their expertise.

A ninth trustee, who manages his family's philanthropic foundation, is concerned that, without a mandatory admission charge that is high enough to act as a barrier, the ACAC may quickly be overrun by the several dozen homeless people who now camp out at the edge of the park. This could be particularly problematic in the rainy season. His foundation's attorney has advised him that, given the underlying city land, it might be difficult to keep these people out of the building during the ACAC's regular public hours. Although he does not personally object to offering shelter, he can imagine that the habitual presence of these people might prove a deterrent to other visitors and to potential corporate sponsors. He is also apprehensive about vandalism (and the impact that this might have on the ACAC's ability to borrow exhibitions) insofar as some of these people may be mentally disturbed.

A tenth trustee, the retired president of a local bank, agrees that there should be an admission charge in most instances but wants to be sure that it is in all cases fair. Senior citizens, for example, should certainly get a special discount. He also favors a special discount (perhaps slightly larger) for students. He would also like to see the establishment of a free day on either a weekly or monthly basis, free admission for those who accompany handicapped visitors for the purpose of giving them assistance, investigation of a reciprocal membership arrangement with other museums in the area, a combination entry ticket with the nearby natural history museum, a first-time visitor introductory reduction, a special annual pass for teachers and practicing artists, and a reduced charge for members of museum-related, art-related, and craft-related professional organizations. He would, however, limit the number of fully applicable discounts for any one visitor to two on weekends and perhaps three on weekdays except on the free day (which would be free).

Finally, the eleventh trustee, the owner of a chain of one-price women's shoe stores, disagrees with all these suggestions. For better administrative convenience and the simplicity of public communication, she says, there ought be a single widely known and well-understood admission price that

is equally applicable to all visitors, at all times, and for all exhibitions. It works for shoes, she says. It should also work for shows.

## DISCUSSION QUESTIONS

Should the board of the ACAC be addressing this issue? If so, what considerations should it take into account in evaluating these various suggestions? If not, which should the to-be-hired staff take into account? Which two or three of these, by themselves or in combination, does your group find most attractive? Which two or three does it find least attractive?

# 19

# ROB ROY'S GIFT REVISITED

I must study politics and war, that my sons may have liberty to study mathematics and philosophy, geography, natural history and naval architecture, navigation, commerce, and agriculture, in order to give their children a right to study painting, poetry, music, architecture, statuary, tapestry, and porcelain.

—John Adams to his wife (1780)

## FOUR YEARS AGO

The confidential letter to the chairman of the Crawgo Museum's board of trustees could not have been more to the point. The letter came from Rob Roy, Jr., the chief executive officer and, along with his three sisters, one of the four principal stockholders of Rob Roy Enterprises (RRE), the armaments firm founded by their father, the legendary General Rob Roy. In brief, Rob Roy, Jr., wanted his eldest son Rob Roy III elected to the board. If the chairman could assure him that several informal conditions could be met, he was then prepared to pay for that and to pay well.

Adapted from "Rob Roy's Gift" by Stephen E. Weil and James R. Glenn, Jr., first published in *Ethics in Nonprofit Management: A Collection of Cases* (San Francisco: University of San Francisco), 1990.

"Your endowment currently stands at $40 million," he wrote. "My gift of $10 million worth of RRE common stock would increase it by 25 percent in one shot. What I ask of you in turn is twofold. First, that the members of the board's investment committee undertake to be guided by me in voting this stock. The armaments business is a tricky one, and the most innocent-appearing of stockholder proposals may often harbor an unexpected and unwelcome hook. Second, the investment committee must undertake to retain this stock indefinitely as a block, regardless of whatever pressure there may be to diversify the Museum's portfolio and regardless of the fact that the stock may not always perform well. RRE's core business—providing original equipment, replacement parts, and training to police and militia throughout the world—is a volatile one, and there will inevitably be some bad years mixed in with the good. Under no circumstances can the investment committee panic. The stock must be retained."

"Lest this latter point still be of concern to you, consider it this way: something is invariably better than nothing. If the value of this stock should fall even as low as $1 million, that is still $1 million more than the Museum has today. The worst that you can finish is dead even. If the logic of my proposal still eludes you, then I can just as easily find a board position for my son in another cultural organization, one that would be only too happy to accept such a $10 million gift and hold it—through good times and bad. Rob III would be a splendid candidate anywhere. He graduated from Yale with honors, he has an MBA from the Wharton School, and over the past fifteen years at RRE he has advanced entirely on his own merits to become an assistant vice-president for finance and administration. That I will place him elsewhere if you cannot agree to my terms is not an idle threat. The control that my sisters and I still retain over RRE is by a relatively narrow margin. Our family simply cannot afford to let this block of stock fall into the hands of strangers."

"Finally, please understand that the contents of this letter are to be treated on a need-to-know basis. With your forty-plus member board of trustees, information like this must of necessity be restricted. You will clearly need to share the main points with the nominating committee as well as with the investment committee. As I count it, that means eleven people at most. Beyond that, this letter is to be regarded by you as a privileged communication. To maintain its confidentiality, I will require nothing from the board itself. Your personal and verbal assurance will be sufficient."

Persuaded that this truly was a win-win situation, the chairman convinced the members of the nominating committee that nothing was to be lost by accepting Rob Roy, Jr.'s proposal. Rob Roy III was subsequently interviewed by members of the committee and he made an extremely favorable impression. With his broad cultural interests, his enthusiasm for the Museum, and his manifest financial skills, he promised to be a valuable addition to the board. His nomination was unanimous, as was his subsequent election. Shortly thereafter, Rob Roy, Jr.—profoundly moved, he said, by this honor so recently conferred on his son—announced his $10 million gift to the Museum.

## DURING THE PAST FOUR YEARS

As expected, Rob Roy III has proved to be an energetic and popular member of the board. He has been active on the acquisition, investment, and budget committees, has taken the initiative in organizing several successful fund-raising events, and has recently helped to recruit two new and extraordinarily well-connected trustees. Following his first three-year term, he was easily reelected for a second.

Meanwhile, though, just as Rob Roy, Jr., had cautioned it might, the stock of RRE has had a precipitous fall. Several outbreaks of peace have had an adverse effect on the armament business. Belatedly, the stock has begun to appear regularly among brokerage house "sell" recommendations. Only the hope that a group of dissident stockholders—they call themselves the "swords into ploughshares" faction and want to move RRE out of the armaments business—might take control has kept the stock from collapsing completely. The Museum's original $10 million stake has shrunk to some $3.6 million. Most recently, RRE abruptly suspended its previously generous dividend.

## TODAY

Word has reached the Museum that the local *Crawgo Times-Star* is planning a series of articles on the different ways in which the local nonprofit organizations—the two private hospitals, the college, the chamber orchestra, and the Museum—manage their endowments. Although this series will ostensibly focus on questions of fiscal probity and social responsibility, it will also provide the *Times-Star* with a vehicle to publish some detailed information about these

endowments recently leaked to it by a former employee of the local trust company. Among other things, this information will show that—notwithstanding its recent $6.4 million loss in value—RRE stock still constitutes more than 8 percent of the Museum's endowment. By comparison, none of the Museum's other holdings—chiefly such blue-chip securities as General Electric, Ford Motor, and Pacific Telesis—amounts to more than 2 percent. In none of the other local nonprofit organizations does the largest single holding in its endowment exceed 3 percent. Inevitably, the *Times-Star* will carry a follow-up editorial demanding that the Museum explain why it continues to maintain such a disproportionately large holding of RRE stock.

Because the board's budget committee had counted on using the endowment's actual income toward meeting the current year's expenses, the abrupt suspension of RRE's dividend will require the deferral of a planned salary increase and the elimination of several positions. The *Times-Star* series will probably touch on that as well. One affected employee told a reporter that the Museum was trying to cover up the fact that it had recently "lost millions of dollars" through a stupid investment. Was it fair, he asked, that the staff should have to pay for the board's mistakes?

The Museum's powerful curatorial council has for some years urged that the Museum divest itself of investments in any companies that did a substantial business in [current hot spot]. Toward that end, it recently requested a list of the stocks held in the Museum's endowment. Anticipating that such a list will in any event be published shortly in the *Times-Star,* the Museum's director is recommending that the Museum take the initiative and provide this list itself. RRE does a substantial business in [hot spot], and the Museum's continued retention of its stock as the endowment's largest holding will certainly become a contentious issue with the Council.

A gossip columnist recently reported that there had been a falling out among the late General Roy's four surviving children. Several members of the investment committee (not Rob Roy III, though; he has assiduously avoided any conversations with his fellow trustees about RRE as potentially improper on his part) have discussed among themselves a rumor that two of Rob Roy, Jr.'s three sisters might now be prepared to join with the swords into ploughshares faction to try to replace RRE's current management. How the Museum votes its shares in a shortly upcoming RRE board election may be both (a) critical to the election's outcome and (b) a matter of public record.

Whereas the investment committee has normally decided itself how to vote the Museum's shares in corporate elections, the committee chair feels strongly that in this instance the matter is so important that it ought be decided by the entire board. Because that may conflict with what he understands to be the board chairman's original agreement with Rob Roy, Jr., the committee chair intends to seek guidance from the board chairman as to how best to proceed under these circumstances.

## DISCUSSION QUESTIONS

1. To what extent does your group find that the conduct of the following either falls short of or meets the customary legal standards that require those who serve as trustees of not-for-profit organizations to avoid conflicts of interest and to exercise prudence in the discharge of their responsibilities?
   (a) The board chairman
   (b) Rob Roy III
   (c) A trustee who serves on neither the nominating nor investment committees and is otherwise employed as president of the local college
   (d) A trustee who serves on neither the nominating nor investment committees and is otherwise employed as a grade school teacher

2. Does your group have any common response to Rob Roy, Jr.? Is there any standard to which you feel he is required to adhere? If so, what is it and has he done so?

3. Assume that your group constitutes the Museum's board of trustees and that you have just been made aware of this entire situation. What are your principal concerns? What would you consider most important steps to include in a comprehensive plan of action?

4. Turn back the clock by four years. Assume that Rob Roy's original offer had been fully disclosed to your group as the Museum's board of trustees. How might you have best dealt with this if you had known all the details of his offer from the beginning?

5. What did you find to be the single most important lesson from this case?

※ ※ ※

# SOME

※ ※ ※

# LEGAL AND OTHER

※ ※ ※

# CURIOSITIES

※ ※ ※

# RESALE ROYALTIES FOR ARTISTS: BOON OR BOONDOGGLE?

Nestled inconspicuously within the Visual Artists Rights Act of 1990 that President Bush signed into law in December 1990 was a provision directing the Register of Copyrights, in consultation with the Chair of the National Endowment for the Arts, to conduct a study on the feasibility of implementing "a requirement that, after the first sale of a work of art, a royalty on any resale of the work, consisting of a percentage of the price, be paid to the author of the work."[1]

The campaign for such a nationally mandated resale royalty has been waged more or less continuously since Diana B. Schulder first proposed such legislation in a 1966 article in the *Northwestern Law Review*. Within the United States, only California has adopted such a statute—a 5 percent resale royalty in 1976. A subsequent effort by the Art Dealers Association of Southern California to have the law declared unconstitutional was defeated in the federal courts.

---

1. The report of the Register of Copyrights was forwarded to Congress on December 1, 1992. In it, he reported that "the Copyright Office is not persuaded that sufficient economic and copyright policy justification exists to establish *droit de suite* in the United States."

First published in *ARTnews* 90 (May 1991).

This new study of resale royalties is to be concluded by the spring of 1992 and conducted in consultation with, among others, "artists, art dealers, collectors of fine art, and curators of art museums." Yet to be seen is whether it will fan what only recently appeared to be a dying ember or finally extinguish what many have opposed as a flawed proposal.

My views concerning a resale royalty (in essence, that it would prove detrimental to the art community as a whole) were first set forth in these pages more than a dozen years ago.[2] My contention that such a royalty would further enrich a minority of economically successful artists at the expense of the vast majority of less successful ones paralleled the conclusion reached ten years earlier by Monroe and Aimée Brown Price in their pioneering study of the resale royalty in France: "To those who have shall more be given." Has anything happened in the years since to change that conclusion?

To the contrary, the situation that prevailed in 1978 has, if anything, become exacerbated. The disparity between the earnings of a handful of highly successful artists (those most likely to benefit from a resale royalty) and the overwhelming majority of less successful ones now appears greater than ever. (Such an increasing gulf would accord with what happened to incomes in the United States generally during the 1980s.) Today, it is not unusual for a number of well-publicized artists to sell their work in the primary market for six-figure prices or, in the case of those few already considered "masters," even seven-figure prices. The resale or secondary market for these artists is often higher still.

Meanwhile, what was widely suspected in the 1970s now appears to have been dismally confirmed: that the resale market for most contemporary artists (those least likely to benefit from a resale royalty) is a killing field. Less often than not does a work of contemporary art ever again attain the price at which it was originally sold. In the two-tier art market, what is not ranked "zowie" seems to be worth "zip." One has but to review the sales results at Christie's East or Sotheby's Arcade sales to find instance after instance of collectors selling works of art at nominal prices considerably below what they originally paid. To take inflation into account simply compounds the loss.

Such market trends aside, however, the proponents of a resale royalty have still never countered two of the principal objections leveled against it. The

2. See "Resale Royalities: Nobody Benefits," *ARTnews* 77 (March 1978): 58.

first involves fairness. One of the justifications urged for such a royalty is that there is or ought be a continuing economic connection between the artist and his or her work. The connection envisioned, however, is one that works wholly to the prejudice of the collector. It is, in essence, a one-way umbilical cord. The artist shares in profits but not in losses. Neither does the artist share in any of the time-related expenses of collecting such as loss of income on the funds invested or the costs of insurance, storage, and conservation, notwithstanding that these may ultimately contribute to a work of art's retention or increase in value.

Moreover, a resale royalty based on a percentage of the gross sales price rather than on whatever profit the collector may realize produces an irrational distribution of benefits. The velocity of turnover can replace ultimate market value in determining which artist gets what. Using the California formula of a royalty equal to 5 percent of the gross selling price, we can obtain the following result: Two artists each sell a painting for $10,000. One is resold four times at the progressively higher prices of $20,000, $40,000, $60,000, and $80,000. The artist receives a total of $10,000 in resale royalties. During the same time period, the other painting is resold only once, but for $100,000. The second artist—albeit his work is more highly valued by the market—gets $5,000, or just half.

That anomaly might be cured if the royalty were only applicable to the profit realized and not to the entire purchase price. (Italy, for example, has a remarkably intricate resale royalty intended to do just that.) To do so, however, would be to expose the resale royalty for what it really is: a private income tax, uniquely imposed not to benefit the public at large, or even the art community generally, but only a handful of specific and, for the most part, already affluent individuals.

Private art collectors no longer enjoy the income tax benefits that they once did. In recent years, the benefit of favorable capital gains treatment on any art-generated income has been all but eliminated and, beginning with this year, collectors have also seen an increase in the top marginal rate applicable to their other income. Might the imposition of still a further 5 percent tax (on both their income and return of capital) through the resale royalty be a disenchantment to collecting contemporary art? Economists think that it would and that (through the loss of some sales without an offsetting payment of royalties) most contemporary artists would be the principal losers.

Ought we not have learned by now (see Eastern Europe, for example) that economic policy (even in so small a puddle as the art world) ought to be based on probable outcomes for real people and not on abstract theories about the justice or injustice of markets? However commendable the resale royalty may be as an ideal, in the form thus far proposed its application can only be counterproductive. The forthcoming public study ought to make that finally clear.

# RESALE ROYALTY HEARING:
# NEW YORK CITY

As the panel members know, I have previously raised questions about the propriety, the utility, and the potential consequences of the resale royalty in two articles originally published in the March 1978 and May 1991 issues of *ARTnews* magazine. Copies of those articles have been submitted to the Copyright Office, and I will not attempt to repeat their substance here. The observations that follow are brief and are intended to be largely supplementary. They represent solely my own views and in no way reflect those of the Hirshhorn Museum or the Smithsonian Institution.

Like any market, the art market is a complex mechanism. Proposed legislation that would substantially interfere with its customary operation ought not to be considered lightly. That a particular group of visual artists might themselves benefit through the establishment of a resale royalty is not in itself a sufficient reason for its imposition. To justify resale royalty legisla-

Testimony presented March 6, 1992, at a hearing on resale royalties held by the U.S. Copyright Office in New York City. Portions of this testimony were subsequently reprinted in the *Columbia-VLA Journal of Law and the Arts*. The Copyright Office's report based on both this and an earlier hearing in San Francisco on the same subject was published on December 1, 1992, under the title *Droit de Suite: The Artist's Resale Royalty*. An accompanying appendix included transcripts of both hearings as well as other materials.

tion, something more would be necessary. A simple three-part test might be as follows:

1. What (in the language of an old English case) is the particular "mischief" that the proposed legislation would be intended to remedy?
2. To what extent would such legislation in fact be effective to remedy that particular mischief?
3. In its consequent redistribution of economic benefits and burdens, to what extent might the proposed legislation be the source of some new mischief as great or greater still than the mischief it was initially intended to remedy?

The case of the resale royalty has been argued intermittently in the United States since it was first proposed by Diane B. Schulder in 1966. In my own view, its proponents have yet to offer any consistently satisfactory answer to the most basic of these questions: What is the "mischief" that such a royalty would be intended to remedy? In general, their efforts to justify a resale royalty have followed four principal lines:

1. Increases in the market value of a work of art subsequent to its first sale are attributable to the artist's continuing efforts.
2. The inequality of bargaining power between those who produce art and those who collect it gives rise to a situation through which collectors are enabled to enrich themselves unjustly at the expense of artists.
3. Visual artists suffer an economic disadvantage in comparison with such other serious creative individuals as authors and composers who receive a greater part of their compensation through royalties.
4. The resale royalty—functioning as a sort of economic "umbilical cord"—might serve as the means through which visual artists could maintain a continuing relationship with the works of their own creation.

To consider these arguments in order:

That an artist's continuing efforts might—as an incidental consequence—increase the secondary market value of his or her earlier work is certainly true. It is equally true, however, that the artist's premature death might produce exactly the same effect. So could the artist's failure—see, for instance, the examples of de Chirico, Vlaminck, or Utrillo—to live up to his

or her earlier promise. So could a devastating studio or warehouse fire that reduced the available supply of the artist's work. So could the inclusion of the artist's work in a particularly well-known collection. So even could an inflation of the art market generally. Unpalatable as some may find it, works of art in the marketplace are priced like any other commodity. Their value in the market fluctuates with the interplay of supply and demand. Any number of factors can have an effect on one side of that equation or the other. What the artist does is simply one.

Let us assume, though, for argument's sake, that the artist's continuing efforts *could* be identified as the principal factor in increasing the value of his or her work. By what self-evident principle would it then follow that the artist was entitled to a share of any such increase? If I should be able to sell my house for more than otherwise because a real estate developer had built a golf course nearby, would anybody seriously argue that I should pay the developer some portion of that incidentally bestowed benefit? Likewise, if the value of my house were to increase because the architect who designed it subsequently became famous, would anybody really contend that the architect was entitled to share in some portion of the sale proceeds? Incidental benefits, like incidental burdens, are simply a normal part of everyday life. We do not keep books on them. We simply assume that they will more or less balance out over time.

The argument that would justify a resale royalty on the unequal bargaining power of artists and their collectors appears rooted in that romantic vision of the art world that Monroe and Aimee Brown Price described in their 1968 *Yale Law Journal* article[1] analyzing how such royalties worked in France. It was, they said, a vision

of the starving artist, with his genius unappreciated, using his last pennies to purchase canvas and pigments which he turns into a misunderstood masterpiece. The painting is sold for a pittance. . . . The purchaser is a canny investor. . . . Thirty years later the artist is still without funds and his children are in rags; meanwhile his paintings, now the subject of a Museum of Modern Art retrospective . . . fetch small fortunes at Parke-Bernet and Christie's. . . . The *droit de suite* is *La Bohème* and *Lust for Life* reduced to statutory form.

---

1. "Government Policy and Economic Security for Artists: The Case of the Droit de Suite," *Yale Law Journal* 77 (1968): 1330.

The description of the nineteenth-century Parisian art scene given by Liliane de Pierredon-Fawcett in her comparative law study *The Droit de Suite in Literary and Artistic Property*[2] is not markedly different:

In point of fact, while Impressionist masters, excluded from official publications, were scorned by the public, certain shrewd dealers bought their paintings at ridiculously low prices. General disdain was followed by infatuation and these same paintings then commanded extraordinary amounts of money. . . . The artists were excluded from this wealth.

Whether this once was the case in France, it is most emphatically not the case in the United States today. It is true, certainly, that the overwhelming majority of American artists earn extraordinarily little from their calling. A 1991 study by the Center for Arts and Culture at Columbia University indicated that 73 percent of currently active painters earned annual incomes of $7,000 or less from the sale of their artwork. Fewer than 5 percent had annual incomes from their art of more than $40,000. In each case, these are gross figures before any deduction for studio and other art-related expenses.

It is also certainly true that there are several living American artists whose work can regularly command five- to seven-figure prices in the secondary market. There are not, however, very many of these. For works of art to be offered for auction in the main salesrooms of Sotheby's or Christie's, for example, their estimated value must generally be $10,000 or greater. According to a representative of Sotheby's, the total number of living American artists whose work was thus offered for sale at either auction house during the 1990–1991 season was 219. That constitutes something considerably less than 1 percent of all the visual artists now working in the United States and perhaps even as little as one-tenth of 1 percent. Adjust this figure as you may, it will still include only a handful of artists.

What has yet to be demonstrated is that any substantial number of contemporary American artists are themselves living in reduced circumstances while their work is simultaneously commanding high prices in the secondary market. That should be no surprise. These markets are not independent of each another. They are functions of one another. What emboldens

2. Center for Law and the Arts, Columbia University School of Law, 1991.

a collector to pay a higher price for an artwork on its first sale in the primary market is the knowledge of a strong secondary market that can act as a safety net in case the work should be resold. A $100,000 painting that can, with some certainty, be resold for at least $90,000 requires a great deal less courage to purchase than a $20,000 painting that can never be resold at all.

Also implicit in this unjust enrichment argument is the suggestion that collectors may be able to use their putatively greater bargaining power to buy works of art from artists for less than their real worth. This, too, involves a romantic fiction. In economic terms, there is no "real worth" to a work of art (or anything else in the market) except what a purchaser will pay for it. Works of art are worth what they sell for once the calculus of supply and demand has run its course. The argument that collectors enrich themselves unjustly at the expense of artists remains to be proved.

Again, it certainly is true that visual artists are compensated in a different manner than other creative individuals. That, however, has not necessarily worked to their disadvantage. To the contrary, the successful visual artist would, when measured in economic terms, appear to have been enormously successful. Although Pablo Picasso (with an estate estimated in the billions of dollars) or—to move from the sublime to the local—Andy Warhol (on February 11, *The Chronicle of Philanthropy* reported his estate to now be valued at $298 million) may represent an extreme, one must nevertheless be struck by the number of American artists who have been able to leave behind such sizable charitable enterprises as the Rothko Foundation, the Pollock-Krasner Foundation, or the Adolph and Esther Gottlieb Foundation. There is no evidence that serious creative artists who are compensated through royalties have done nearly so well as have successful visual artists.

It is argued, lastly, that the resale royalty might serve as a sort of "umbilical cord" to permit the artist some continuing relationship with his or her work. As I have pointed out elsewhere, though, an umbilical cord that transmitted nothing but potential gains would be a very curious and selective appendage indeed. Filtered out entirely would be the collector's ongoing expenses for framing, insurance, conservation, storage, and the time-use of capital. Filtered out as well would be whatever loss the collector might suffer on a resale, even a resale of the same artist's work. In the best of all worlds, where it did not cost anything to own anything and the art market could only go up, such a one-way umbilical cord might still have a certain plausibility. In the real world,

where everything has a cost and the value of artworks can both go up and go down, it seems manifestly inequitable.

To move then to the second point of our inquiry, if we nonetheless could perceive some mischief here that needed to be remedied, what kind of a resale royalty would be effective to provide such a remedy?

If the collector's putatively unjust enrichment is taken to be the basis for imposing such a royalty, then the basis for calculating the royalty ought be relatively simple. It would be based, presumably, on the net amount by which the collector had been enriched after reducing the gross profit realized by the cost of resale and by whatever other deductible expenses had been incurred during the intervening period of ownership. It would, in other words, be calculated in much the same fashion as any other income tax. Thorny questions to be resolved might include the degree to which losses on the sale of contemporary art might be balanced against gains, the degree to which inflation might be taken into account in measuring gains and losses, and the calculation of the cost-basis of works of art received as gifts or bequests or through exchanges.

Whether the Copyright Act (not to say the Copyright Office) is the most appropriate vehicle through which to operate such a mechanism or whether it would be better left to the Tax Code and the Revenue Service is by no means clear. Also unclear is how such an additional tax might be integrated into the existing system of tax law. Neither is it clear whether a proposal to increase the tax burden on capital gains transactions of this particular kind would have any real political viability just now.

Wholly clear, however, ought be how rational such an income tax–like approach would be in comparison with what has most frequently been proposed and what actually became the law in California: a resale royalty based on an artwork's entire resale price (i.e., on both the collector's profit *and* on the collector's underlying capital investment). In her study of the *droit de suite,* Ms. Pierredon-Fawcett acknowledged that such an approach, as it was applied in France, "departed from [the] rationale" of the resale royalty. She seemed to suggest, however, that a resale royalty based on appreciation alone (i.e., one that functioned as a form of income tax) would have been impractical in France because of the difficulty in tracking successive sales. Our situation in the United States is different. In general, the requirement that such sales be reported for income tax purposes would put most of the necessary information on official record.

Rather than remedy any claimed mischief, a resale royalty calculated on the entire selling price produces a wholly arbitrary distribution of benefits. In place of some estimate of the increase in the value of art works, it substitutes the velocity of their turnover as the chief detriment of who is to get how much. As I pointed out previously,

Using the California formula of a royalty equal to 5 percent of the gross selling price, we can obtain the following result: two artists each sell a painting for $10,000. One is resold four times at the progressively higher prices of $20,000, $40,000, $60,000, and $80,000. The artist receives a total of $10,000 in resale royalties. During the same time period, the other painting is resold only once, but for $100,000. The second artist—albeit his work is more highly valued by the market—gets $5,000, or just half.

Even that, however, may be beside the point. Regardless of how a resale royalty is to be calculated, it still cannot remedy the mischief complained of if the law itself is readily avoidable. We have been told in the past, for example, that the California law has not been wholly effective because it was too easily avoided by the removal of commercial transactions to other states. Art world transactions can be removed to other countries as well. The recent decision of the Court of Appeals in Düsseldorf that the German artists' proceeds right—a part of German copyright law—had no extraterritorial application to a sale of German art (specifically the work of Joseph Beuys) in England should be a caution.

For highly valued works of art, the cost of removing their resale from the United States to a more hospitable jurisdiction might be a fraction of the resale royalty that would be otherwise payable by selling them here. Although this outcome might, in turn, be avoided by truly reformatting the resale royalty into some form of an income tax, there would be mind-boggling complexities in collecting such a tax through the Treasury Department and then redistributing it as some kind of a government grant-in-aid to a specific group of largely well-to-do artists.

Once again, though, let us suppose that the resale royalty could be justified and that these hurdles could be overcome. Are we certain that the good that is then to be accomplished for some few artists will not be outweighed by the harm that may be done to the mass of them? By no means.

The 1978 analysis of the California Resale Law by the Vanderbilt University economists Ben Bolch, William Damon, and C. Elton Hinshaw[3] is clear on this point. According to their calculations, the introduction of the royalty could be anticipated to depress prices generally in the primary market. For a handful of artists, that would later be compensated and more by the royalties expected to be received in subsequent years. For most artists, however, the initial loss would never be made up. They wrote that

profitable resale of art work is rare; few artists have a secondary market and few works of art appreciate significantly in value. The resale royalty law will result in only a small economic gain to a few and an economic loss to many. [The California law] should be repealed for the sake of the artists affected.

The Bolch-Damon-Hinshaw analysis contemplated that the introduction of resale royalties would generally depress the prices collectors were willing to pay in the primary market. Under an even grimmer scenario, however, some number of those collectors might abandon the market for contemporary art altogether in favor of some other and less-disadvantaged form of collecting: art by long-dead artists, baseball cards, or American pottery. They need only be a fraction of collectors to have some impact on contemporary artists generally.

This is speculation, but nonetheless the possibilities that the introduction of resale royalties might have an effect on both the price level and breadth of the primary market for contemporary art and, simultaneously, drive some part of the secondary art market overseas ought give pause to even its most ardent proponents. If the moneys collected were to perhaps benefit the visual artist community generally—if they were to be used, for example, to help provide more adequate health insurance for artists—then those risks might be justified. It might even then make sense to seek a royalty on *all* sales of art, on sales of new art and old art alike. A universal surtax on art sales to benefit artists generally is not, however, what is before us. What we are considering is a narrow impost on contemporary art that would provide only a small group of artists with any substantial benefit.

3. "An Economic Analysis of the California Art Royalty Statute," *Connecticut Law Review* 10 (1978): 689.

As hitherto formulated, the resale royalty directs its benefits to those artists who least need them while at the same time posing a distinct danger and offering little or nothing by way of recompense to those artists who could most benefit from its help. It is not merely, as the Prices concluded in their 1968 study of the *droit de suite,* that "to those who have shall more be given." Worse still, it is all too possible that from those who already do not have very much that even more shall be taken.

Twenty-six years of discussion ought be enough. However well meant in its conception, the resale royalty simply will not work under the specific conditions of the art market as we know it in the United States. It deserves to be put to rest.

# UNPUBLISHED MATERIALS
# AND COPYRIGHT:
# WHAT CAN A MUSEUM DO?

Copyright is among the legal obstacles that may impede the free flow of information between a museum and its public or even between one museum and another. Museums in the United States, for the most part, have developed a considerable expertise in dealing with the copyright aspects of the artworks contained in their collections, as well as those they may sometimes borrow for special exhibitions. By contrast, they have given relatively little attention to the somewhat different copyright considerations that cluster around the manuscripts, photographs, and other documentary materials in their files that may support and illuminate these owned and borrowed collections. One of the most typical situations is the case of a museum's correspondence with an artist concerning, among other things, the works created by that artist that the museum holds in its collection.

This article is condensed from a paper presented on September 22, 1992, during the triennial meeting of the International Council of Museums (ICOM) in Quebec City, Quebec, Canada. The presentation was made to a joint meeting of ICOM's International Committees on Documentation, Exhibition Exchange, and Management. Reprinted with permission from *Museum News* 72 (July–August 1993). Copyright 1993, American Association of Museums. All rights reserved.

One point should be made at the outset. Copyright law is essentially territorial. Regardless of an artist's birthplace, citizenship, domicile, or habitual residence and regardless as well of where the artist's work was created, the only copyright provisions that the courts of the United States will apply to the artist's work are those to be found in the United States' own Copyright Act. Although those provisions may be extended in a variety of ways to cover claims of foreign origin, such claims will nevertheless be subject to all the Act's many peculiarities (including such formal requirements virtually unique to the United States as publication, deposit, and registration).

By way of illustration, let us suppose that a museum of contemporary art located in Chicago has collected over the years a considerable body of work by a prominent French artist whose entire working career was spent in Paris. Most of these works were purchased directly. A few were gifts. For fifty years before the artist's death in 1968, the museum's senior curator (who has also since died) corresponded regularly with her concerning possible gifts and purchases, a variety of conservation problems, some important questions of iconography, and the possibility of a never-realized retrospective exhibition. Some of this correspondence also touched on little-known facets of the artist's personal life. Until recently, this correspondence had been misplaced, and none of it has previously been published. What uses can the museum now make of this correspondence? Can the museum publish it? Can the museum put it on display? Can the museum make its contents available to other museums and outside scholars?

As a threshold question, we might inquire whether this exchange of letters can possibly be treated as a single entity—for instance, as a joint work created by the curator and the artist—or whether it must, for legal purposes, be separated into its component parts. On this point, the law seems clear. Notwithstanding the similarity of such an ongoing exchange to the back-and-forth dialogue of an interview—a literary product that may arguably be considered to be the joint creation of the interviewer and the interviewee—each letter in a series of correspondence stands as the independent creation of its author. Although the recipient of each letter owns and has the unqualified right to sell or otherwise transfer the physical object (i.e., the letter itself), the intellectual property embodied in the letter (i.e., its literary content) will normally remain the property of its author. This is the case regardless of

whether the letter is an ordinary business document, a lively snippet of gossip, a profound meditation on art, or a personal confidence.

Concerning the curator's side of this correspondence, the museum should be able to deal with that in any manner it chooses without the need (except as a courtesy) to consult with her heirs. Assuming she was regularly employed (i.e., that she was on salary and not a consultant working under contract) and that the correspondence was generated within the scope of her employment, then her side of the correspondence will constitute what the Act defines as a "work made for hire." As such, the museum itself would, as her employer, hold the exclusive copyright to it for whichever expired first of a period ending, in the case of each letter, one hundred years after its creation or seventy-five years after its first publication.

Altogether different, however, is the situation regarding the artist's side of this correspondence. During the artist's lifetime (i.e., up through 1968) and for ten years thereafter, the very fact that this correspondence had never been published would have automatically put it beyond the scope of the Act. The federal law then in effect dealt exclusively with published material. Unpublished works were left to be covered by whatever local or foreign law might be applicable. What such local law most frequently provided was a partial analogue to statutory copyright generally referred to as common law copyright or the right of first publication.

A sweeping amendment to the Act in 1976—it became effective on January 1, 1978—changed that situation entirely. A new section 104(a) brought all unpublished as well as published works fully within the framework of federal law. Moreover, it did so without regard to the nationality of the author. In this respect, the protection it gave to unpublished works was even more comprehensive than that given to such published works as, for example, the paintings that the museum had bought from the artist before her death. Since January 1, 1978, the question of whether the museum can publish the artist's correspondence—notwithstanding that the artist had already been dead for ten years when the new law took effect and notwithstanding that she might never once have left France—is one to be answered entirely under the amended Act.

Fundamentally, that answer is a simple one. The artist's letters are protected by copyright. Unless and until it has permission to do so from the artist's heirs or can bring their publication under the Act's exception for "fair use," the

museum will have no right to publish these letters before they enter the public domain on the expiration of copyright.

That the copyright in unpublished material should ever expire at all was among the major changes wrought by this 1976 amendment. Under the common law copyright previously applicable to unpublished works, the artist's heirs would have had, at least in theory, the right in perpetuity to withhold her letters from publication. In this, common law copyright paralleled the so-called right of divulgation, its analogue in France and those other countries that recognize the *droit moral* or moral right with respect to works of art. By contrast, the amended Act limited the protection of unpublished works to a statutory period. Depending on a series of technicalities, the artist's correspondence would fall into the public domain in either the year 2018 (i.e., fifty years after her death) or some nine years later on December 31, 2027. Burdensome as such a delay might be, the museum would still be better situated than under the pre-1978 law when the artist's correspondence might have been kept from publication indefinitely.

Assuming, however, that the museum would not want to postpone its publication of these letters, might it successfully argue that this constituted "fair use"? Fair use is among the amended Act's most distinctive features. It codifies in statutory form what had previously been a judge-made rule developed in a string of court cases that date back to the mid-nineteenth century. Fair use is essentially a rule of reason. As pertinent to museums, it permits what would otherwise be infringing copies to be made and distributed for such purposes as scholarship or research when the context is a nonprofit educational one and when such use would have little adverse effect on the potential market for the copyrighted material.

Not so well understood, however, is that, under still another judge-made rule, the doctrine of fair use has been given only the most limited application in the case of unpublished materials. The distinction has been explained thus: In the case of an already published work, the issue is essentially economic. The author has already made the decision to make the work available to the public. The principal remaining issue is whether a particular and technically infringing use would unfairly divert the author's potential profits. If not, such a use may be deemed to be "fair," and permitted.

In the case of unpublished materials, however, there may be more than an economic issue at stake. There may also be an issue of privacy. Even if a

particular use might otherwise be fair, the courts have not been sympathetic to the notion that an author might be forced to publish or permit to be published materials that he or she has up to that point determined to leave unpublished. In our hypothetical case, for example, the artist's letters do include, along with their business and art-relevant content, a certain amount of information concerning her personal life. Given such an analysis, not only might the museum be precluded from publishing the artist's letters in their entirety, but conceivably, it might not even be able to avail itself of the fair use doctrine to publish a selected group of quotations. In October 1992, the Congress further amended the Act in an effort to put the fair use treatment of unpublished materials on the same basis as that provided for published ones, but the courts have yet to interpret this new provision.

What would be the situation if the museum chose instead to summarize or paraphrase these letters rather than publish them whole or through selected quotations? Here it might be on safer ground. The first principle of copyright is that it protects forms of expression, not ideas. There might be no supportable claim of infringement so long as the museum's summary or paraphrase was significantly different in language, tone, and structure from the mode of expression used by the artist. In that instance, the privacy interest would also be subordinated.

Likewise, if the museum chose to display the artist's letters as part of an exhibition (as distinct from reproducing them through a publication), it should again be on safer ground. Notwithstanding that this too might compromise the author's privacy in almost precisely the same way as the "fair use" of unpublished material, section 109 of the Act specifically provides that the owner of the tangible object in which copyrighted material is embodied may publicly display that object without the authority of the copyright owner. For museums in the United States, this is among the most important of all the Act's provisions. Without it, they could not exhibit the many works of art in their collections to which an artist or some third party continues to hold the copyright. Under section 109, the museum also would have the right to lend the artist's letters to others for display in the same manner as the museum might display them itself.

Beyond display, may the museum also make occasional copies of the artist's letters either for the use of its staff or for other museums or outside scholars? The provisions of the Act that cover such copying are extremely complicated.

Although they permit a certain limited exception, this is restricted, first, to "a library or archives" and, second, only to those libraries and archives that are either open to the public generally or, at the very least, are open to outside researchers working in the particular field in which the library or archive specializes. Libraries and archives that are part of a larger entity such as a museum or historical society would appear to qualify so long as they meet, as well, the second criterion of permitting some degree of public access.

In the case of unpublished materials such as the artist's letters, a qualifying library or archive can make photocopies, including microfilms and microfiche, either for preservation and security purposes (i.e., to avoid any danger of damage or loss from the improper handling of the originals) or "for deposit for research use" in another library or archive that would meet the same qualifying standard as the museum's own library or archives. Note, however, that this second library or archives (or third, or whatever number—there is no specific limit on the number of copies that a library or archives can thus distribute on a one-at-a-time basis) cannot itself make any additional photocopies for further distribution. That right is limited solely to the owner of the original material.

What if the museum, whether willfully or through negligence, should fail to comply with the Act? What risks might it face? The remedies provided are generally classified under two headings: those that involve some intervention by the courts and those that may result in the assessment of money damages, court costs, and attorney's fees.

The most forceful of these interventions—the imposition of criminal penalties that can, in the case of the infringement of a literary work such as the artist's letters, include a jail sentence of up to one year and/or a fine of up to $25,000—would presumably not apply. Such criminal penalties are reserved for infringements that involve commercial advantage or private financial gain. By its very nature as a nonprofit institution, neither the museum nor its staff should be subject to criminal penalties. The museum, however, would by no means be exempt from such other interventions as a temporary or permanent injunction against the reproduction or distribution of any infringing materials, the impoundment of any such materials (including the printing plates from which they were reproduced), and even the eventual destruction of such infringing materials. A museum that willfully chose to risk such a penalty as impoundment and destruction might be well advised, using

the artist's letters as an example, to reproduce such potentially infringing materials in some separate pamphlet rather than as part of a large and expensive exhibition catalogue.

Whether and to what extent these remedies would be available in the instant case and, more particularly, whether the artist's heirs could recover money damages (either actual damages or "statutory" damages that can range up to $100,000 for a willful infringement), court costs, and attorney's fees might depend on some of the peculiar formalities of deposit and registration referred to earlier. For reasons too arcane to consider here, the heirs of a French artist would be better situated to obtain certain of these remedies than would, for example, the heirs of an Argentinean one. In either case, however, regardless of the artist's nationality, his or her heirs would be in a better position to assert their claims if they were able to comply with the Act's deposit and registration provisions than if they failed or were unable to do so.

Regardless of its outcome, such a litigation could only be vexatious. Far more satisfactory from the museum's viewpoint would be either to secure the copyright in these letters for itself or, more likely, to obtain at least some form of license that would authorize their publication. Here, the distinction between an exclusive license (which requires a writing signed by the licensor) and a nonexclusive one becomes important. If the museum wants merely to use this material for its own purposes rather than to exercise absolute dominion over it, a nonexclusive license should be adequate to accomplish this. Despite all its other and sometimes daunting formalities, the Act does not prescribe any particular form for such a license. It might, for example, be spelled out through an exchange of letters in which a curator wrote that, unless the artist objected, the museum would consider itself entitled to publish their correspondence at some later date. At the most casual extreme, and assuming that the required evidence could subsequently be produced, such a nonexclusive license might even be effective if given verbally.

Ideally, such permission ought to be sought contemporaneously with the creation of the material. As a routine matter, curators, conservators, and others engaged in correspondence with artists, critics, and others should be sensitive to copyright issues and consider how they might best secure permission for the future use of the material that is being generated. It is almost invariably easier to get such permission at that time than on the eve of publication when, all too often, copyright questions are first considered. Once

the artist (or critic or other) is no longer living, to identify, track down, and deal with heirs may prove more complicated.

The late Joshua C. Taylor frequently observed that a museum was both a collection of things and a collection of information about those things. Too often, in considering the use of a museum's collection for scholarly purposes, museum workers have concentrated on copyright issues as they pertain to things but not as they pertain to the ancillary information that helps us to understand those things. A museum could enhance its usefulness as a source of information if more thought were given to ensuring that it had the right to use and disseminate the materials it holds in its files.

The considerations discussed here concerning an artist's letters may apply as well to such other archival documents as photographs, audio tapes, and video recordings. By trying to deal in advance with the copyright problems that may later ensue, a museum will not only maximize its ability to serve the public as an information resource but may also save itself from a considerable subsequent expense, effort, and even pain.

# THE ART WORLD OLYMPICS

Midway between the 1988 and 1992 Olympics, a quadrennial question recurs. Most of us neither hurl javelins, risk our necks on luges, nor toss around 16-pound shots. Although these all may be admirable skills, they scarcely seem relevant to our own daily experience. Ought there not also be an Olympics of Everyday Life? And perhaps one especially for the art world? This Olympics could emphasize and reward strength, concentration, agility, and endurance. Certain ancient Greek games included competitions in trumpeting, declamation, and other performing arts. Why could we not have competitions in the visual arts as well? Reaching beyond the simple and, as a spectator event, boring format of the juried exhibition, what might a full-fledged Art World Olympics be like? Who would compete? At what? How?

The contests for sculptors, painters, and printmakers might well follow the two-part format already so familiar from gymnastics and figure skating. For the compulsory phase, artists could be assigned a model or motif from which to work. A panel of critics might then award them points in such categories as rendering, speed, neatness, and finish. In the second or free-style phase, a further round of work could be judged for its style, originality, and *je ne sais quoi*.

First published in *The Journal of Art* 3 (December 1990): 6.

Lest this seem wholly fanciful, consider the James Wilber Johnston National Sculpture Competition for Figure Modeling. Established in 1978 and now administered by the International Sculpture Center in Washington, D.C., the Johnston Competition pits young artists against one another in a twenty-four-hour sculpting contest spread over five consecutive days. Working side by side (actually armature by armature) and from a single live model, their common assignment is to create a full-length figure in the round, between thirty and thirty-six inches high. The jury-determined winner receives a cash award and the chance to see his or her work cast in plaster.

Unique to these Olympics, though, would be those events especially designed for some of the art world's other players: writers, scholars, curators, dealers, and private collectors. For example, "Yellow Journalism" would be a contest intended for art writers. Furnished with only two hints, an innuendo, a lead, and a word processor, the participants would be required to compose a series of news stories about some prominent art world individual or institution. Lawyers and weekly tabloid editors would serve as judges. Top prize (the "best bash" medal) would go to the writer able to depart farthest from all the known facts while still not stepping over the line into libel. In an alternate scoring system, lapses into libel might simply require that penalty points be deducted from a score otherwise based in equal measure on bulk, brio, and bushwah.

Most apt for scholars, perhaps, might be "Reach for the Real," a contest modeled on the Rembrandt Research Project. Competitors would be asked to distinguish authentic from misattributed works for a wide range of artists. Those whom the judges determined had most thoroughly eviscerated an artist's oeuvre would be the winners. A less strenuous event for senior scholars might be "Fakes and Fortitude." In that, public ridicule would be heaped on competitors who failed to detect fabrications introduced by the organizers into the catalogue raisonné of an otherwise obscure nineteenth-century lithographer. The contestant bearing the heaviest load of ridicule would be declared the winner.

For museum workers, an individual event of some interest might be "Curatorial Mop-Up." Competitors would be confronted with an irresistible five-figure honorarium and a group of sixty-five previously selected and seemingly unrelated paintings. Working against time—a mammoth hour-glass might be positioned in the center of the stadium to heighten the drama—they

would be required to produce a five-thousand-word catalogue essay that seamlessly linked these arbitrary choices and convincingly spelled out the inevitable and historical impact of their temporary conjunction. The curators would be scored on their style and originality. The discovery of any new "isms" would earn them bonus points.

In "Late Great Artist," a contest for dealers, an artist's estate, brimming with marketable paintings but with no urgent need to sell, would be installed at the center of the stadium. Surrounding this target would be a field of international dealer-competitors, each armed with nothing more than a $10 million line of credit, an offshore lawyer, and a CPA. The top award would go to the contestant who would outmaneuver his or her competitors to sign the estate to an exclusive ten-year worldwide contract at a commission of 30 percent or more. If two dealers managed to obtain exclusive contracts, then the one negotiating the higher commission would be the winner.

Most dramatic of all might be "You Be the News," a contest for private collectors. Competitors would be seated on a specially leveled playing field. A world-class masterpiece (if possible, an object also central to some small nation's patrimony) would be hoisted onto a high platform. Contestants would struggle against one another to purchase this work by cacophonously shouting out progressively higher prices in a multitude of tongues. Adjustments for dollars and other out-of-favor currencies would be calculated and displayed on an electric scoreboard. When all but one participant had exhausted his or her purchasing power, the surviving contestant—traditionally required to pound his or her chest in a ceremonial gesture of triumph—would be declared the victor. Along with a medal would be a minimum of three press conferences and a flattering profile in a national news weekly.

# 24

# REMARKS FOLLOWING
# RECEIPT OF THE
# KATHERINE COFFEY AWARD

After those words from Kenn Starr, you might appropriately ask that this gallery be flooded to a depth of some two feet or so—to make me prove that I can really walk on water. In the meanwhile, though, please bear with me while I try (with some earth-bound discursiveness) to tell you why it means so much to me to receive the Katherine Coffey Award that you have so generously given me today.

As many of you may know, I can sometimes be fanatical about taking note of anniversaries—not just the major multiple-of-five or multiple-of-ten ones, but also the little in-between ones and occasionally even fractional ones. Last week there were two such anniversaries—both, as it happens, whole-year ones and both distinctly connected to this afternoon's ceremony.

Last Monday, October 22, was the thirty-eighth anniversary of the day in 1952 when—just a little north of here at Camp Kilmer, New Jersey—I

These remarks followed the author's receipt of the Katherine Coffey Award during the 44th annual meeting of the Mid-Atlantic Association of Museums in Trenton, New Jersey, October 29, 1990. Reprinted with permission from *Courier* 11 (January–February 1991). Copyright 1991, The Mid-Atlantic Association of Museums. All rights reserved.

received an honorable discharge from the U.S. Army. The following day, Tuesday, October 23, was the twenty-third anniversary of the day in 1967—fifteen years later—on which I started my very first museum job at the Whitney Museum of American Art in New York City.

October 22, 1952, is a day I still recall vividly. There were four of us from Manhattan who received our discharge papers at the same time that morning. Outside the gate to Camp Kilmer, with no thought of the cost, we flagged down the nearest taxi and urgently commanded the driver, "New York City, please. Nonstop." We yipped all the way there, finished with the war (the Korean one), exhilarated to be still alive, and happy to be free. As far as I can remember, none of us had a kind word to say about the military experiences that we were leaving behind.

That evening—I had arranged it some weeks earlier—I had tickets for a Broadway play. The very act of attending the theater that night had been specifically planned to symbolize my reentry into civilian life. The play was *The Four Poster,* and the two-person cast consisted of Hume Cronyn and Jessica Tandy. Those of you who remember it, or who perhaps saw the movie, may recollect that it traces the story of a married couple through various moments in a lifetime together that in total spans some four or five decades. What struck me as so very singular that evening was how smoothly these two lives seemed to roll forward, almost as if they were gliding from past to future along well-worn grooves.

After the acute state of puzzlement in which I had left the army that morning—I no longer had the faintest idea of what I wanted to do except not to be a soldier—I had a foreboding that evening that my life was not going to be in any way like the life that Hume Cronyn and Jessica Tandy were leading up there on the stage. Rather than smoothly unrolling, it seemed to me that night that for me—even, perhaps, for anybody coming of age in the second half of the twentieth century—it was far more likely to be a bumpy life, abruptly discontinuous and prone to accidents, a life guided as much by good or bad luck as by deliberate intention. My premonition was accurate. That's just the way it's been, with, happily, a great deal more good luck than bad.

Of the many accidents that have gone to shape the thirty-eight years since, two seem particularly relevant today. The first did not actually involve me. In fact, I do not even know the name of the person to whom it happened. She was a lady who had gone to the circus, dressed in all her best finery, and taken

a seat in the very first row. During the performance, an elephant had backed up to where she was sitting, lowered his rear end over the protective railing, and . . . anyway, you get the picture.

Just out of the army, I was visiting a friend who was then in his first year of law school. Idly looking through one of his casebooks—the subject, as it happened, was *Torts*—I encountered the case of the lady and the elephant. She was suing the circus and seeking damages for the ruin of her finery. She was seeking still further damages for acute emotional distress. She was seeking even still further damages to punish the circus for its gross negligence. The court, however, did not see things so simply. Had she, the court wondered, assumed some degree of risk in sitting so close to the arena? Moreover, it wanted to know, was there anything in that particular elephant's past history to indicate that the managers of the circus ought have made a special effort to keep him away from the audience? (In dog law, this is called the "one-bite" rule.) What, in fact, were the evacuation patterns to be expected of elephants generally or of circus elephants particularly?

Well, this seemed to me heady stuff. Something like philosophy but richer, more full of life, more action-oriented. I was fascinated. Was all of law school like that? My friend lied. He told me it was. So off I went to law school, and only a little of it turned out to be like that at all. Most of it concerned how to obtain a *subpoena duces tecum* or figuring out how the liability to pay federal income taxes was properly to be imposed on the partners in different kinds of partnerships.

The second accident occurred nearly fifteen years later. Some seven years after finishing law school, I had left the practice of law—I loved the law a lot, and still do, but did not like how it was practiced—and was by then managing an art gallery in New York City. The scene was something like one of those fifteenth-century *Annunciation* panels in which Mary, interrupted in her reading, sits stunned as the messenger angel tells her about the remarkable events that are about to transpire. In my case, the angel was a trustee (the board president, actually) of the Whitney Museum who all but unexpectedly dropped by one summer day in 1967 to ask if I would like to work for the Museum. He did not need a hasty answer. I should please call to let him know.

There followed a battle of head and heart. My head said that, with a non-income-producing wife and three children still younger than ten, there was simply no way I could afford to take the approximately 40 percent cut in

salary that going to the Museum was going to require. Although my heart kept seditiously whispering "So what? Do it anyway," those whispers were not yet loud enough to counter the cold fiscal calculations of my head. On that Friday afternoon, I called the board president to tell him that I was reluctantly compelled to decline his invitation. "He just left," his secretary said, "about five minutes ago." "I see. And will he be back in the office this afternoon?" "Oh, no. He's gone to Europe on vacation. He'll be back in four weeks."

It was during those next four weeks that my head weakened, my heart strengthened, and I determined to join the Museum. If I could not afford to work in a museum in money terms, well then in more-than-money terms—in real life terms—I could not afford not to. What seemed perfectly clear was that this was not an invitation likely to come again. When the board president returned from his vacation, I hastened to call to tell him I would be ready to start work in late October. Had I called five minutes earlier on that first Friday, though, I have no idea where I would be *this* October afternoon twenty-three years later—but certainly not here, and not with you.

What was it that so strengthened my heart during those intervening four weeks? Two things, I think. First, it seemed to me that an art museum was a place where a person could work without the need for any kind of apology, that it was a fundamentally good place, unquestionably and unconditionally. The pull of that notion was made all the stronger by the insidiously hustling and sometimes shabby atmosphere which then pervaded the New York commercial art scene. It left little of which to be proud. The second thing that lured me was the realization of just how much I liked all the museum people that I had ever met, and how rewarding I thought it would be to have them as colleagues.

Curiously, after nearly a quarter-century, the first of those two notions—the view of the art museum as an unquestionably and unconditionally good place—is no longer universally accepted. Important questions, questions that we must absolutely now confront, are today being raised about the legitimacy of the art museum and about the source, validity, and authenticity of the standards that it claims to maintain. How well we are able to deal with those questions will have great consequences for these museums throughout the 1990s and beyond.

Concerning the second factor that decided me, though, my enormously positive experience of the people who worked in museums—with respect to

that my view has never wavered or changed. To have worked for these past twenty-three years with so many hundreds and thousands of honorable, talented, and generous colleagues has proved to be one of the most enormous pleasures of my life.

I talked earlier about accidents and luck. In my view, however, it is neither an accident nor merely a matter of luck that the people who work in museums (that's us) should be as special a group as they (we) are. Let me suggest some structural reasons why, as a group, museum people might be different from some of the people who work in other fields.

For one thing, as I have written elsewhere, nobody does this kind of work for the money. It just is not there. The only people who work in museums are people who really want to, people who are enthusiastic about their occupation even to the point of making a substantial economic sacrifice to pursue it. A working world made up of such people feels very different from one that is populated by the sometimes bitter, trapped, and alienated personalities who assure you in the law, advertising, and elsewhere that they would leave in a minute if it weren't for the money.

Although museums may occasionally complete for donors or for particular objects, they rarely compete for market share. That permits museum people a degree of candor and supportiveness in their dealings with one another that might not be possible in a more basically competitive situation. (Imagine, for example, art dealers exchanging confidential information in the way that museum people do.) It is just this atmosphere that has made possible such training programs as the Museum Management Institute and other mid-career efforts that rely heavily on the willingness of participants to be forthcoming about their day-to-day working experience in museums.

That the museum field contains an interlacing of so many different skills and backgrounds gives it a tremendously cosmopolitan aspect. I am by no means alone in having arrived in museum work by such a wholly unexpected and accident-filled route. Hundreds of our colleagues, and certainly many of you here today, came to museums in just that same almost-random way. All of us, I think, have been greatly enriched by this diversity of background and by the myriad interactions that it regularly fosters.

Finally, the very museum enterprise itself is to a degree bottomed on notions of respect, caring, and decency. Museum work necessarily assumes that the natural world and the accomplishments of its inhabitants are worthy of preservation and transmission. It also assumes that there will be future generations with the responsiveness and interest to benefit from the work that museum people do in preserving and transmitting their heritage. Such assumptions are acts of faith. Institutions infused with faith and built on such qualities as respect, caring, and decency must inevitably strengthen and bring to the fore those very same qualities in the people who work with and for them.

Because the Katherine Coffey Award is one that comes so specifically from you, my old and new colleagues in museums, I could not be more greatly honored. To the end of my days, I shall always rejoice that—whether it was by accident or destiny, which may all be one—I did not make that particular Friday afternoon telephone call five minutes earlier and thus have been able to take a place in your ranks. Proud as I am that you have chosen to recognize me in this way, I am prouder still to be able to count myself as one of you.